THE BOOK OF
PORTRAIT
Photography

THE BOOK OF
PORTRAIT
Photography

Jorge Lewinski and Mayotte Magnus

EBURY PRESS

The Book of Portrait Photography was
conceived, edited and designed by
Dorling Kindersley Limited,
9 Henrietta Street, London WC2

Project Editor
Judith More
Designer
Mark Richards
Art Director
Stuart Jackman

Published by Ebury Press
National Magazine House
72 Broadwick Street, London W1V 2BP

First impression 1982

ISBN 0 85223 226 8

Typesetting by Chambers Wallace, London
Reproduction by F. E. Burman Limited, London
Printed and bound in Italy by A. Mondadori, Verona

Contents

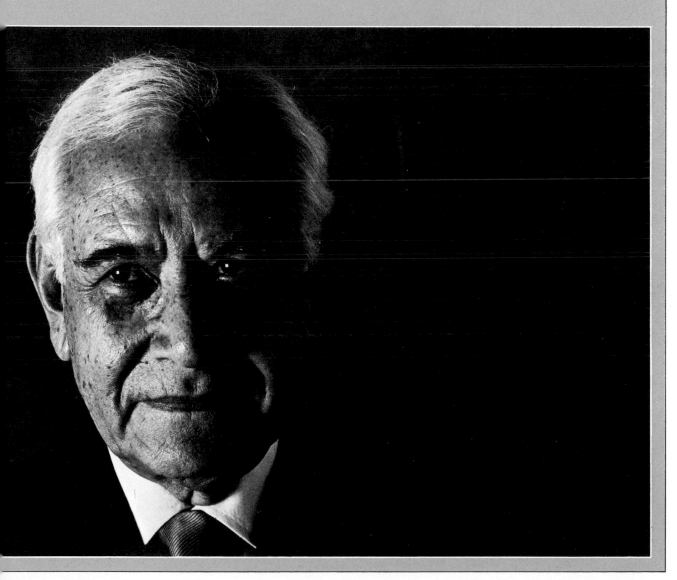

Introduction

From the earliest times, other people's outward appearance, character and way of life have exerted a strong fascination. This has been translated into a strong desire to convert impressions of other individuals into permanent records; in other words to produce portrait images.

The field of photographic portraiture is a very rich and diverse one. A portrait study can be a simple, powerful image of a head, or a small figure set against a sweeping landscape. Portraiture is as much about appearances as it is about ideas and impressions. A photographic portrait arranged in a formal, painterly manner can seem stilted, while a simple snapshot is often a lively, convincing likeness. The reason for this lies in the nature of the photographic medium. The great realist Paul Strand said that a photographer creates meaningful images only when he "naturally and inevitably utilizes the true qualities of his medium in its relation to his experience of life". Photography is at its weakest when the reality of the scene – which is, after all, its main subject matter – is drastically altered and reorganized by the photographer. The camera *can* lie, but on the whole not very convincingly. Photography is very much a medium of "this very moment", and the best photographic images are often those that seem to embody a strong sense of real life. This is something no other medium can do. Painting is always a synthesis of moments and impressions, whereas photography is one real moment – a fragment of life – selected by the photographer to give his impression of an event or person. In fact, the photographer can usually capture several such moments, producing a range of choices rather than a single final image.

Yet portraiture is not merely fleeting moments and impromptu snapshots – it requires thought, preparation, reflection and application, and indeed fine images can originate in a studio as well as on location. In fact, some types of portraiture should be carried out in the studio, as photographers like Irving Penn and Richard Avedon have amply proved. Wherever you are shooting a portrait you should always remember that you are working in a very special medium. The camera, like the human eye, should never be still for a moment. It should be constantly mobile, looking and searching, always in quest of the best and most potent image.

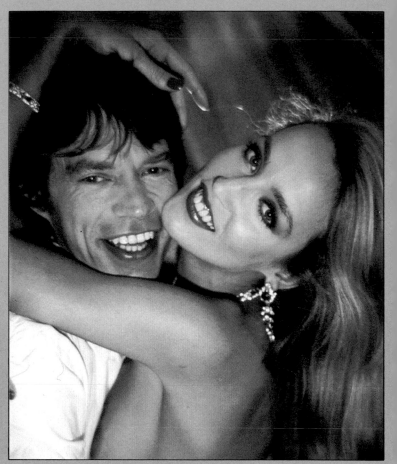

Mick Jagger and Jerry Hall by Norman Parkinson △ Photography allows the portraitist to record every nuance of expression or fleeting gesture that the sitter makes. While a painter may have to rely on a number of sittings, creating a synthesis of moods and expressions, the photographer can catch a rare moment of revelation.

◁ **Close-up by Pete Turner** There are a great number of ways in which photography can represent a sitter's most important feature – the face. To suit the interpretation, a photographer may choose to show it as an integral part of the environment that it inhabits, or capture it in an intimate close-up.

◁ Retired worker by
Eve Arnold
This sensitive, informal,
photojournalistic portrait of
an elderly Chinese lady is
an excellent example of
photography's ability to
communicate the intense
reality of the image to the
viewer. In general, real
people in real situations are
by far the best subject
matter for photography.

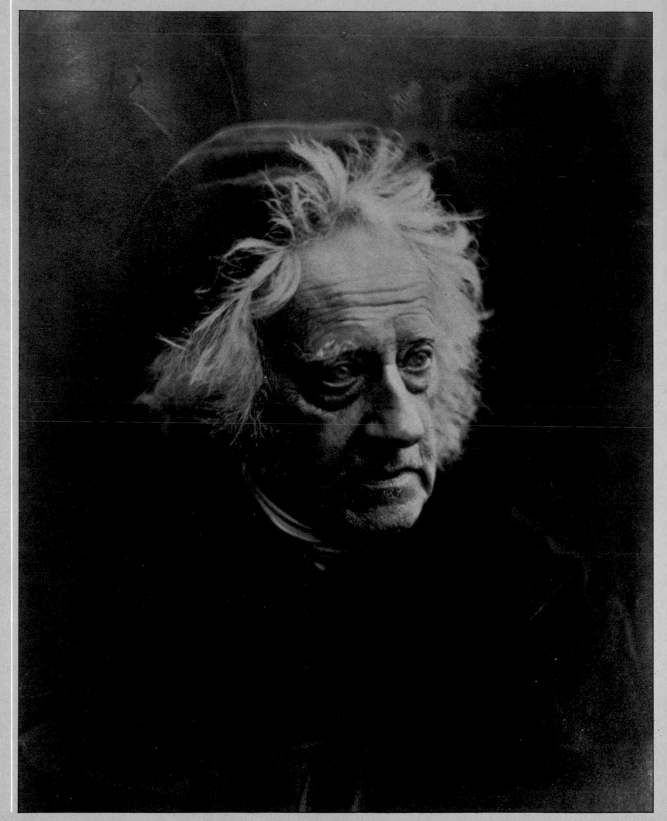

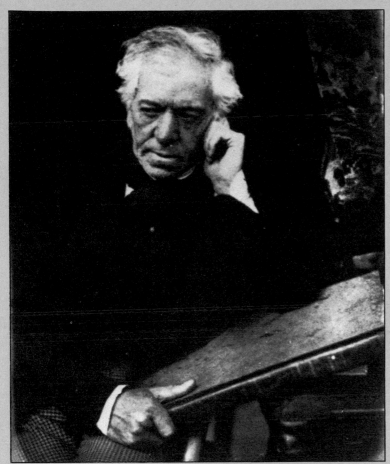

John Murray by D.O. Hill and Robert Adamson △
Hill and Adamson formed a partnership of a painter and photographer. Together they photographed a splendid gallery of notable 19th-century personalities.

Small girl by Lewis Carroll ▷
The author of *Alice in Wonderland* was also an accomplished amateur photographer. He was the first early portraitist to use photography as a more informal and natural medium.

◁ **Sir John Herschel by Julia Margaret Cameron**
Cameron used long exposures (up to 7 min), a very small studio with only one top window, very long lenses and large format cameras. This created enormous technical difficulties, and as a result her pictures are often unsharp, but this does not impair their impact.

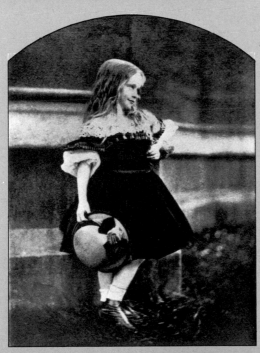

The forerunner of portrait photography was the painted portrait. The earliest surviving examples of these are paintings attached to sarcophagi in Roman Egypt, dating from the first and second centuries A.D. By the beginning of the sixteenth century, the High Renaissance masters had brought the painted portrait to a peak of perfection. But portraiture was commissioned by the rich and mighty, who demanded that their portraits show nobility, grace and authority, and artists had to make concessions to this vanity. Most artists therefore suffered from a lack of creative freedom. Social changes in the nineteenth century began to alter this, but by then photography had begun to replace the painted portrait.

Painters of miniatures were the first to feel the pinch of competition from the new medium, and although the anguished prophecy "from today painting is dead" (uttered by the painter Laroche at the official unveiling of the new discovery in Paris in 1839) was not entirely fulfilled, it certainly had some truth as far as the painted portrait was concerned. The new, accurate photographic likenesses soon eliminated all but the best portrait painters.

The earliest Daguerreotypes were not suitable for photographing people – no one could sit still for the necessary half-hour exposure. However, improved chemicals, lenses and cameras quickly reduced the minimum exposure time to about one to two minutes in full sun. Daguerreotype plates had another serious drawback: each exposure was unique and could not be duplicated. The first negative/positive photographic process – the Calotype process – was invented in the same year as the Daguerreotype (1839) by an Englishman, William Henry Fox Talbot. The Calotype process was used by the world's first great artists of photographic portraiture – two Scotsmen named David Octavius Hill and Robert Adamson. The next photographic advance relevant to portraiture came in 1851, when Frederick Scott Archer invented the collodion or wetplate process, in which the negative was recorded on a glass plate. As well as possessing the capability for endless reproduction, this process shortened exposure times considerably. Although the process was cumbersome for outside work (since the plate had to be sensitized and developed while still damp, requiring a complete location darkroom), it was a boon for the studio-bound portraitist.

Portraiture flourished in the third quarter of the nineteenth century, with a host of great exponents on both sides of the Atlantic. In America, Mathew Brady, Albert Sands

Mark Twain by Alvin Langdon Coburn ▷
Coburn's portraits of writers and artists combine naturalistic elements with meticulous regard for classical composition and balance. Although he is best remembered for his experiments in photographic abstraction, his more conventional portraits are now fast gaining in esteem. He took this Autochrome study in 1910.

◁ **Bibi by Jacques-Henri Lartigue**
Lartigue started to take his remarkable photographs of pre-First-World-War society as a child. When one of the earliest color materials — Lumiere's Autochrome plates first marketed in 1907 — came into his hands he experimented with this new material enthusiastically. The relaxed attitude and expression of his sitter are notable in view of the long exposures required.

Southworth and Josiah Johnson Hawes all achieved distinction, while in France Etienne Carjat, Camille Silvy and Nadar were prominent. In England the incomparable Julia Margaret Cameron reigned supreme between 1864 and 1875.

Nevertheless, with the notable exception of Julia Margaret Cameron, who broke all the rules with her large close-ups of celebrated heads, and perhaps Lewis Carroll, who adopted a more relaxed, informal style, nineteenth-century portrait photography mainly consisted of adapting painted portrait styles. The majority of portrait photographers perpetuated the formula of static, slightly ponderous images. A typical study consisted of a well-lit three-quarter view of a sitter, usually in an armchair, with some drapes or a painted background imitating the natural environment. In spite of the example of some inspired innovators and photographic realists, this painterly approach to portraiture, with some obvious modifications and improvements, was continued by a large number of portraitists, right through the first half of the twentieth century.

◁ **Audrey Hepburn by Sir Cecil Beaton**
Beaton was not only a famous photographer, but also a leading theatrical designer. He combined his two skills in his sumptuous, decorative studies where color is often given a free reign. Beaton was a leading photographer for *Vogue* magazine for three decades, where he originated a new style of portraiture in which the sitter seemed to become a part of the decorative environment.

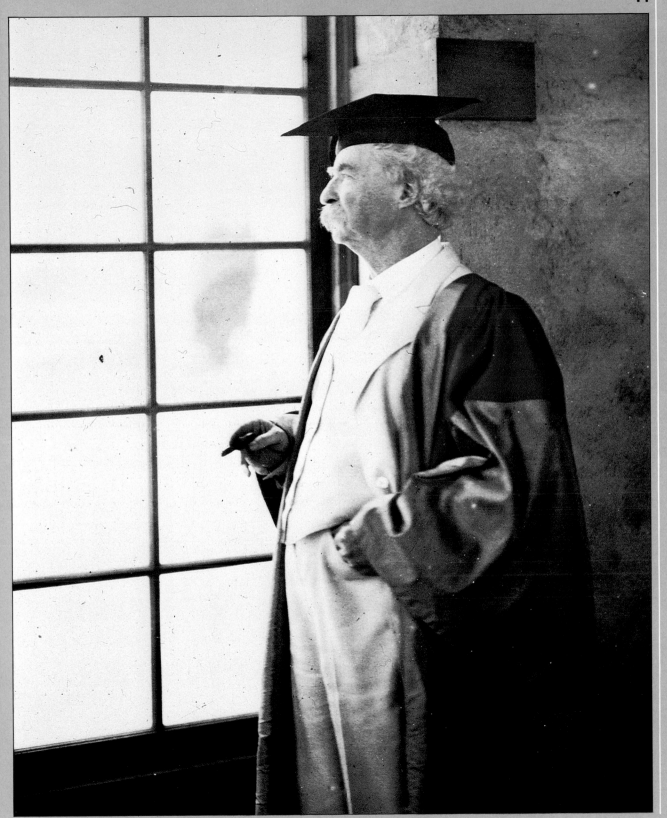

The large majority of twentieth-century portrait photographers have emphasized only two aspects of portraiture — regarding the studio as the only possible place for portraiture, and investing lighting with an element of mystique and sanctification. These "unwritten laws" of portraiture have held back its development by preventing the photographic medium from being used to its full potential. Most twentieth-century portraiture has been dominated by studio work – A. L. Coburn, Man Ray, Hugo Erfurth, Howard Coster, Chargesheimer, Edward Steichen, Gisele Freund, Yousuf Karsh, Philippe Halsman, Irving Penn, and Richard Avedon all carried out their portrait work almost entirely in the studio.

Nevertheless, while the majority of mediocre portraitists were producing stereotyped shots, the variety and scope of invention of these masters was exceptionally wide. Man Ray invented solarization (see p. 132), creating many wonderful, almost three-dimensional studies of heads and figures. Edward Steichen used shadows and props imaginatively to create

The Migrant Mother by Dorothea Lange ▷
Lange was one of the finest American documentary photographers. She shot this portrait in the 1930s when she worked for the Farm Security Administration. "The Migrant Mother" is certainly one of the most famous images of this century, and perhaps the best example of documentary portraiture. It was unposed, unrehearsed and totally realistic.

◁ **Ernest Hemingway by Yousuf Karsh**
Karsh is possibly the best known post-war portrait photographer. He is famous for his masterly use of large format cameras and meticulous and powerful lighting. His portraits were very popular in the 1950s and 1960s.

◁ **Lord Atlee by Jorge Lewinski**
This shot is an example of editorial interpretive portraiture – taken in available light during a very short session in the subject's own study. It would have been very difficult to achieve a natural, relaxed expression in the more formal environment of a studio.

Franco Zeffirelli by Bill Brandt △
Brandt is undoubtedly the finest contemporary interpretive portrait photographer. His portraits are all very different, since each is created to show the most pertinent aspects of his sitter's personality. It is a sign of his greatness that in spite of his total faithfulness to his sitters he has still developed a unique style, characterized by a brooding, surrealist mood.

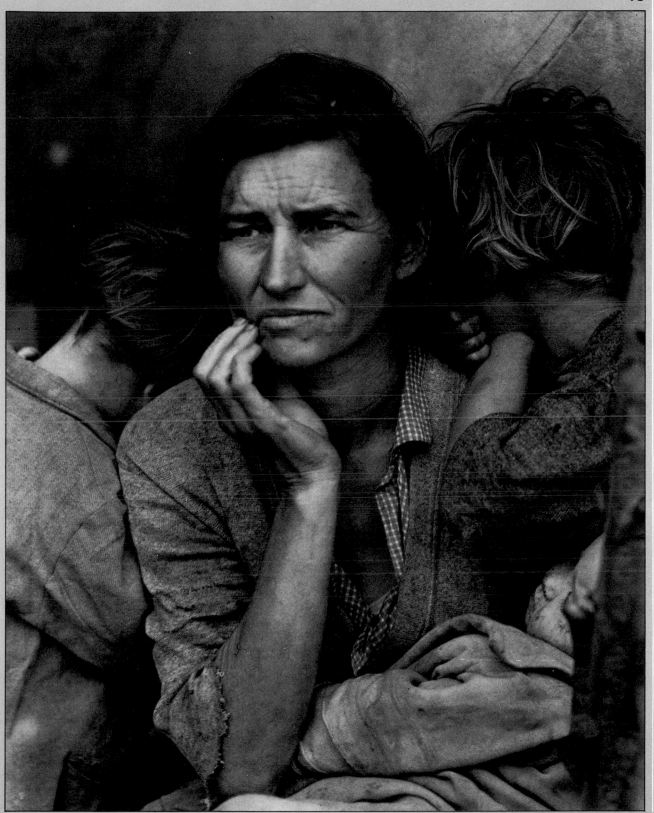

stylish portraits of stars and celebrities. Chargesheimer developed a distinctive style of strong, very high contrast studies. And Irving Penn, also working almost exclusively in a studio, has used very simple lighting – often daylight – to take close-up shots of sitters enhanced by strong patterns of shadow and light. Penn also became well-known for his use of very simple props such as an angled wall, or boxes covered with rough sacking. And Richard Avedon has become renowned for his supremely realistic, uncompromising studies of prominent personalities.

Despite the fact that they only ventured outside their studios on rare occasions, all these photographers were and are undoubted artists of the medium. This is mainly due to the fact that they all vary their approach and lighting technique to suit the individual sitter. It is only when technique becomes too dominant a factor that the personality of the sitter is forgotten. Unfortunately, a great number of portrait photographers – perhaps because of the success of Yousuf Karsh – have become obsessed with lighting. Karsh's portraits became so distinctive in their technical excellence, and his lighting techniques so bold, that a great many photographers have imitated

◁ **Family group by Mayotte Magnus**
This informal family portrait is in fact a carefully-thought-out image. All the participants were arranged with attention to composition and balance. The viewer's eye moves naturally from the father in the window to the mother and daughter on the right and then to the two remaining children.

Self-portrait by Ami Phul △
This self-portrait is an example of dramatic low key portraiture. Photography is capable of creating any kind of mood merely by the choice of lighting and pose. Here, the low angled floodlight throws the head into relief.

Girl by David Hamilton ▽
Hamilton's characteristic style of portraiture – soft-focus, high key light, with some slight texture – is well-suited to his favorite subjects. He invariably uses a range of delicate, pastel hues which he partly diffuses.

his style quite indiscriminately, producing pictures that are largely just show and glitter, and which have very little soul, substance or understanding.

Memorable portraits depend more on matching a thoughtful and sensitive adaptation of technique and style to the individual requirements of each sitter. A good portrait should first and foremost reveal the personality of the sitter. The earliest exponent of this approach was the pre-Second-World War photographer, Felix H. Man. More recently, the photojournalists Henri Cartier-Bresson and W. Eugene Smith, and the fine post-war photographer Bill Brandt have developed the approach. All these photographers decided to forgo the facilities and comfort of a studio to search for the quintessential identity of their subjects in their own environments. When the sitter is on his own ground he is at ease, and objects, furnishings or the tools of his profession can amplify his identity. Bill Brandt went still further, by selecting, at times, a special locality or environment to clarify the character of his sitter. The photographer selects what to include and exclude, and decides how he is going to represent the sitter. In a sense, no photograph is ever entirely objective – even realists like Paul Strand or August Sander still select the moment and place.

Three more photographers are worth looking at for inspiration – Sir Cecil Beaton, Lord Snowdon, and Arnold Newman. Beaton's portraits – both those taken on location or in natural environments, and some of his simpler pictures taken in the studio – achieve a great deal of power and understanding, in spite of the fact that many of his elaborate arrangements tend to be merely decorative. Snowdon is one of the most perceptive and versatile contemporary portrait photographers. He spends a long time with his sitters, and as a result his portraits show them in depth, capturing a great deal of their characters. Newman is possibly the most design- and composition-conscious portraitist of all – a fact that can be seen by looking at his superb portraits of Stravinsky and Mondrian.

The aim of this book is to show how wide the field of photographic portraiture is today. The old-fashioned idea of a portrait as merely a head-and-shoulders studio study is inadequate and outdated. In fact, photographic portraiture encompasses all kinds of different ways of portraying human beings. Not only do we try to show the versatility and richness of the medium of photography, but we also try to demonstrate that it is undoubtedly the best

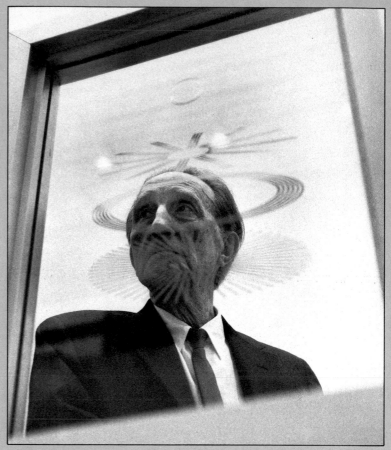

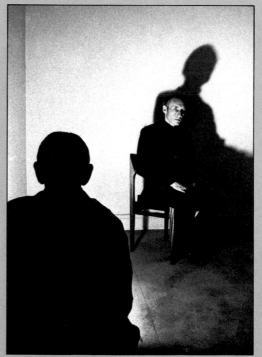

Marcel DuChamp by Jorge Lewinski △
The artist is seen through one of his paintings on glass. This shot was taken at an exhibition, whilst the subject was giving an interview to a journalist. Photography is at its best when character and personality are captured in an unrehearsed moment.

◁ **William Burroughs by Mayotte Magnus**
To capture the nightmarish atmosphere of the author's novels, a shadowy figure in the foreground looms over the subject, holding the single photoflood. The shadow of Burroughs himself adds to the effect.

Harmonica player by Jorge Lewinski ▷
Although this photo-journalistic shot was taken quickly, the composition was carefully visualized with the head of the man in the triangle of the river, and the lines of the bridge and houses strengthening the pattern.

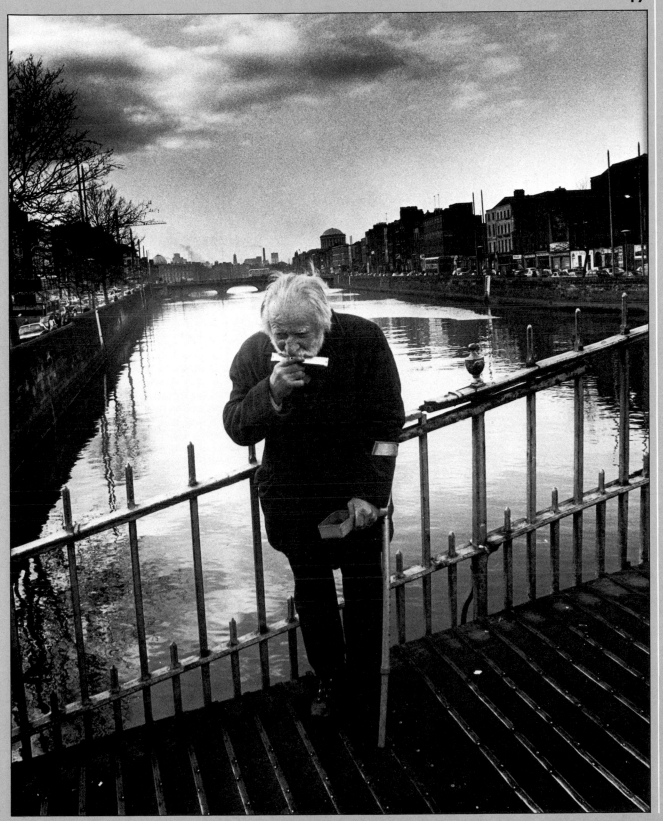

medium for portraiture. When photography is used with skill and thoughtfulness, it can produce images of people that are so revealing, so penetrating, and sometimes so moving, that no other medium – with the possible exception of cinematography – can approach it. Our book contains examples of all contemporary (and some traditional) styles of portraiture as well as most of the possible methods of approach and technique. We hope that you will not adopt one method or style exclusively, but vary your own approach to suit each individual sitter.

Photography is at bottom a science-based discipline, relying on the sophisticated interaction of optics and chemistry. The final image on the film is created by a chemical process, and it is a machine that records it on paper. And yet many of the photographs which have been originated over the past 140 years are undoubted masterpieces, the work of photographers who are indisputably artists. Is it then so surprising that the status and direction of photography have been the center of so much controversy since its early days?

Is photography a science, an art, or a craft? What we can be certain of is that we judge a photograph by its ability to communicate, by its power to move and inform us. In this respect photography is a potent medium, ranking with the other artistic disciplines. Yet when we look closer at photography we discover that, as with the other arts, creativity does not reside in the medium but in the ability of the user to manipulate it.

It is an inescapable fact that you cannot fully control your medium until you master all the technical skills associated with it. In portraiture, as in the other branches of photography, the photographer cannot apply himself freely to the creative challenges of the medium if he is defeated by the technical demands of the subject. The working sections and appendix of this book are designed to smooth out these problems, and make the basic skills of portraiture accessible to every photographer.

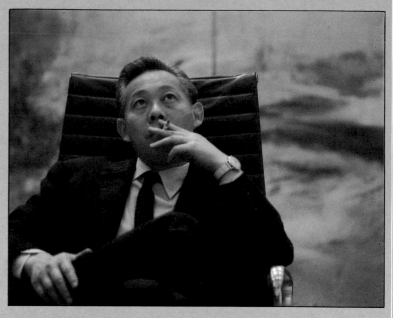

Za-wou-ki by Jorge Lewinski △
This artist's studio had excellent, if low, illumination. My camera was set up on a tripod, and I carefully selected a moment when the painter's movements would not blur.

Dame Barbara Hepworth by Mayotte Magnus ▽
This is an example of the simple, modern style of photojournalistic portraiture. These portraits are usually shot on location in the sitter's environment, so all the lighting and equipment

has to be portable. At least one image taken during the session should be a head and shoulders study, as here.

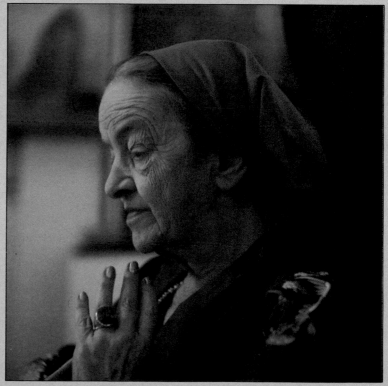

BASIC PRINCIPLES OF PORTRAITURE

The dictionary defines the word "portrait" as "a record of certain aspects of a *particular* human being, as seen by an artist". The most important attribute of a good portrait is that it captures some individualism in the subject. The picture should not be merely a shot of a pretty girl or an old man, but a portrait of that *particular* girl or old man, and no other. Portraitists are first and foremost observers, noting human traits of character, idiosyncrasies, habits and gestures, movements and speech, and singling out the individual features in each sitter.

However, do not forget that while portraying a personality you are also fashioning an image. Composition, lighting, and overall design – as outlined in this section – are also important considerations in creating a good portrait. You should not just look at the sitter alone, but note all the additional elements of the scene – furniture, plants, shadows on the wall – and make use of them to enhance the attractiveness of the image and add meaning to the portrait. A good portrait is only very rarely the result of a lucky, random shot; in general it is the end result of careful thought and planning. The personality of the sitter, the environment, the composition, and the choice and quality of lighting all contribute to the final result.

Composing the image

The human eye prefers order and simplicity, and emphatically rejects chaos. Therefore, the first principle of good composition is to eliminate any confusing, superfluous or disturbing elements within the picture so that your subject dominates. In general, it is impossible for the photographer to rearrange elements in the way that a painter can. Picture-making involves careful framing to select only part of the scene. Because every situation offers many possible results, you can improve a poor composition merely by shifting the camera slightly, or by altering your distance from the subject, or by changing your lens (see p.40).

The positioning of the main subject within the frame is a major factor in composing a portrait. Find a place where your sitter is unhampered by other prominent shapes. Even-tone, white or black, uncluttered backgrounds – such as a plain wall or an expanse of sky – are usually best.

You can sometimes strengthen your pictures by making use of the traditional rules of composition – the division of thirds (see the diagram at the bottom of the page), and the principle that the eye enjoys being led through an image, following a line or a succession of shapes. Try including close or overlapping

Line and composition ▷
You can make use of lines to draw the eye into the image. In this simple composition, the lines of the bench lead the eye to the sitter, see diagram below. And the dark foliage in the background keeps the eye within the picture, focusing attention on the subject. I placed the sitter slightly off-center to make the composition more dynamic.
Pentax 6×7, 75 mm, 1/60 sec at f16, Tri-X.

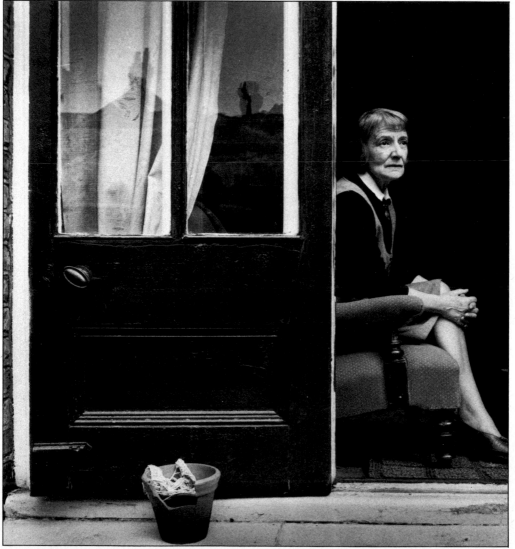

◁ **The rule of thirds**
Think carefully when you compose a picture – a portrait is not merely a representation of a person, it should also be an attractive image in its own right. I used a classical arrangement to strengthen this portrait of the poet Stevie Smith. I placed her on the division of thirds, see diagram below, to give an impression of balance and order to the picture. The sitter's pose and the broken pot echo her loneliness and her advancing age.
Mamiyaflex C3, 75 mm, 1/60 sec at f16, Tri-X.

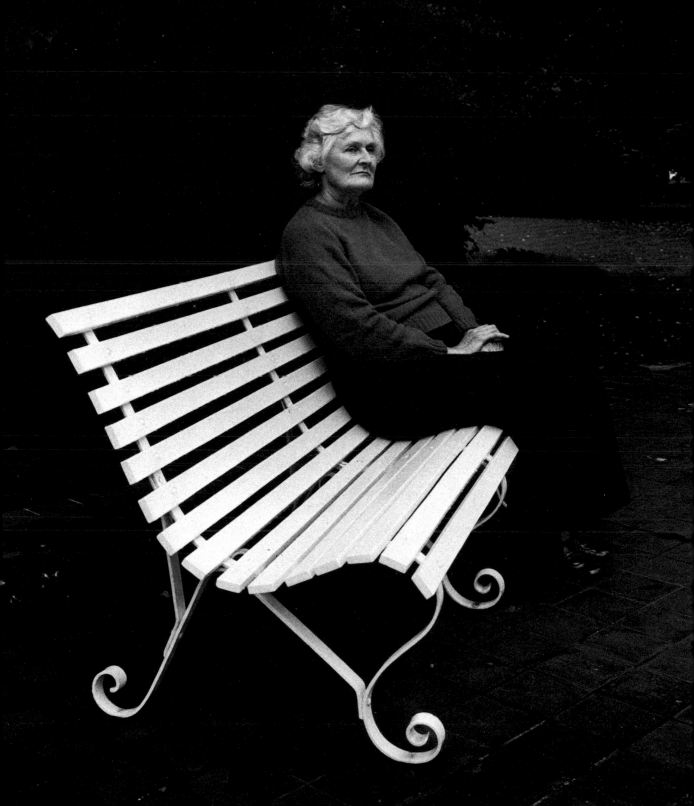

shapes, which the eye accepts as one continuous unit, in your pictures. Do not alter a pleasing view of the subject to fit in with these rules, however. Because photography is a dynamic medium, you should never become too obsessed with rules, or you will forget the most important element in portraiture — capturing the subject in a lively, expressive manner.

You can also use composition to enhance the vitality of the image. Avoid anchoring the viewer's eye in the center of the picture — an entirely central position for the sitter's head is often the weakest and least interesting. Try placing the head slightly off-center, balancing it with another element such as the sitter's hands, a picture on the wall, or even the line of the shoulders. If you want to (or have to) place your subject centrally in your composition, make sure that you use other elements — such as color, foreground interest, unusual lighting, or frames within frames — to enliven your image. Whatever type of composition you choose, you will always find that an organised, simplified image is visually strongest.

Off-center composition ▷
This strong, unusual composition has a group of three on one side of the picture, balanced by the seascape and single figure seen through the window. The eye moves from face to face, then to the beach and back again, see diagram below. Although the left side contains weaker shapes, it holds its own because the subject matter attracts the eye.
Pentax 6×7, 55 mm, 1/30 sec at f16, Agfachrome 50S.

Central composition ▽
This straightforward shot, with the sitter almost centrally placed, is enlivened by additional elements. Color contrast creates a lively effect, the lines of the painting "frame" the image, and the paint and brushes provide foreground interest.
Mamiyaflex C3, 65 mm, 1/30 sec at f11, Agfachrome 50L.

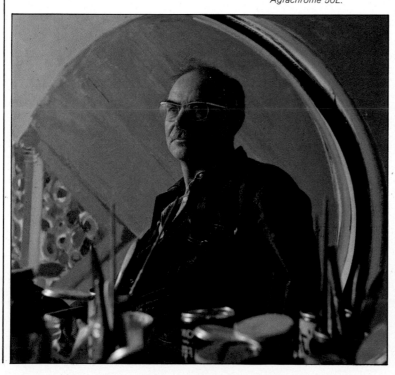

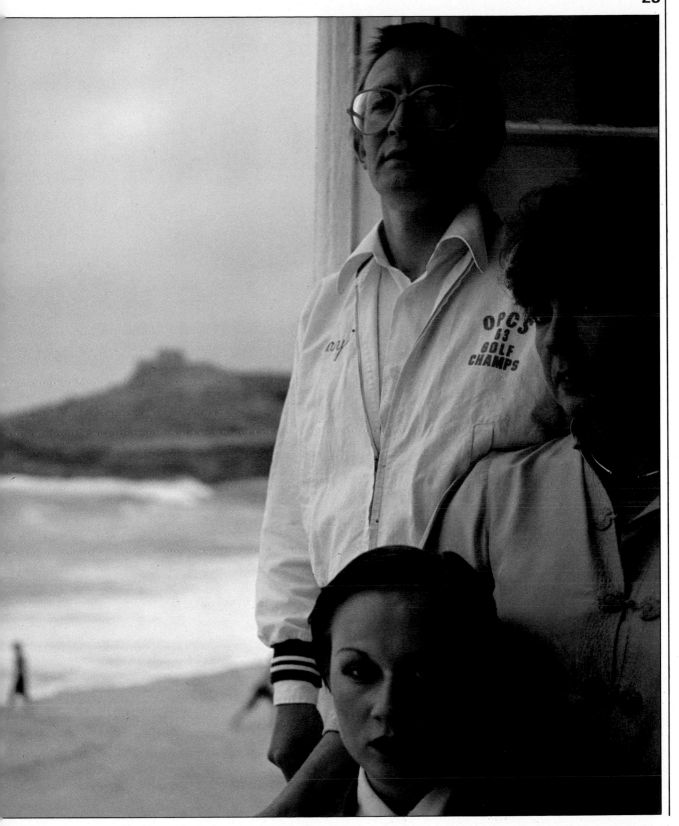

Framing your composition

Photography is a dynamic medium – it relies on a sense of life, movement, and immediacy for its impact. Traditional rules can give a quality of suspended action – looking at a photograph, the viewer should feel that the subject has not stopped and posed deliberately, but is about to move off to continue his or her normal activities.

Make use of the picture frame to create a dynamic composition which avoids the static look of traditional portraits. Try placing the head or figure of your sitter off-center, instead of "becalming" it in the middle of the frame. But when you place the main shape near the edge and include nothing else in the frame, you may find that the picture will seem to topple over. To restore the disturbed sense of balance add a secondary center of interest, enabling the eye to move freely from the sitter to the secondary attraction and back again. This motion within the image creates a sense of movement, which you can enhance further by leading the eye along diagonal lines.

With 35 mm and 6 × 7 formats always look at the subject with the camera held vertically as well as horizontally, before you decide on your final framing. An upright or "portrait" format is not necessarily the best choice – if you want to include the sitter's environment you may find that the horizontal or "landscape" format is more suitable.

The unexpected view △
A number of photographers were taking pictures of Dame Barbara Hepworth at her exhibition, all shooting from the front of her sculpture. I decided to shoot from behind, through the circular opening in the sculpture, showing only her profile and hand.
Mamiyaflex C3, 65 mm, 1/60 sec at f8, Tri-X.

◁ **Exploiting picture edges**
This strongly off-center composition, with the artist almost on the edge of the frame, is balanced by the two circles of the canvas, which echo his glasses. The use of picture edges is very important in creating impact – any shape tends to become stronger and more prominent the nearer you place it to the side of the picture.
Pentax 6×7, 55 mm, 1/60 sec at f8, Tri-X.

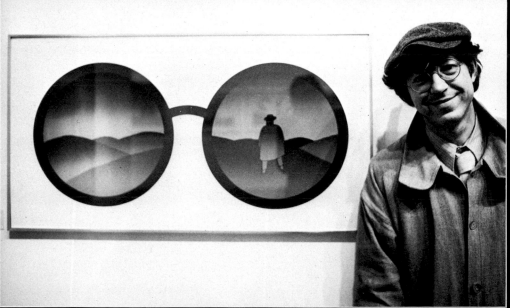

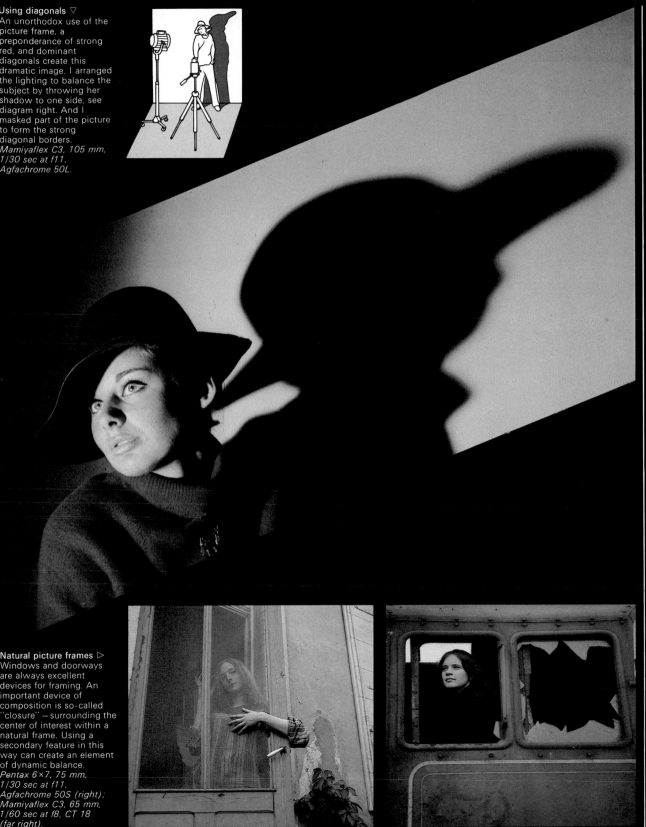

Using diagonals ▽
An unorthodox use of the
picture frame, a
preponderance of strong
red, and dominant
diagonals create this
dramatic image. I arranged
the lighting to balance the
subject by throwing her
shadow to one side, see
diagram right. And I
masked part of the picture
to form the strong
diagonal borders.
*Mamiyaflex C3, 105 mm,
1/30 sec at f11,
Agfachrome 50L.*

Natural picture frames ▷
Windows and doorways
are always excellent
devices for framing. An
important device of
composition is so-called
"closure" – surrounding the
center of interest within a
natural frame. Using a
secondary feature in this
way can create an element
of dynamic balance.
*Pentax 6×7, 75 mm,
1/30 sec at f11,
Agfachrome 50S (right);
Mamiyaflex C3, 65 mm,
1/60 sec at f8, CT 18
(far right).*

Making use of color

Effective composition in color involves understanding and using the two "opposing" groups of colors – the warm colors – red, orange and yellow – and the cool colors – blue, green and magenta. You can achieve a pleasing combination of colors by using only one or other group in a picture, producing either warm or cool harmony.

But this is not the only possibility open to you – for a more lively effect you can make use of contrasting colors. The traditional rules of color composition, based on color pigments, define the three main colors – red, yellow and blue – as primaries. The primaries combine to create all other colors. The other three important colors are known as secondary or complementary colors because they are made up from two primaries – orange from red and yellow, magenta from red and blue, and green from yellow and blue. Green is complementary to red, orange to blue, and magenta to yellow. If you pair a primary color with its complementary you will produce contrast. Color contrast highlights a dramatic, vibrant mood, whereas harmony conveys a calm, restful atmosphere. In a few cases the use of clashing colors can be worthwhile. For example, in the portrait on p. 29 green and red combine with shocking pink and yellow to produce a lively result.

The introduction of color does not alter the basic principles of composition significantly. You will still have to arrange the main shapes or the areas of strong, even tone within the frame of your picture in such a way that you retain a feeling of order and balance. But the shapes are

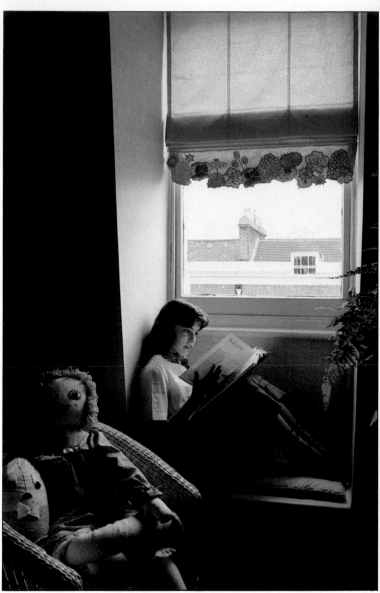

◁ **Bright colors**
The colors in this portrait of Lynn Seymour, the ballet dancer, give a restless, vigorous impression that reflects her personality and her preference for energetic, unorthodox dancing parts. Yellow – the brightest color – is scattered throughout the image, giving it a strong sense of design. *Hasselblad 500C, 80 mm, 1/60 sec at f5.6, Agfachrome 50L.*

Cool colors △
Cool hues dominate this composition, giving the portrait a relaxed, restful air that fits in well with the girl's pose. The furnishings in the room and the sky outside the window are all in harmonizing tones of cool blue. *Pentax 6×7, 75 mm, 1/30 sec at f16, Ektachrome 200.*

Warm colors ▷
Diffuse light, as well as being a good source of illumination for the face, also tends to reduce the brightness of colors. Here, the soft, warm colors are mainly concentrated in two bold bands in the background. This picture was taken in a disused railway carriage lit by bright sun from one window and a crack in the door. *Mamiyaflex C3, 65 mm, 1/8 sec at f8, Agfachrome 50S.*

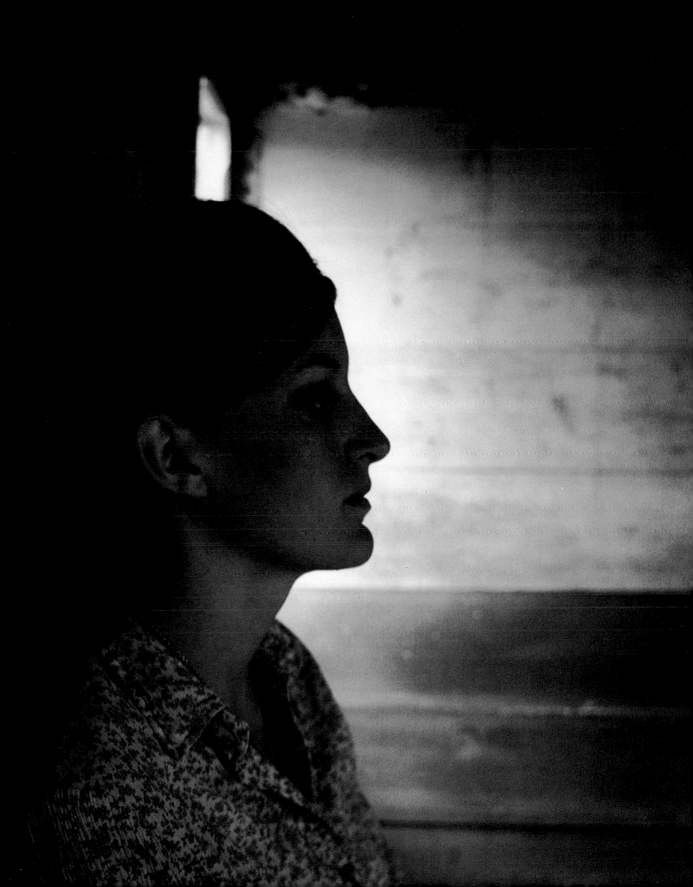

no longer only black, white or gray – they may be an infinite number of hues. In a black and white composition the areas of pure black and pure white are most striking, and consequently attract the eye first. In color work certain strong colors seem pre-eminent.

In fact, not all colors affect the human eye in exactly the same way. Whereas we tend to react to shapes and lines in black and white in a detached and rational way, colors affect us in a much more direct, even emotional or irrational way. These responses are difficult to tabulate – they are based on personal preferences and traditional associations that are sometimes sub-conscious. For example, we associate green with joy and renewal, blue with peace and rest, and red with fire and danger.

Colors also differ in that they are markedly dissimilar in the amount of brightness that they emanate. If you place two identically-sized patches of yellow and blue next to each other, it will be obvious immediately that the yellow area is far more brilliant and luminous than the blue one. To achieve balance in a picture containing these colors, you should therefore place a relatively small patch of yellow against a large expanse of blue. On a rough scale, yellow is the brightest color, followed in decreasing order by orange, red, green, blue, and violet.

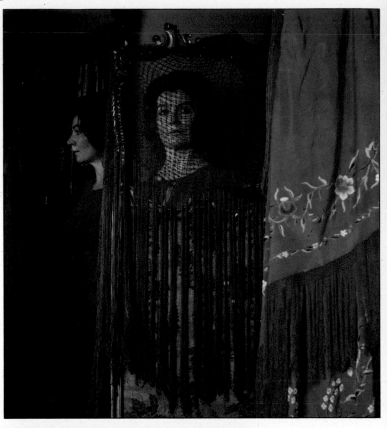

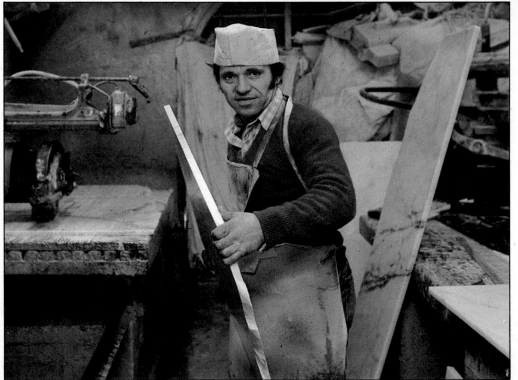

Dominant color △
A single, dominant color can convey an intense mood or atmosphere. Here, I used a mirror and shawl to create a picture entirely infused with red. This color seemed to suit the personality of the novelist Edna O'Brien.
Hasselblad 500C, 80 mm, 1/30 sec at f8, Agfachrome 50L.

◁ **Isolated color**
The whole workshop in this picture is covered with a layer of pale dust, so that the subject's red sweater forms the only splash of bright color. Often a very small area of vivid color used against a flat, even area of contrasting or muted, monochromatic color will create a strong visual impact.
Pentax 6×7, 55 mm, 1/30 sec at f16, Ektachrome 200.

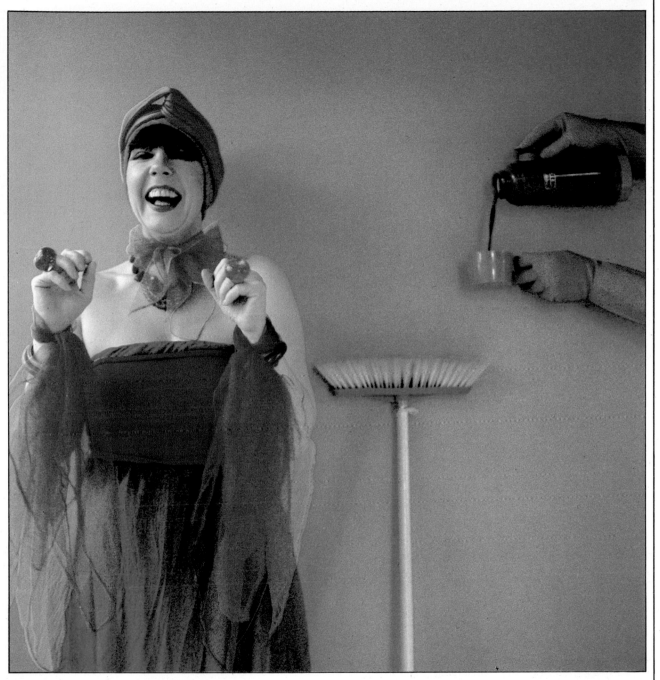

Discord for effect △
When I went to photograph Molly Parkin — a self-confessed eccentric, and a writer of risqué novels — I noticed the green wall now included in the picture. I planned this discordant scheme on the spot. The bright, contrasting colors create a visually lively, even aggressive picture which reflects the subject's bold lifestyle. *Hasselblad 500C, 80 mm, 1/60 at f8, Agfachrome 50S.*

Understanding light

Although light is not the most important concern in portraiture – since a good portrait must be rich in meaning as well as an attractive image – no photographer can completely master portraiture without understanding and appreciating the characteristics of light.

First, you must be aware of the effect of brightness – the visual strength or intensity of light. This intensity is governed by the amount of light reflected back from the subject to the lens. Various parts of the scene can differ radically in brightness, and a given illuminated area will appear visually brighter if it is next to a dark one. Your exposure calculation and the composition of your picture depend on how these areas of different intensity are distributed in the picture area.

The second major characteristic of light is its quality – the degree of its harshness or softness. The quality of light affects the appearance of objects and people quite considerably. Soft-textured light gives the human face a quality of delicate roundness; it lights up shadows and softens the appearance, making most skin defects less apparent. Overcast sun or a well-diffused floodlight gives this type of light. Harsh light creates a dramatic effect, with strong contrasts of light and shade. It is not flattering, but the resulting picture will have great strength and impact. Strong, direct sunlight or a spotlight will produce this effect.

The direction of light – its angle in relation to the sitter – reveals form and structure. When the light is head-on to the subject, the light is

Color temperature scale (measured in Kelvins) ▽
The color of light will vary quite dramatically with different sources, time of day, weather, and even geographical location. Color film is balanced either to artificial light (3,200K) or to average noon daylight (5,400K). Other variations will give a color cast unless you use a correction filter (see p. 42).

Candlelight	150/200W household bulbs	Projector lamp	Photofloods	Sunrise or sunset	Fluorescent tubes	Daylight electronic flash	Snow, water, blue sky
1930	2600 2800	3200		4200	4800	5400	18000

Morning light ▷
Early morning sunlight shows a tendency toward a cool, light blue cast, especially in the shadows. Use a pale pink filter (see p. 42) or a weak flash to fill-in shadows and add a little warmth.
Pentax 6×7, 105 mm, 1/60 sec at f8, Ektachrome 200.

Midday light ▷
Midday light is usually strong and direct. The contrasty midday Moroccan sun here is possibly a little warmer than the average noon sunlight in the Northern hemisphere, to which all daylight color films are balanced.
Pentax Spotmatic, 50 mm, 1/125 sec at f11, Agfa CT18.

Afternoon light ▷
In summer, afternoon sunlight is often a little warmer than standard daylight. Here, the subject matter suits the slightly warmer effect. The ostrich egg shows the beautiful softness of this light.
Pentax 6×7, 75 mm, 1/30 sec at f11, Agfachrome 50S.

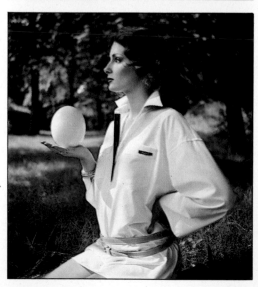

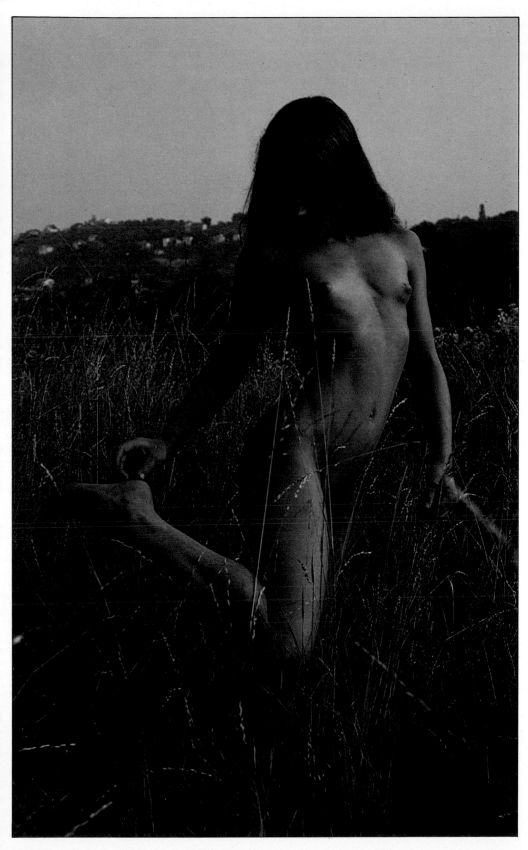

◁ **Early evening light**
Light from the setting sun is the most romantic of all natural lights. It is excellent for portraiture because the low angle of the sun will directly illuminate the face without casting unpleasant, harsh shadows. Although it is warmer than average daylight, this is acceptable because we associate sunset with a yellow to red color cast.
Nikkormat FT2, 28 mm, 1/60 sec at f5.6, Kodachrome 25.

flat, making the subject's face appear only slightly three-dimensional. As the light moves to the side and the angle increases, the more the form of the features is revealed. Facial modeling is also affected by the height of the light source in relation to the sitter. A light on a level with the face will give a shadowless, flat result. But, as the light moves upward, the shadows of the nose, brow and cheekbones appear. A very high elevation (nearly 90°) will cast deep shadows on the features. If the head is lit from below you will get upward shadows which create a sinister impression. All the principles covered so far apply to both natural and artificial light.

The most important thing to understand before you start using artificial lighting for portraiture is that one light source – spot, flood-light, or flash – must always be dominant. All other lights should complement this main modeling light. The most attractive lighting for a portrait is the "Hollywood" style which uses at least two lights. One is placed to give a compromise between a harsh, angled light and a flat, frontal one, see below right. This accentuates cheekbones and gives the face a narrower, oval shape. The second light acts as a fill-in and does not create shadows of its own, but merely lights the shadows created by the modeling lamp. This light must be much weaker and more diffuse than the main light (about one third of its power). To prevent it casting its own shadows, place it as close to the camera as possible, or shine it against a light-colored surface to reflect light back. Better still, use a reflector – white cardboard or a white sheet – opposite the main light.

Positioning lights ▷
When you move a light around your subject you will alter the effect of the lighting on the face. A frontally-lit subject (1) will show a lot of detail but its form will be flattened. As you increase the angle of the light (2) the features will become more prominent. Sidelighting (3) lights only one half of the head. Move the lamp further round and the majority of the head and face is in shadow (4). A backlit subject (5) is seen in silhouette.

1

2

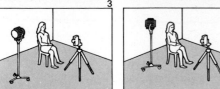

3

4

5

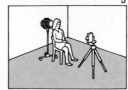

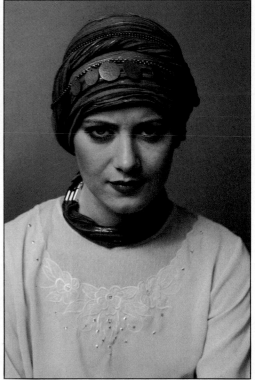

The "Hollywood" lighting set-up △
I placed the main light in a "classical" position – at 45° to the sitter and about 3 ft (1 m) above her head. And I used a weaker, diffused fill-in light near the camera, see diagram right, to light the shadows cast by the main light.
Pentax 6×7, 105 mm, 1/30 sec at f11, Ektachrome 160.

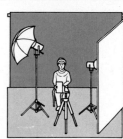

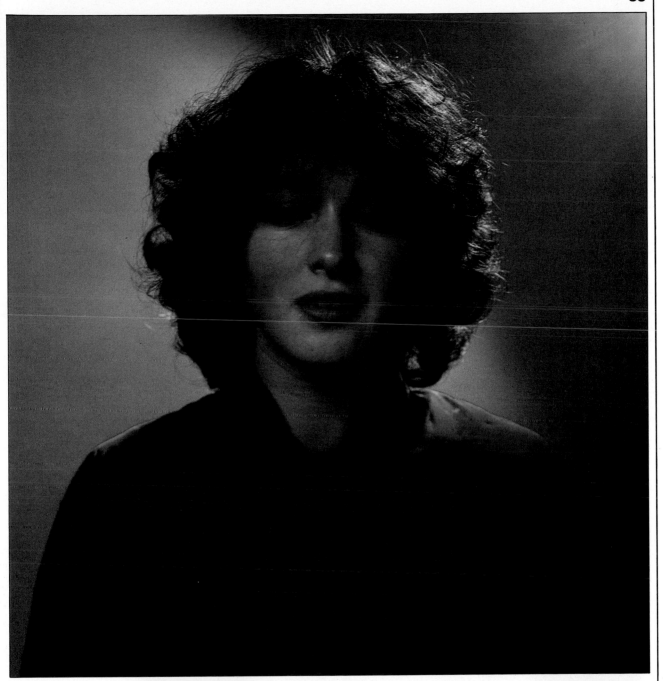

Balancing lights △
With artificial illumination you must always use one main lamp as a modeling light. You can only use other lights as subsidiary sources. For the picture above I used one floodlight as a main light and a weaker light reflected off a white screen to fill in shadows, see diagram right. The picture on the left shows how confusing the lighting becomes when two lamps of similar strength light the face from different directions.
Pentax 6×7, 105 mm, 1/8 sec at f11, Agfachrome 50L.

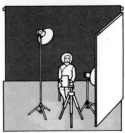

Lighting problems outdoors

No artificial light source can compare with natural daylight – even a photograph taken under the most sophisticated lighting set-up will lack the translucent beauty of a good daylight shot. Clear, diffused daylight is best – it is sufficiently strong to give distinct modeling of the face, and it also softly penetrates more shadowy areas, acting as an ideal fill-in. To achieve a similar effect on a bright, sunny day, place your sitter in an open, shaded spot. Make sure that your subject's face is in shade – spots of sun on the face will cause a burned-out mark. And avoid a sunlit background, as this will be grossly overexposed.

Not all daylight is effective for portraiture – strong, direct sunlight is the worst possible illumination. It casts hard, unpleasant shadows that almost completely obscure the subject's eyes. The only time you can use sunlight as direct illumination is at early morning or late evening, when the oblique angle of the sun lights the face without casting shadows. However, if the sun is exactly behind the subject – backlighting or "contre-jour" – you can use direct sunlight to create a "halo" around the head and shoulders. You must have a lens hood to prevent flare. If your sitter's head is in shadow, use a fill-in such as a white wall, or small on-camera flash unit diffused with a double thickness of tissue.

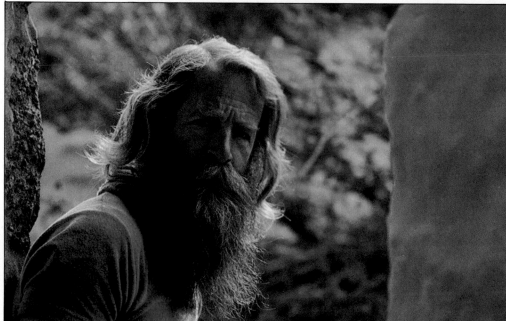

◁ **Shading the sitter**
To convey Edna O'Brien's strong affinity with nature, at her suggestion I used this tree in her garden as a "pastoral" setting. The sitter's face was in shadow, and the branches and leaves on the tree acted as a natural fill-in.
Hasselblad 500C, 80 mm, 1/60 sec at f8, Agfachrome 50S.

Using early morning light ▷
This shot was carefully planned to make use of the low rays of the early morning winter sun, and show the family house over Jessica Mitford's shoulder. The camera was placed on a high tripod, see diagram below.
Hasselblad 500C, 80 mm, 1/30 sec at f11, Ektachrome 200.

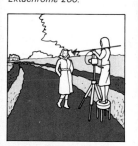

Backlighting for effect ▷
I asked my subject to stand in a doorway, with the sun behind him. In order to retain some tones in the backlit hair, I set a short exposure. To compensate for this, I had to use fill-in flash on camera, diffused with a double layer of tissue, see diagram below.
Nikkormat, 28 mm, 1/60 sec at f11, Agfachrome 50S.

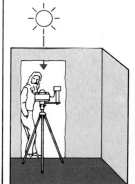

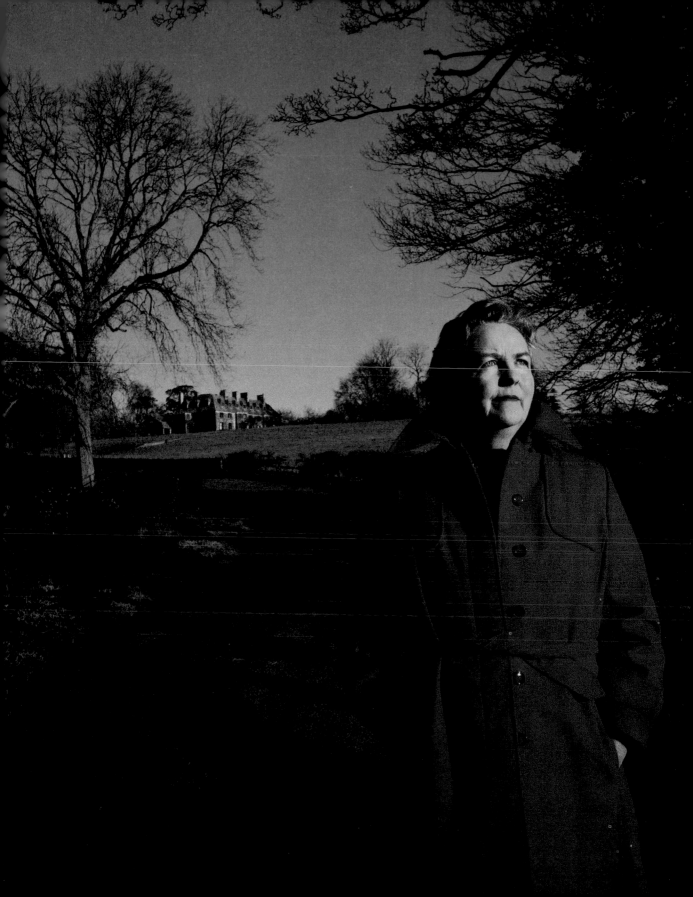

Available light indoors

It is often best to use natural light alone when shooting portraits indoors, so that you avoid difficulties with color balance (see pp. 30–2). The mixture of light sources in the home sometimes make additional lighting – whether tungsten or flash – inadvisable, particularly with color film. The chief requirements for available light photography are a reasonably bright day, a suitably placed window, and a tripod. Seat your subject near the window, making sure that no direct sun falls on him or her. It is almost impossible, especially with color film, to control the contrast between bright patches of sunshine and comparatively dark, shadowy portions of the scene. Try to use diffused, bright daylight, and avoid shooting right into the window if you are using a low camera position, or you will include a large area of sky. Although this rarely results in flare, the light that enters the lens is sufficiently strong to reduce contrast and color saturation. In order to balance window light so that it does not affect quality, and yet retain some of the attractive backlit effect, you must have either light-colored walls or a natural fill-in like a large piece of paper or a white sheet to reflect light back onto the sitter's face. Take an exposure reading by holding your hand in the light which illuminates the sitter's face so that you do not disturb your subject.

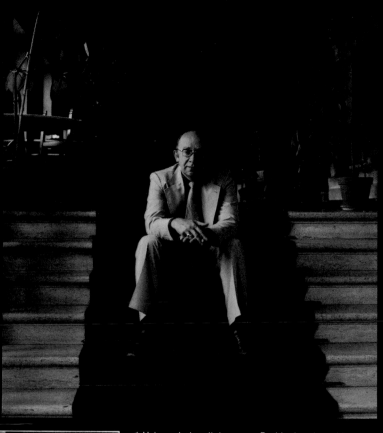

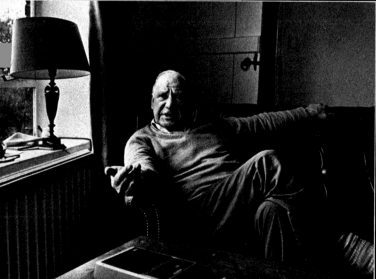

◁ **Using window light**
A large window will enable you to illuminate an indoor subject by natural light. Here, plenty of light was flooding in through a sizeable window in the subject's living room. And a white wall to the left of the sitter provided the right amount of fill-in.
Nikon FE, 24 mm, 1/60 sec at f2.8, FP4.

Positioning the subject in natural light △
In available light the usual arrangement is to seat the subject in a chair in front of the window, see left.
For this photograph I decided to try a variation – I placed my subject on a staircase between two corridors, lit by daylight from a large window on one side, with fill-in on the other side. As the light level was still low, I used a fairly slow shutter speed and asked him to sit still.
Pentax 6×7, 55 mm, 1/30 sec at f11, Ektachrome 200.

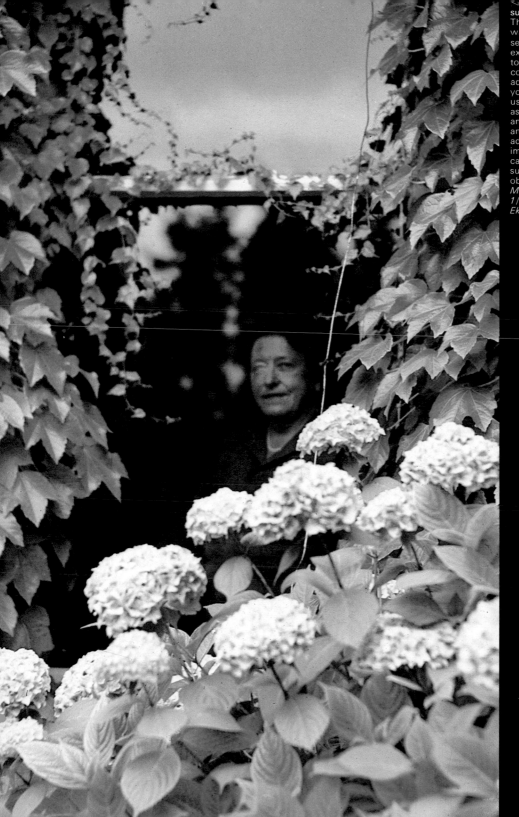

◁ **Shooting an indoor subject from outside**
This shot was taken as I was leaving at the end of a session. Again, I used an exterior shooting position to avoid problems of contrast. The other advantage of this is that you enhance your shot by using the window or door as a frame. The mass of ivy and the reflections of sky and clouds in the window add an air of mystery to the image. I composed my shot carefully so that the subject's face was not obscured by cloud.
Mamiyaflex C3, 65 mm, 1/125 sec at f8, Ektachrome 64.

Adding extra light indoors

When there is insufficient available light indoors for a good exposure you must decide whether to use flash or tungsten illumination. Flash is much more convenient – it is lighter to carry and its short duration freezes movement, allowing your sitter to talk and move freely. Try to acquire a flash system with two or even three flash heads. Three heads will give you far greater flexibility – for example, you can use one head at full power as your main light, diffuse the second head or bounce it off a reflector as a fill-in, and use the third head to illuminate the background. But flash has some serious drawbacks. First, it limits your control over lighting effects because you can never foresee the final result precisely. Most professionals who use flash therefore shoot a test shot on instant film first. Second, there are only a limited number of flash set-ups, and as a result all your portraits will begin to look alike.

Third, you will find that some sitters react to flash by shutting their eyes.

Tungsten lighting is much more flexible for portraiture. The light is constant so you can see precisely how your sitter is lit, and you can move or change your lamps until you get the desired effect. The numerous different types of tungsten lamp allow you a wider range of set-ups than are possible with flash. On the negative side, tungsten lighting often requires longer exposures and/or wider apertures, so you must work harder to obtain lively expressions from a virtually static sitter.

It is highly inadvisable to mix tungsten and flash because they have different color temperatures. Use tungsten-balanced film with tungsten lighting and daylight film for flash. Portraits shot on wrongly-matched film will have a strong cast (pp. 42–4). And if you mix lights you will not be able to filter the cast.

Movement under tungsten lights ▷
I used a tungsten lamp, a white reflector and an additional lamp to fill in, see diagram below. Tungsten lamps enable you to predict effects, but you cannot freeze movement at slower shutter speeds as the hand here shows.
Pentax 6×7, 75 mm, 1/30 sec at f11, Agfachrome 50L.

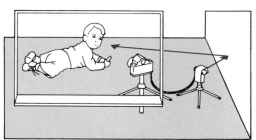

◁ **Flash in the studio**
I used a flash unit fitted with a diffusing umbrella to provide soft, even lighting. And a white reflector placed on the subject's right acts as a fill-in. Flash has the advantage of freezing movement, but its effect is difficult to predict.
Pentax 6×7, 75 mm, 1/60 sec at f8, Agfachrome 50S.

Using bounced flash △
Even with fast film, the level of natural light indoors is not strong enough for action shots. You must use bounced flash to boost illumination. Use a synch lead to allow you to place the flash off-camera and bounce it off a white surface, see above.
Pentax 6×7, 105 mm, 1/30 sec at f11, Tri-X.

Choosing lenses

You should always choose your lens carefully, making sure that it matches the purpose of your picture. In general, a long lens is best for close-ups; a standard lens for a medium-long shot; and a wide-angle lens is most suitable when you are working in a limited space, or to exaggerate part of the sitter for effect.

Traditionally, portraitists used only long lenses, because these render facial features in exactly the right proportions, without any distortion. With a shorter lens (below 90 mm for 35 mm cameras) you have to bring the camera very close to the face in order to fill the whole frame with the head. In a full face portrait, the nose may be distorted. To avoid this, shoot a three-quarter view or a profile, and be careful not to place parts of the sitter (like the knees and hands) too close to the camera, or they will appear too large.

The more modern style of portraiture, which shows the sitter in his environment, suits medium and short focal length lenses. Many photojournalists use wide-angles in order to include part of the interior as well as the sitter, even when working in a very small room. And a standard or wide-angle lens allows more contact between photographer and sitter — when you use a long lens, you have to be further from your subject, making natural conversation difficult.

Using a long lens ▷
A long focal length lens is ideal for this kind of head and shoulders portrait. The sitter's hands are much nearer the camera than his head, and a shorter lens would have enlarged them disproportionately. The narrow depth of field throws unnecessary background and foreground elements out of focus.
Pentax 6×7, 200 mm, 1/15 sec at f16, Ektachrome 200.

Standard lens shot ▷
A standard lens allows you to include some of the sitter's environment — in this case his shop. I placed my subject in near profile to avoid distortion.
Pentax 6×7, 105 mm, 1/30 sec at f11, Ektachrome 200.

Wide-angle distortion ▽
I shot from a very low angle, deliberately positioning myself close to the sitter's face. As a result, his chin appears much larger than the rest of his face.
Pentax 6×7, 55 mm, 1/30 sec at f11, Ektachrome 200.

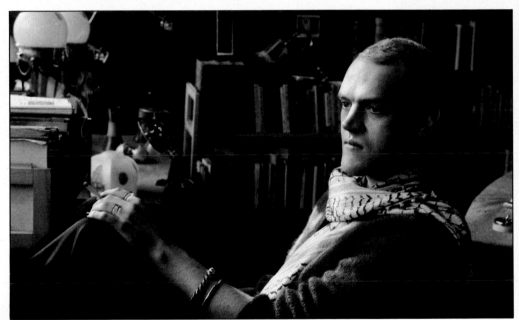

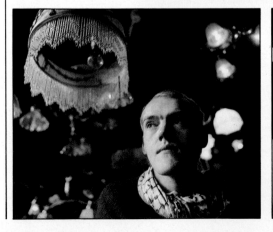

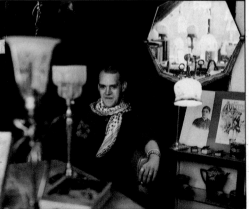

◁ **Using selective focus**
The area of sharp focus in your picture depends on f stop, distance from camera to sitter, and lens focal length, see diagram. Here, I used a wide aperture, focusing on the sitter, to blur the lamps in the foreground.
Pentax 6×7, 105 mm, 1/60 sec at f5.6, Ektachrome 200.

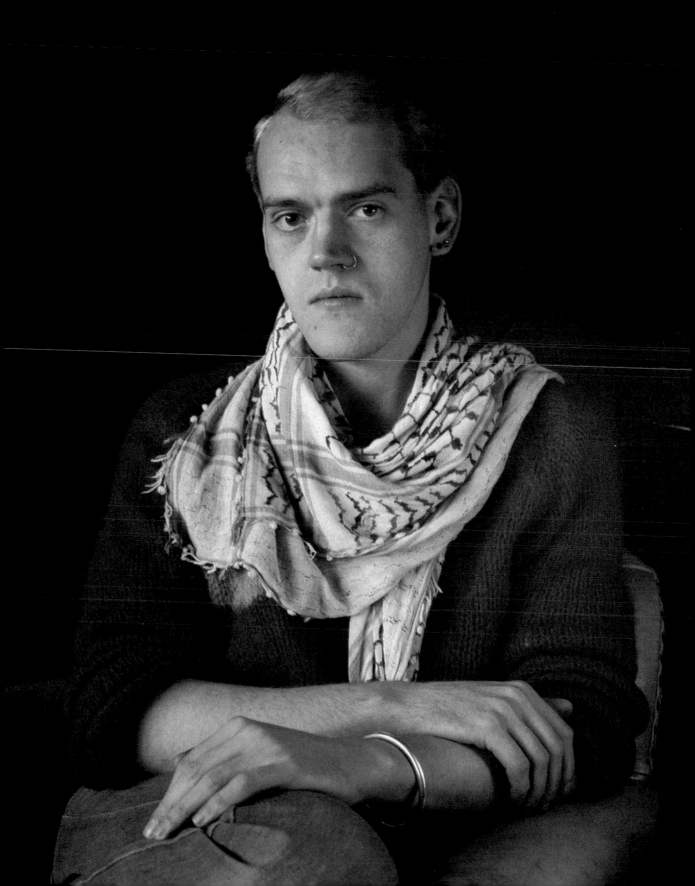

Using filters

Filters help you to cope with lighting problems which would otherwise affect your picture. Color-balancing filters alter the color temperature of the light that reaches the film (see p. 30), color compensating types correct heavy color casts, UV (ultra violet) filters counteract a bluish cast, and polarizing filters eliminate unwanted reflections.

Daylight color films are balanced to average midday (temperate zone) light. However, toward sunset daylight acquires a warm, yellowish hue and, if you want your subject to have an entirely normal skin color, you must use a pale blue filter. At high altitudes, or near the sea your results will be slightly bluish. To correct this use an ultra-violet filter. In fact, it is a good idea to keep a UV filter on your lens at all times – it does not affect correctly-balanced light, and will protect your lens from dust and scratches. If a UV filter alone is not sufficient to correct excessive blueness, you may have to use a stronger compensating filter such as a pale yellow filter.

Polarizing filters remove polarized light rays, as shown in the diagram below. Rotate the filter on the lens to reduce glare from reflective surfaces. Outdoors, polarizing filters deepen blue skies. All indoor, artificial tungsten light

Filtering tungsten film for daylight ▷
If your camera is loaded with film balanced to tungsten light and you shoot in daylight you will get a cold, blue result, below. To take the correctly-balanced picture on the right I used a yellow conversion filter (85B). You will have to compensate for light loss. Here, I had to open up one stop. *Pentax 6×7, 105 mm, 1/60 sec at f11 (below), 1/60 sec at f8 (right), Ektachrome 160.*

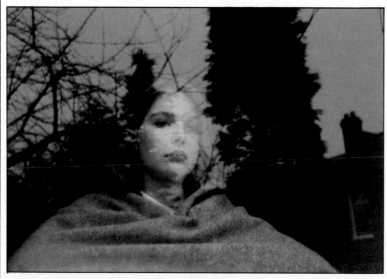

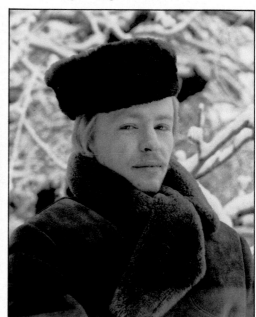

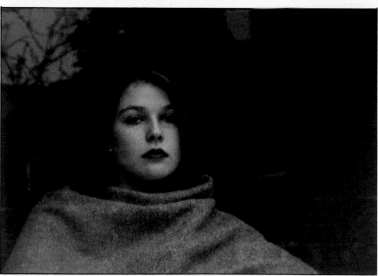

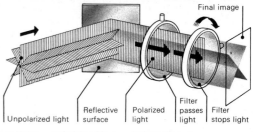

Final image

Unpolarized light | Reflective surface | Polarized light | Filter passes light | Filter stops light

◁ **Using a polarizing filter**
Reflections can interfere with a clear image, top. Rotate your polarizing filter in its mount until reflections are reduced, bottom. *Pentax 6×7, 105 mm, 1/30 sec at f11 (top), 1/15 sec at f11 (bottom), Ektachrome 200.*

Polarization △
Rays of light travel in waves along a straight line, oscillating in several directions from the axis of this wave. A polarizing filter restricts the light to a single plane, reducing reflections from shiny surfaces.

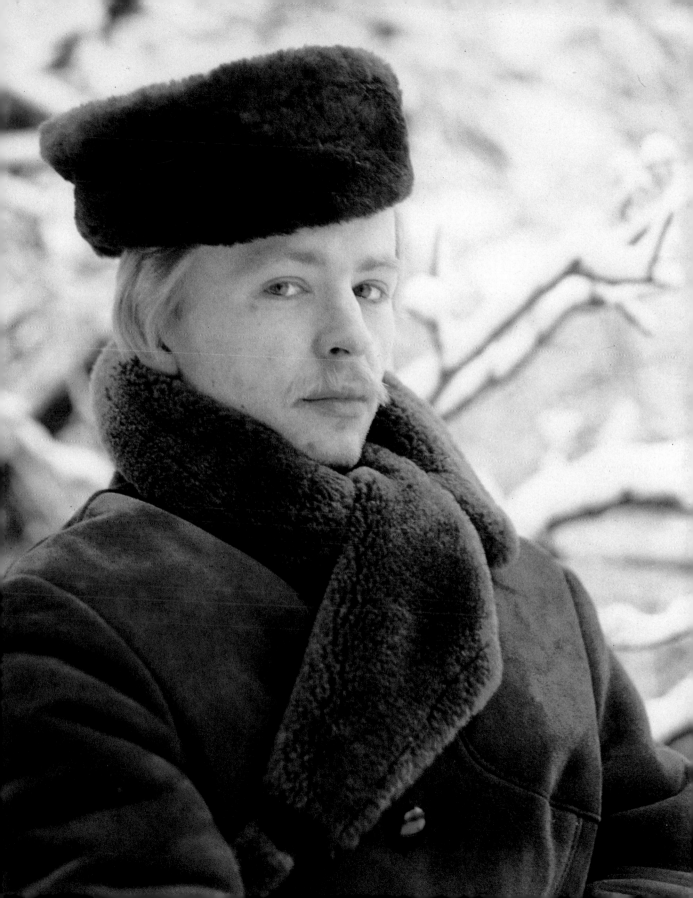

has a pronounced yellow cast. If you shoot on daylight film in tungsten light without a filter, your result will therefore be very yellow unless you use a color-balancing filter like a Kodak 80A. And use tungsten light film in daylight with a yellow correction filter (Kodak 85 or 85B) to avoid a blue cast. Unfortunately, there is no perfect remedy for fluorescent lights since these vary in color temperature. In general, it is better to use daylight film with a weak magenta filter (about CC20) to counteract the green cast.

Filtering daylight film for tungsten light
At times, using a daylight film in an artificially-lit interior, as in the shot on the left, can be quite acceptable. A number of photographers use this combination to create a warm mood. However, if you want a naturalistic result, as in the picture below, you must use a blue correction filter (80A). Increase your exposure by two stops to compensate for the filter.
Pentax 6×7, 75 mm, 1/30 sec at f8 (left), 1/8 sec at f8 (below), Ektachrome 200.

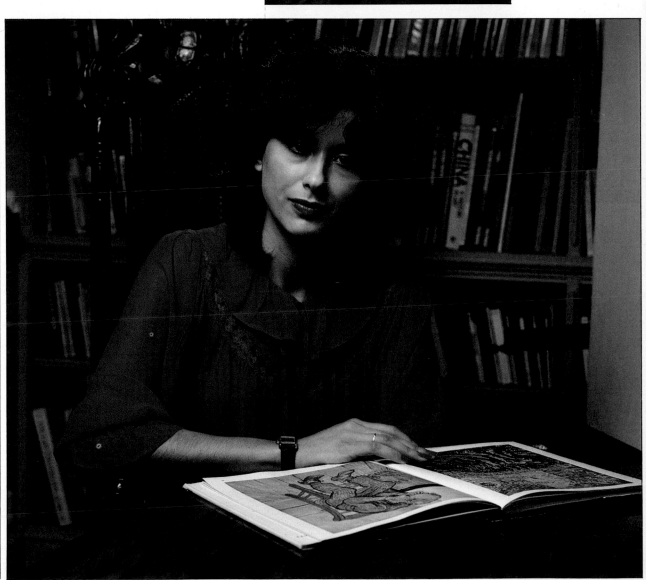

THE SESSION

There is no such thing as a standard portrait session. Just as each individual is different, so the problems and approach to each session will vary. In order to achieve a consistently high standard it is important that you do not develop a routine – each new portrait session should be a challenge to you. Build up an interest in your sitter, not only during the session, but, if possible, before your first personal encounter. Research the sitter beforehand, and use any information about identity and personality as a basis for your approach and to determine the way in which you conduct the sitting.

Many questions will occupy you before the session: How should I photograph my subject? Where? Which traits of his character would I like to reveal? What impression would I like to give the viewer? Only when you are able to answer these questions can you approach the session with confidence and self-assurance. You must give your sitter the impression that he is being photographed by a skilful, sensitive portraitist. Your approach and the way you conduct the session should be positive and purposeful. This feeling of decisiveness will impress the sitter, and you will gain the confidence and cooperation without which no session can be a real success.

Setting up the shot

Although your pre-session preparation and research will give you some idea about your sitter, and as a result you may have already decided what sort of portrait you would like to take, your final decision should come during the actual session. The contact with your subject is decisive. Do not start to photograph right from the first moment. Instead, load your camera in the sitter's presence to give yourself a few extra minutes to size up the situation and to start a conversation. This will help you to conduct the session in a relaxed, sociable manner, and make sure that your sitter does not become tense or bored.

The first problem you will encounter is how to get your sitter into the sort of arrangement you want. It is often best to suggest a position, and then wait patiently until the sitter adopts a suitable pose. In order to give yourself a better chance of taking a good·picture, and to keep your subject interested and alert, you should move your camera up and down, and to the right and left, to find an ideal angle or position. As you move around your subject you must constantly examine how the image changes. When the camera position alters, the relationship of your subject to the surroundings also undergoes a change. Shadows on the background, pictures on the wall or the back of your sitter's chair will occupy a different place in the frame, and light falling on the sitter will change direction and quality. Make sure that everything is exactly as you want it before you press the shutter release.

◁ **Close-up view (1)**
First, I took a shot of the sitter in profile. I moved in close to give a good view of the sitter and table. I used the large lamp in front of my sitter and the smaller one behind him. *55 mm, 1/15 sec at f16.*

Including the surroundings (2) ▽
A wide-angle lens allowed me to include most of the workshop. The objects on the table give a sense of scale. I placed the large lamp to my subject's left, the smaller one on his right. *55 mm, 1/30 sec at f11.*

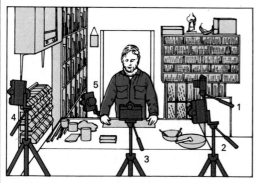

Working round your subject △
This diagram shows the way I moved the camera and tripod around my sitter during the session. Although I used a tripod I kept the camera mobile all the time, changing its position in relation to my subject and also changing its height. I lit the craftsman with two floodlights — a large one and a smaller one with an adjustable beam. *For all the pictures: Pentax 6×7, Ektachrome 160.*

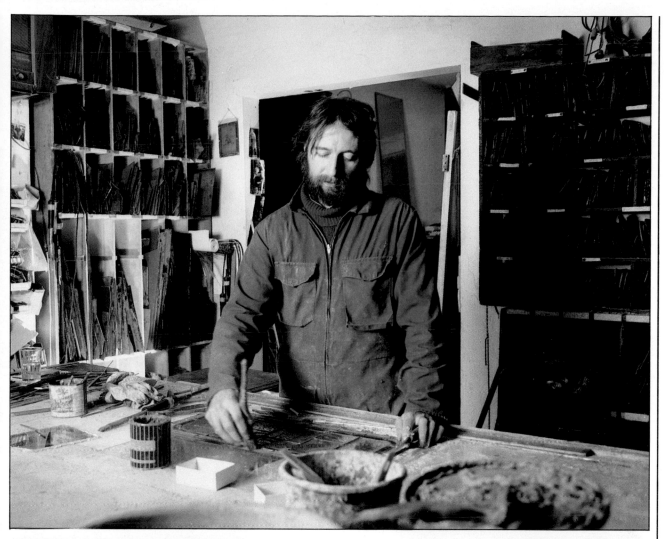

High viewpoint (3) △
The camera was positioned above normal eye-level. With my subject's central position this gives a more formal result. The large lamp lit the subject, the smaller one the background.
75 mm, 1/8 sec at f22.

◁ **Using a wide-angle (4)**
I took this wide-angle shot in order to show the scale of my subject in relation to his high workroom, and to include the stained glass on the walls.
55 mm, 1/30 sec at f11.

Low viewpoint (5) ▷
I moved to a low position behind the artist's work-bench to show him with his colorful finished product. One lamp lit the subject and the other lit the glass from behind.
75 mm, 1/8 sec at f22.

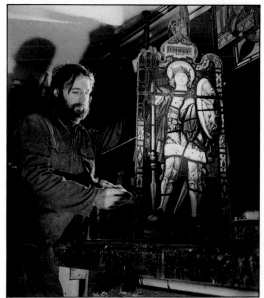

The classic portrait

A classic portrait places its strongest emphasis on the sitter's head, and includes only a minimum of other visually disturbing elements. It is a serious portrait, endeavoring to show the sitter in the best light. The intention is not so much to interpret the character or individual features of the sitter, but to show his or her external appearance to the best advantage. A classic portrait is never a snapshot, it is a consciously created, sympathetic image of the sitter.

A classic portrait should also be of high technical quality, and have a certain serenity and dignity. Generally, you should use more than one light, with the main and fill-in lights placed in a "classical" position (see pp. 32–3). The lighting should be simple but strong. The direction of the main light should follow the line of the nose, so that the front of the face is evenly lit. This kind of light is the most flattering to the human face. And, if necessary, use a third light for the hair and a fourth for the background so that the portrait is fully lit, with no important parts of the subject left in shadow. The viewer should be aware of the quality of light, but its effects should not become obtrusive. The head of the sitter should dominate the image, with the light merely accentuating its most attractive features. And because the sitter's eyes are a crucial part of the sitter's face, always try to make them a focal point of your composition. Never expect a complex lighting set-up to produce a good portrait automatically. In fact, a straightforward set-up is often better – some of the world's best portraits were shot with the simplest lighting.

Taking a classic portrait ▽
A classic portrait should use lighting, color, and exposure to enhance the sitter's appearance without making the viewer aware c the techniques employed. The final result should be simple and natural, and yet have some extra sparkle.
*Pentax 6×7, 105 mm, 1/3(
sec at f16, Ektachrome 16(*

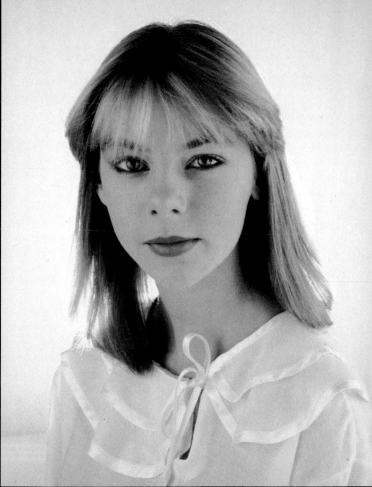

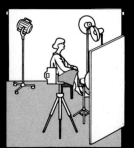

Shooting a profile △
Here, I asked my sitter not to look directly ahead, but to turn her eyes slightly toward the camera to show the white of her eye. The main light was opposite the face, with a fill-in bounced off a white screen. A spotlight lit the hair and another flood lit the background, see right.
Pentax 6×7, 200 mm, 1/15 sec at f11, Ektachrome 160

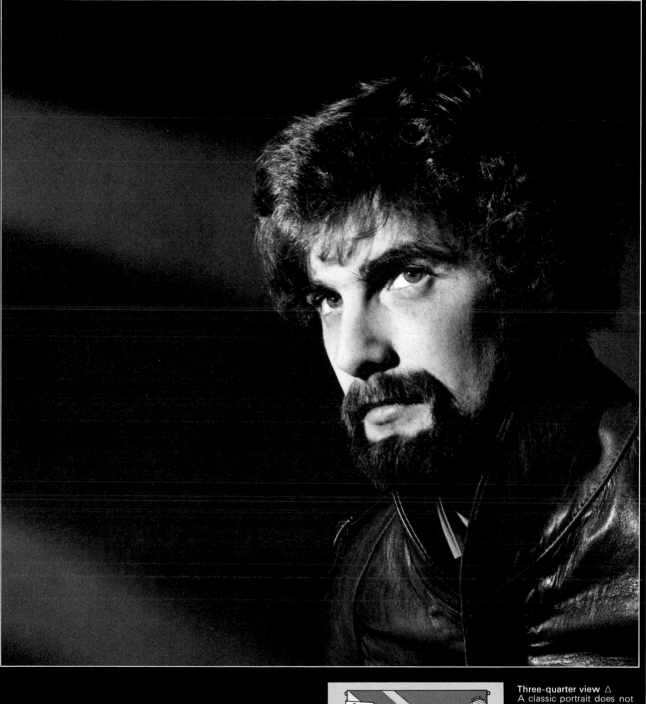

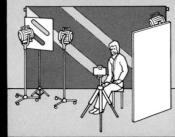

Three-quarter view △
A classic portrait does not
aim at a snapshot effect.
Therefore, this does not
rule out the use of high
and low key lighting (see
pp. 62–5). Here, the dark
background is only slightly
relieved by two shafts of
light from a cut-out, see
diagram left. The head was
lit from all sides.
*Pentax 6×7, 105 mm, 1/15
sec at f22, Tri-X.*

Varying the picture elements

Although we often think of a portrait as being traditionally a head-and-shoulders shot, this is in fact rarely the case. Often, you can create a more interesting picture by introducing other elements – such as the hands – or by shooting a full-length view of the sitter.

For a full-length portrait it is far better to allow your sitter to lean on something, or to sit rather than stand. It is also much easier to shoot in natural light, outdoors if possible. A full-length portrait in the studio is one of the most difficult shots to take, since it requires plenty of space and a well-thought-out lighting set-up.

Hands are notoriously difficult to photograph. Even the most natural arrangements often seem posed and awkward in the final portraits, so give your sitter some time to relax before you shoot. Once you add hands to your picture you must also think about the way that they are lit. Hands placed on the sitter's lap will certainly be underlit if the main light is above the head. The same will apply to the rest of the body, especially if the clothing is fairly dark. For this reason, traditional photographers like Yousuf Karsh often used an additional small spot to light the hands. If you are unable to use an additional light try to arrange the fill-in lamp so that it acts as an additional source of illumination for these areas.

◁ **Full-length portrait**
When shooting a full-length figure it is often better to ask your subject to stand with one side toward the camera, rather than facing it. The figure usually looks slimmer and taller when seen from the side.
Pentax 6×7, 75 mm, 1/30 sec at f11, Ektachrome 200.

Using flash to catch movement ▷
It is almost impossible to freeze swift movement in tungsten lighting. Umbrella flash is the best solution. Here, I used one flash head to light the subject, with fill-in from a reflector, and a second head on the background.
Pentax 6×7, 105 mm, 1/30 sec at f11, Ektachrome 200.

Including the hands ▷
The hands are always an attractive feature in a portrait. They add a secondary point of interest for the eye. Arms also can act as a strong compositional element, far right. Gestures are always very expressive and add immediate vitality to the picture, right. The most natural movements of the hands happen during a lively conversation, and if your sitter uses his or her hands while talking you should exploit this. I used an umbrella flash with a reflector for both these pictures.
Pentax 6×7, 105 mm, 1/30 sec at f11, Ektachrome 200.

Shooting in close-up

A great deal of the fascination of portraiture is due to the fact that each subject differs – not only in character and achievement, but also in external appearance. And the human face is, without doubt, the most individual part of the body. Yet all human heads contain the same basic ingredients – a mouth, a nose, two cheeks, two eyes and ears, and a forehead. Some portraitists make the mistake of always photographing a head at the same size and in the same position within the frame, producing a monotonous effect. You should look at a face as an abstract arrangement of shapes – a triangle for the nose, two hollows for the eyes, an oval shape for the mouth, and a square plane for the forehead – and vary the permutations of these ingredients in the frame.

For maximum variation, experiment with photographing small sections of the head. Very few photographers today, with the notable exception of Irving Penn, experiment with large close-ups, and yet close-up portraiture is extremely interesting. Most cameras and lenses will not allow you to take a close-up shot without special attachments, but these are not expensive. Macro and close-focusing lenses, and some cameras, allow you to come quite close to the face. Because the distance from film plane to lens is greater than normal, you will need to increase exposure by one stop.

Cropping the image ▷
You can convey a good deal of information using a minimum of visual clues. Always consider cropping superfluous parts of the image, retaining only the most interesting ones. I photographed the whole head here, see diagram below, then cropped in on a section at the printing stage. *Rolleiflex, 1/30 sec at f11, Plus X.*

Taking a close-up △
I used an extension tube, see diagram right, with my 200 mm lens, and a single diffused flood placed directly above the camera. An unusual camera angle and contrasty lighting adds a touch of drama to this close-up shot. Strong lighting was necessary because at this distance depth of field is very small, making a narrow aperture essential. Always focus on the sitter's eyes – these must be very sharp – and use your preview button or scale to make sure that the depth of field covers your entire composition. *Pentax 6×7, 200 mm and No 1 extension tube, 1/15 sec at f22, Tri-X.*

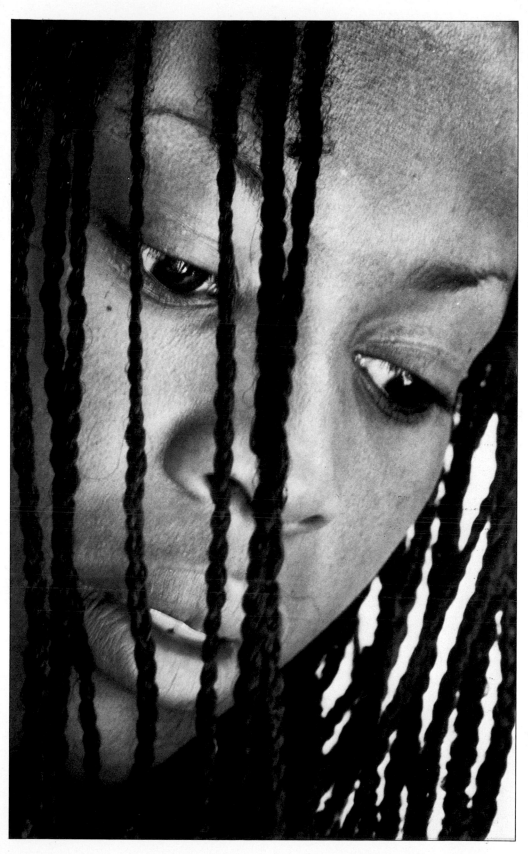

◁ **Using diagonals**
The outlines of the face are an important part in composing a close-up. It is useful to have a ball-and-socket head on your tripod so that you can tilt the camera easily in any direction. If you arrange the eyes on a diagonal, you will invariably give your picture visual impact, because the diagonal line acts as a contrast to the frame of the image. Here, I used the lines of the subject's plaits to counterpoint the diagonal line of her eyes still further.
Pentax 6×7, 105 mm, 1/30 sec at f16, Tri-X.

Backgrounds and props

The backgrounds and props available in a studio set-up are fairly limited. Try to keep arrangements simple so that they complement rather than dominate the subject. For backgrounds you can use a stand and rolls of paper – two telescopic poles fixed between the ceiling and floor with hook attachments that take the roll of background paper. Papers come in a range of twenty or so colors, and you can use two different colors side by side for a dual-color background. An even cheaper and easier method is to use white paper or a white wall, and a set of transparent colored gelatins. You place these in front of a spot or floodlight to color your background. You can also use cut-outs in conjunction with your colored gels to throw shadows onto the background for a more sophisticated effect. On the whole, it is a

good idea to keep the shadow of the sitter away from the background. Random, undefined shadows will give the portrait an untidy look. Consequently, you should keep your sitter at a distance of 6½–10 ft (2–3 m) from the background, so that his or her shadow falls below and out of range of the camera. However, you can use shadows quite deliberately for effect – just as Edward Steichen did in the 1930's with his great portraits of stars for *Harpers Bazaar*.

You can use any object, large or small, as a prop. Glass vases, candelabra, and mirrors are particularly useful for portraiture. It is often best to use props partly abstracted, as in the picture on the facing page, so that they become a part of the design.

Simple props ▷
Here, I used a candelabra as part of the design placing it 10 ft (3 m) in front of the model and 5 ft (1.5 m) from the camera. I focused my long lens on the girl, so that the candles are blurred.
Pentax 6×7, 105 mm, 1/30 sec at f8, Ektachrome 160.

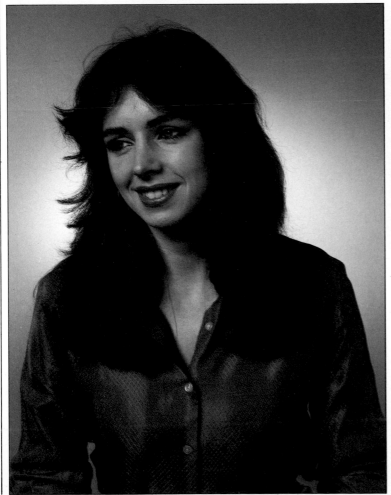

◁ **Avoiding shadows**
I placed the background paper 8 ft (2.5 m) behind the sitter, see diagram below, so that the shadow cast by the main light is not visible.
Pentax 6×7, 105 mm, 1/30 sec at f8, Ektachrome 160.

Shadows for effect △
The model stood close to the background, and I used an open spotlight to give strong shadows. A closed spot would have made the shadows less sharp.
Pentax 6×7, 75 mm, 1/60 sec at f8, Ektachrome 160.

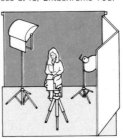

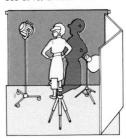

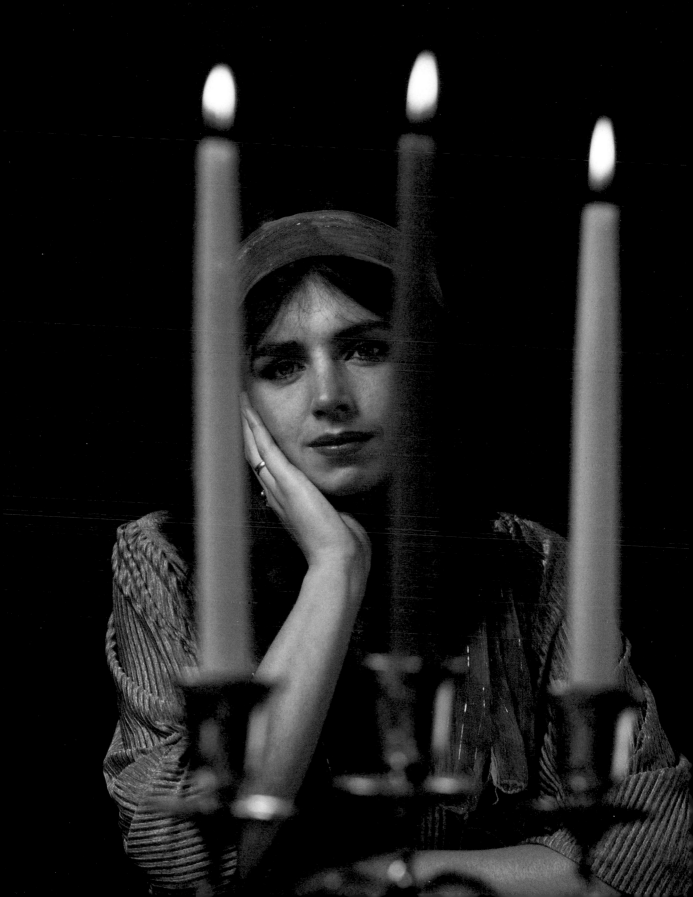

Silhouette lighting

Silhouettes are one of the simplest special effects lighting set-ups. To create a silhouette in the studio, you should use a white or light-colored background, lit with either plain, even-toned lighting or a pool of light behind the sitter. Then pose the sitter just in front of this brightly-lit backcloth.

With a silhouette the outline of the subject is the focal point of the picture, and as a result the composition is even more important than in an orthodox portrait study. You will find that a profile will make the most distinctive silhouette. A lively position is best, with the head placed slightly off-center, and the hands and arms arranged to balance the composition.

You can leave the front of the sitter entirely unlit, so that virtually no detail is visible, or you can partially light the area. A very weak fill-in, for example, will give the viewer a little information – the shape of a collar, the outline of an ear, or the detail of an eye – while retaining the air of mystery that is the strong point of a silhouette. You can even use one well-controlled beam of light from a small spot directed onto one part of the face, while the rest of the figure remains in shadow. In the case of a full silhouette, read the exposure from the main – background – light, not from the face. With a partially-lit face, base your exposure on both lights.

Silhouette with weak fill-in ▷
The white background paper was lit with two floodlights on either side of the sitter, see diagram below. The sitter's front was lit with a weak fill-in – light bounced off two white reflector screens.
Pentax 6×7, 75 mm, 1/60 sec at f11, Tri-X.

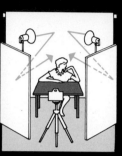

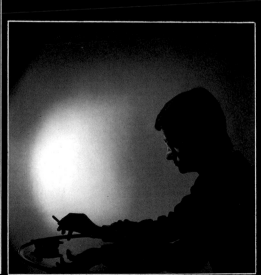

◁ **Silhouette with spot**
The background was lit with two floodlights, creating a circular pool of light behind the sitter, see diagram below. He leaned against a circular table, and a small spotlight was directed onto his face.
Pentax 6×7, 105 mm, 1/30 sec at f11, Tri-X.

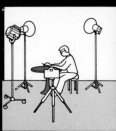

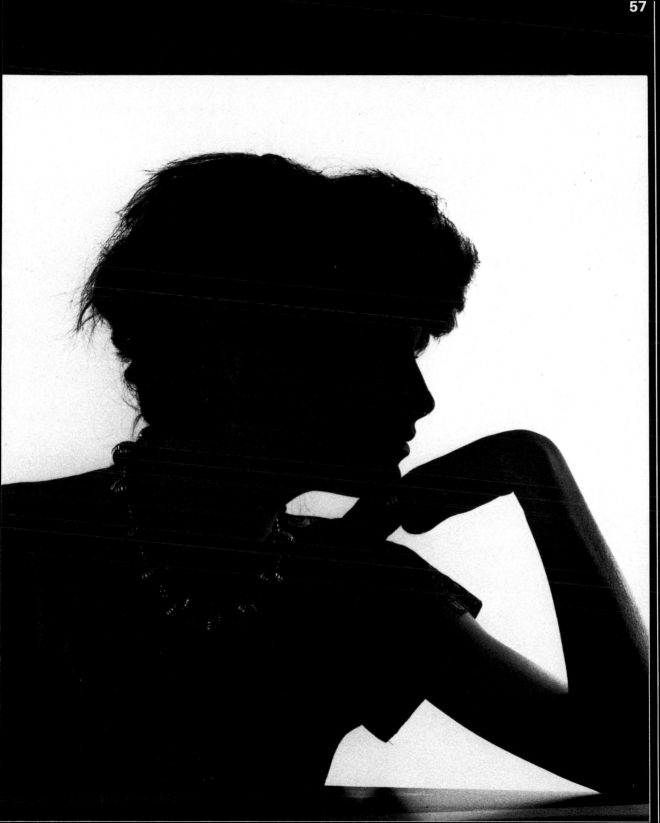

Backlighting

To backlight a subject, place the main light or lights behind the sitter in such a way that they do not shine directly into the lens and cause flare. The simplest and most effective method is to cut a hole about 10–12 ins (25–30 cm) in diameter in a large piece of black cardboard and place a strong spotlight behind it. Arrange the light and cardboard directly behind the sitter's back to create a halo of light around the head and shoulders. At this point, the sitter's face will be in almost total darkness. However, since a frontal light of matching intensity would simply cancel out the backlit effect, the best solution is to light the sitter's face separately with an indirect light that is much weaker than the spot behind the sitter, so that you retain a bright halo behind the head. This indirect frontal lighting is a type of fill-in: it lights the shadows, but does not create an effect of its own. Use two white screens, one on each side of the sitter, with medium floodlights shining into them. Take your exposure reading from the flatly-lit face, not from the strong backlight.

An alternative way of creating a backlit effect is to place a light on each side of the sitter at an angle of about 45° and some 10 ft (3 m) back. You will need to place some screens partly in front of these lights in order to shade them from the camera. In all the examples on these pages we used tungsten lighting, but a flash unit with two heads can be equally effective. Use one head directly as a backlight and bounce the other off a reflector to fill in the face.

Informal backlighting ▽
You can sometimes use backlighting to suggest informality. Frontal, well-arranged lighting is more formal and static, while backlighting can appear almost casual — as if catching the sitter unawares, especially if his pose and expression is relaxed. I used a single spot with a reflector to provide fill in.
Pentax 6×7, 105 mm, 1/15 sec at f11, Ektachrome 160.

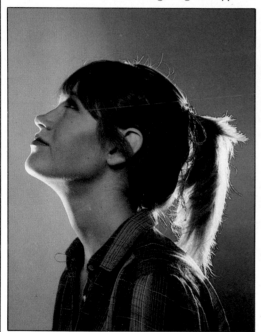

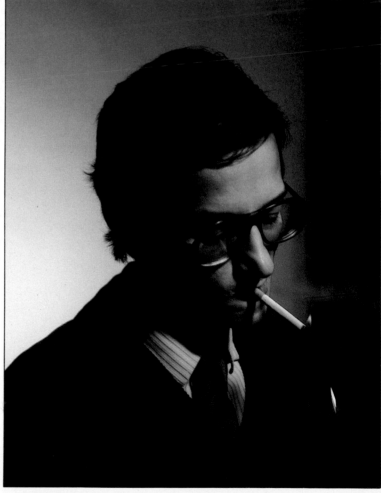

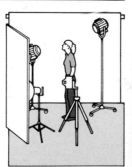

Combining back- and rim-lighting △
A low spotlight to the left of the sitter acts as a rim light on her profile, and a second spot more directly behind her backlights her hair. A third indirect light is bounced off a reflector in front of the sitter, see diagram right.
Pentax 6×7, 105 mm, 1/30 sec at f8, Ektachrome 160.

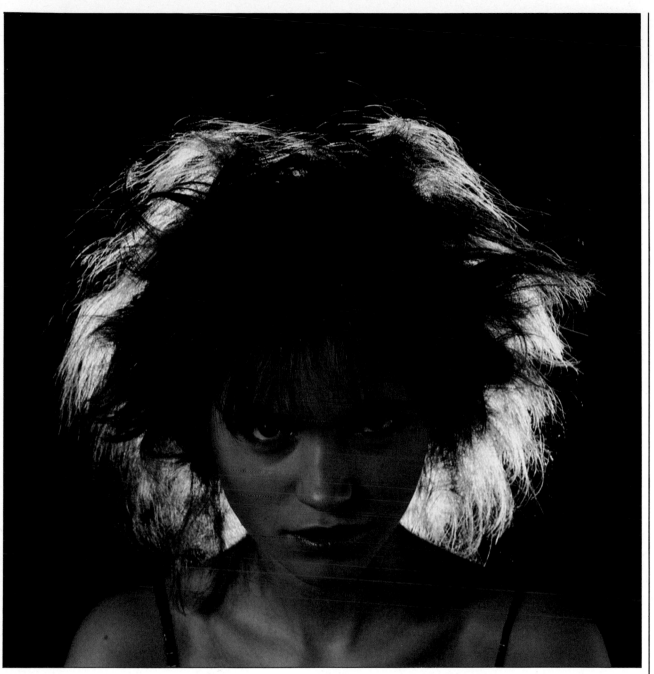

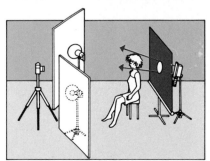

Backlighting hair △
Backlighting works best
with full or fairly unruly
hair. Close-cropped styles
are not as effective because
the light only spreads
slightly, and also because
it is difficult to hide the
lamp behind the sitter's
head. Here, I used one
spot as a backlight, and soft
fill-in from two floodlights
reflected off white
screens, see diagram left.
*Pentax 6×7, 105 mm, 1/30
sec at f11, Ektachrome 160.*

Rim-lighting

Rim-lighting outlines the edges of a face or figure with a delicate line of light. It is one of the most striking, attractive ways of lighting the face. Natural rim-lighting will occur in bright sunlight, and gives a very beautiful effect. However, it cannot be arranged to order. The answer is to use studio rim-lighting consisting of a combination of two kinds of light – one strong, direct, high-contrast type, and the other diffused and non-directional. The dominant light is the light which creates the rim – the backlight. The position of this light is important – you must place it a little higher than the sitter's head. You can vary the distance of the light from the head – move it back to create an outline of the profile, or bring it forward to give a pool of light on the eye and cheek. You must always place it out of the camera's vision, otherwise you will get strong flare. The frontal light that illuminates the rest of the face should be weaker, quite flat and shadowless. Use either a diffuse, soft floodlight or, better still, an indirect light reflected off a white surface. For a special effect you can dispense with the fill-in light altogether to give a rim-lit silhouette.

Studio set-up ▷
The model's position provides a large area to show off rim-lighting effectively. I used a large spotlight and a reflector to provide fill-in so that no extra shadows were created. And I added another spotlight, see diagram below, to light the hair and back, creating a second, less pronounced rim effect.
Pentax 6×7, 105 mm, 1/30 sec at f16, Tri-X.

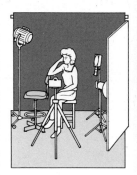

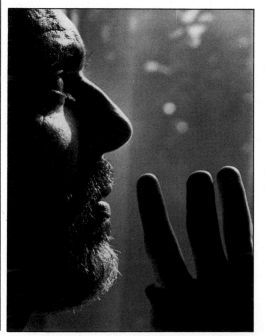

◁ **Natural rim-lighting**
Natural light will also produce a rim-lit effect, although this is often more difficult to control. Here, strong sunlight was streaming through a window behind the sitter, lighting the face from an angle. I did not use any fill-in because I wanted to keep the rest of the face dark. And I asked my subject to turn his head a little to catch the light on his eye and cheek.
Pentax 6×7, 105 mm, 1/60 sec at f16, Tri-X.

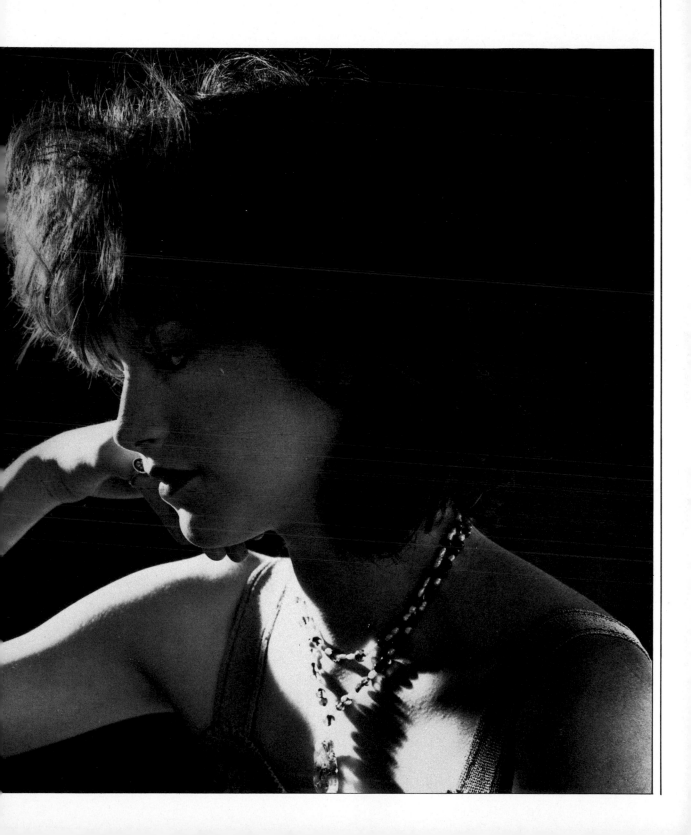

High key

A high key portrait has very light, delicate tones, whether it is in color or black and white. High key relies on the elimination of all dark shadows, and ideally, the portrait should be entirely shadowless, with only the eyes, eyelashes and some outlines of the face as black accents. You can use this treatment to convey mood. It has associations with femininity, delicacy, and gentleness. John French, a leading fashion photographer of the 1950s (his assistants were David Bailey, Terence Donovan and Terence Duffy), first made this style popular with his shadowless fashion shots.

The best lighting for a high key portrait is entirely indirect. Do not direct any light sources at the sitter – instead bounce all the lights off a white surface. You will require a minimum of three lights – the first two on each side of the subject bounced off two white reflector screens, and the third one illuminating the background. The background should also be very light in tone – preferably entirely white. Many professional photographers shoot high key pictures within a specially constructed white tent which surrounds the model with completely white, luminous walls. White light then illuminates the subject from all sides. Since all the lights are of equal strength all shadows are eliminated.

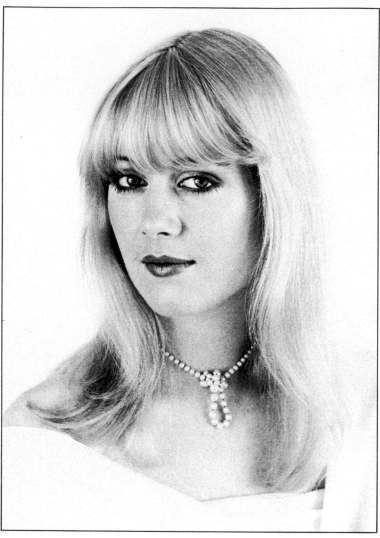

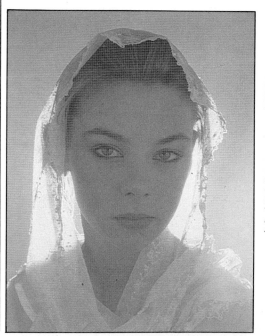

◁ **Using props**
You can often enhance a high key effect with an unobtrusive but appropriate prop. Here, I used a pale, semi-transparent embroidered veil which I backlit to emphasize its translucence.
Pentax 6×7, 105 mm, 1/15 sec at f16, Agfachrome 50L.

Avoiding shadows △
For this shot I used five lights to create a shadowless image – two floodlights bounced off white screens either side of the model, two more illuminating the background, and a spotlight as a backlight on the model's hair, see diagram right. The delicate tones will not be entirely evident unless you have a few strong accents as a contrast. Here I asked my model to strengthen the black of her eyelashes with a little make-up.
Pentax 6×7, 105 mm, 1/15 sec at f16, Agfachrome 50L.

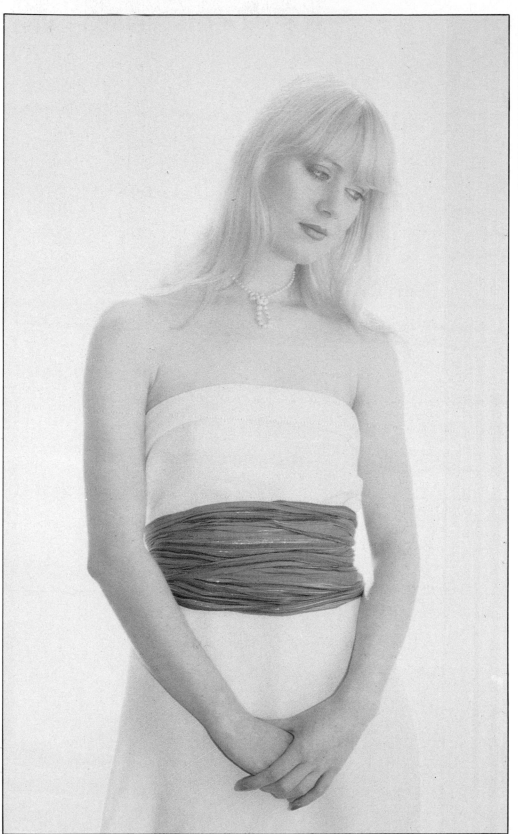

◁ **High key figure**
Applying a high key
treatment to a figure is very
difficult. With so much to
include in the frame you
are likely to get some
unwelcome shadows. You
can avoid this by using a
specially constructed light
tent, but this is not
always practical. However,
well-diffused backlighting
will reduce shadows and
accentuate the translucent,
delicate effect of your high
key composition.
*Pentax 6×7, 75 mm, 1/60
sec at f11, Ektachrome 160.*

Low key

A low key portrait is the exact opposite of a high key picture (see pp. 62–3). The prevailing tones are all dark, the shadows are heavy, and large areas of the picture are underlit. The style is traditionally used for male studies – it gives an impression of strength, resilience and physical force. But a low key treatment should not be reserved solely for male portraiture, since it is equally effective in the interpretive treatment of some women. For example, I used low key lighting for a portrait of the actress Glenda Jackson (see p. 74) to bring out the strength of her personality.

The best low key light sources for portraiture are strong, contrasty, highly concentrated spotlights. In low key studies it is important to limit the illuminated area, and this is not easy with floodlights which provide a broad beam of light. The most effective low key studies are often created with no more than one light source – a spot directed onto the face, or even part of the face, with only a suggestion of the rest of the head and shoulders. However, at times it may be preferable to open up shadow areas a little – you can place a reflector near the camera and control the amount of shadow detail by altering the distance of the reflector from the sitter. The human eye is not reliable in deciding the required amount of shadow details – what the eye sees the film is often blind to. Because of this you may sometimes have to provide stronger fill-in than seems necessary. For a precise result, take a meter reading on both highlight and shadow areas. Where the difference is more than four stops the shadow details will not record. For example, if the exposure for the face is f16, the shadow area should register as not less than f5.6. A difference of two stops is preferable (this would give an exposure of f8 for our example).

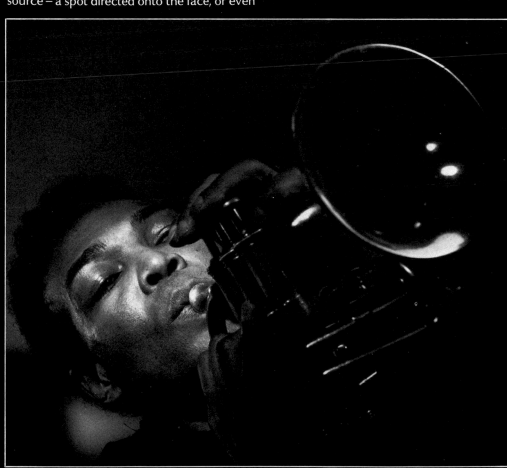

◁ **Capturing mood**
For this shot, I used a low angle and cropped in closely to add impact and give the illusion of high musical notes. The low key treatment seems to suit the mood of the jazz music.
Mamiyaflex C3, 80 mm, 1/60 sec at f16, FP4.

Lighting for low key ▷
I used straightforward low key lighting for this shot, see diagram below. The beam from the spotlight directed onto the face catches the outline of the glass. Fill-in is from a reflector near the camera and I placed an additional light above the head to reveal its outline.
Pentax 6×7, 105 mm, 1/30 sec at f16, Tri-X.

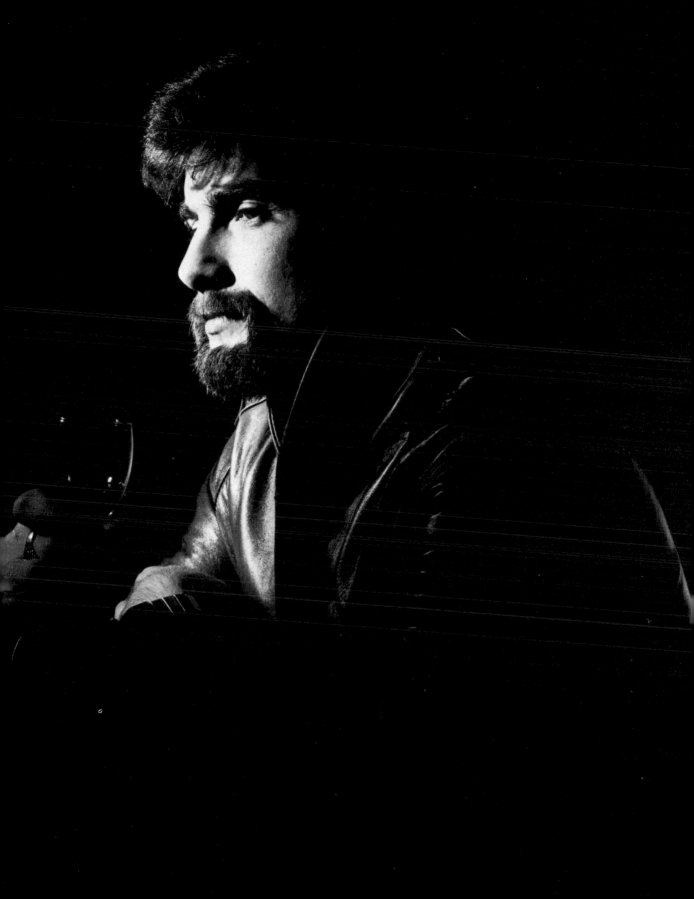

Enhancing your subject

The amount and style of make-up that your subject wears can greatly affect his or her appearance in the final photograph – so make sure that it matches the mood you want to create. For a straight portrait it is generally best to use a simple make-up which will emphasize the sitter's good points. Your subject will need a make-up that is bolder than normal because make-up looks less pronounced in a photograph. You will find that diffused lighting needs stronger make-up than a spotlight.

Three areas of the face – the eyes, mouth, and cheekbones – are most important in a portrait, and you can strengthen or change these with skilful make-up. Cheekbones are important because they give shape to the face. Build them up slightly using blusher to exaggerate the shadow cast by the bone.

When applying lipstick, do not enlarge the mouth, just bring out its existing shape. You

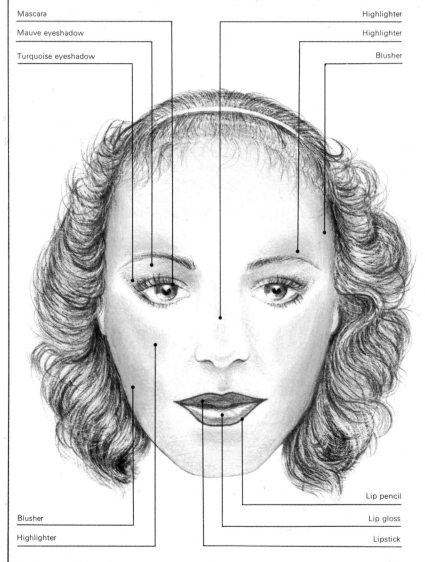

Mascara
Mauve eyeshadow
Turquoise eyeshadow

Highlighter
Highlighter
Blusher

Blusher
Highlighter

Lip pencil
Lip gloss
Lipstick

Simple naturalistic make-up
There is no need to use special theatrical make-up for portraiture, unless an exaggerated effect is required. Use this diagram as a positioning guide to placing make-up. The colors used in this sequence will suit redheads, blondes and light brunettes. For women with a darker coloring replace the blues and pinks with golds and ambers.

Applying make-up
Start with a clean, moisturized face, above. Without any make-up the model's face is pale and lacks shape.

Shaping the face
Use blusher (rose-pink here) to shade the areas that you want to hollow.

should use a brownish-colored lipstick for black and white portraits because black and white films turn red lipstick almost black, and pale colors white.

Eye make-up produces the greatest change in a sitter's appearance and a clever make-up artist can alter the eyes dramatically. The effect in these pictures is naturalistic – the intention is only to make the eyes brighter and more attractive. But you can make-up the eyes in all sorts of different ways to add to the mood of your picture. As an example, contrast this treatment with the slanting oriental look on p. 96. Men, too, can benefit from a little eye make-up, especially for black and white portraits. Many movie stars achieved their "smouldering" look with the help of a little mascara, or even a touch of brown eyeshadow.

However attractive your subject there is usually a small detail or "imperfection" which

Creating a base
First, apply a foundation that is a shade lighter than the model's own skin to get a mat complexion. Use a damp sponge for an even result, and dust on powder to prevent shine.

Enhancing the eyes
Next, apply eyeshadow. Here, the make-up artist used two colors – turquoise and mauve – blended together.

Brows and lashes
Brush the eyebrows into place. Strengthen with eyebrow pencil if necessary. Apply black mascara to upper and lower lashes.

Adding highlights
Apply highlighter (pale pink here) to the areas that you want to stand out.

Applying lipstick
Outline the lips with a pencil or a brush. Use a slightly darker color than your main lipstick. Now fill in with main color (rose-pink here), and finish by adding a touch of gloss.

The final result
Once the make-up is finished, brush out the subject's hair and take her portrait.
Pentax 6×7, 105 mm, 1/30 sec at f16, Ektachrome 160.

could be improved – a nose that is a fraction too long, for example, or small wrinkles on the neck or under the eyes. The neck almost invariably shows age first, so you should use a scarf or carefully arranged lighting to create a shadow which will hide the problem area. To disguise a double chin, place the camera higher than the face. To subdue a large nose, position the camera below the level of the mouth. In general, keep any part which appears too large as far away from the lens as possible, and try to emphasize anything which seems too small.

To soften lines and enhance appearance, the technique of diffusion is invaluable. You will find soft focus attachments cheaper and more accessible than the specialist lenses. The degree of diffusion varies with the type of filter and also depends on the aperture of the lens – the smaller the f stop, the less diffusion, and vice versa.

◁ **Coping with eyeglasses**
Eyeglasses can be a problem, see top picture. They reflect any light source in front of them, and the reflections will hide the eyes. To avoid this, light the face at an angle, never from the front, see bottom picture. Place your main light to the side of the camera. Position your fill-in light slightly below the height of the camera – if you place the lamp too high you will see the shadow of the frames right across the eye. *Pentax 6×7, 105 mm, 1/30 sec at f8, Plus-X.*

Hard and soft lighting △
A sharp lens and harsh lighting, like the direct flood and reflector used here, will emphasize wrinkles. The more flattering treatment produced by soft lighting, see facing page, is usually preferable. *Pentax 6×7, 105 mm, 1/15 sec at f11, Plus-X.*

◁ **Soft focus filter**
This portrait was taken with a special diffusing filter. A good diffuser will hide small skin blemishes and make the hair look softer, while still retaining a certain amount of overall definition. Diffusion has been used for portraits since the end of the nineteenth century, when lens makers started to produce special lenses. You can still buy soft focus lenses today – they give better definition than a filter but are more expensive. *Pentax 6×7, 105 mm, 1/30 sec at f8, Plus-X.*

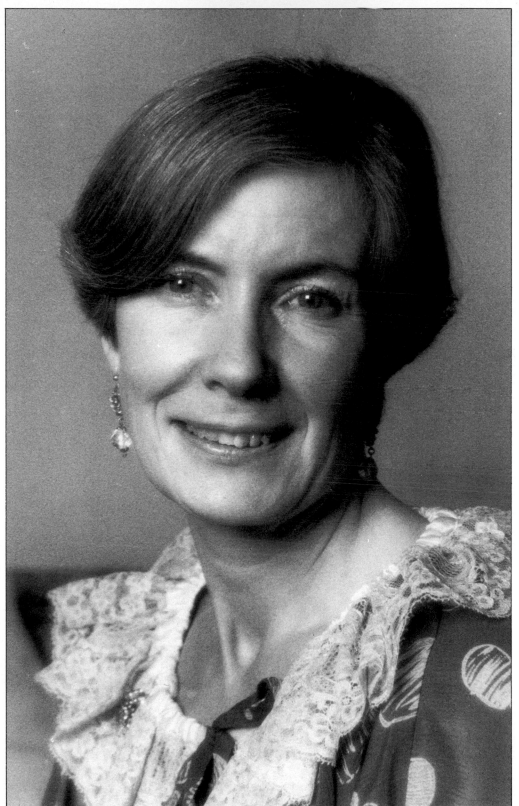

Home made diffuser △
In the absence of a special filter, you can create improvised diffusion effects. For example, petroleum jelly smeared very thinly on a UV filter will give a very soft effect which is easy to control – simply add or remove jelly to increase or decrease diffusion. Some 15 denier nylon stretched over the lens is also very effective. Even simply breathing on your UV filter, as here, will work. *Pentax 6×7, 105 mm, 1/30 sec at f8, Plus-X.*

Working toward the best image

A photographic portrait session divides into three separate, yet closely interdependent stages. The pre-session preparation consists of studying the sitter, imagining your final image, and thinking up arrangements of props and lights. The second phase is the session itself. And the third stage involves processing your film, examining the transparencies or contacts, and then selecting the final image.

At the session you convert the ideas that you formulated beforehand into pictures, making a continuous effort to find the best possible interpretation. The final image often becomes clearer as the session progresses. On location you may find more appropriate or interesting parts of the environment to include in the portrait. In the studio you may gradually improve the lighting arrangement, or your sitter may begin to assume more relaxed positions. We shoot between 40 and 80 frames, working on several ideas and set-ups.

After the session is over, you reach the third, possibly most satisfying stage – looking at the results. While trying to evoke the memory of your sitter, select the picture that best fits this mental image. Compare the lighting, exposure, composition, and the sitter's expressions. Also note if anything unnecessary has crept into the frame. Finally, you will emerge with three or four acceptable shots.

Taking a color shot ▷
Color is so important nowadays that, even when the commission only calls for black and white, most photographers will shoot a few frames in color for their files. Here, I found the colors of my subject's dress, the mellow tones of the walls, and the accent of the mantlepiece irresistible. By this stage in the session it was obvious that this pose was best, so I simply shot a single roll in color. *Pentax 6×7, 75 mm, 1/8 sec at f11, Agfachrome 50S.*

Selecting the final portrait
These sample contact sheets show a few of the 60 or so frames shot during a session with Antoinette Sibley, the ballet dancer. Always shoot several possible variations of each idea, and try a close-up and a full figure. In the series below I experimented with only half the figure, moving in closer with each shot. The second series, right, shows the dancer in full length. First, I tried posing her by the window, but finally the mantlepiece proved to be the most attractive. When you select the final portrait from the contact sheet look for an image that brings out your subject's best features. Use a magnifier to examine each frame for faults and mark the ones you select with a grease pencil.

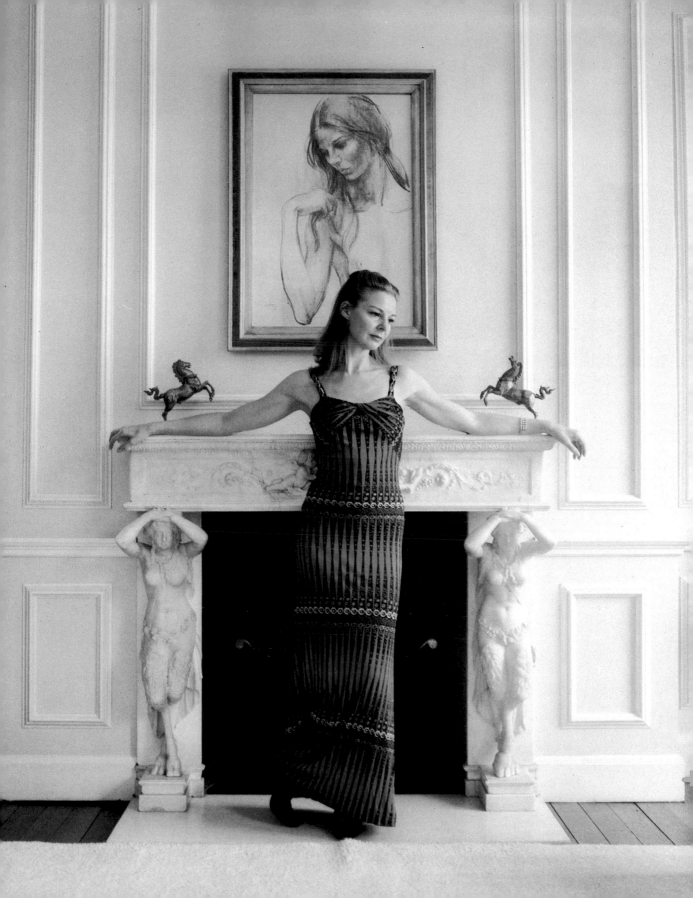

The best close-up ▷
This image was the best of the close-up shots on my contact sheet. Diffused daylight filtering through a large window lit the subject, giving good modeling. Nevertheless, the combination of one-directional light without fill-in and a fairly contrasty, medium speed film was still slightly too hard. To combat this I introduced a little diffusion in the darkroom — I printed through one layer of 15 denier nylon, and held back the shadows.
Pentax 6×7, 105 mm, 1/60 sec at f16, FP4.

TACKLING DIFFERENT SUBJECTS

Photography is a very flexible medium, and when tackling different subjects a portraitist has an enormous variety of methods to choose from. A different approach can – and should – be applied to each type of subject. In the past, even traditional portrait photographers, confined to the studio and a set of lamps, managed to create variations between child studies and portraits of older people. Different interpretations were achieved by varying the lighting, set-up or pose, or by introducing appropriate props. The possibilities open to a modern portrait photographer are much richer. No longer confined to the studio, there is an infinite choice of location – both indoors and outdoors – and a wide variety of different cameras, filters and special effects attachments. The most important point is to be aware of all these possibilities and to use them as creatively and imaginatively as possible. Before tackling each new subject always review the task in front of you and decide on the best approach. You will almost certainly find that your sitter will greatly influence the procedure, the choice of location, and the equipment and materials that you use.

The individual portrait

With portraits of a single subject it is very easy to fall into the trap of photographing every sitter in the same way. This is particularly true of studio work, where many photographers fall back on placing each sitter in the same chair with the same lighting and pose. Producing a formula shot time and again is easy enough, but making a different kind of image with each new session and sitter requires technical skill and professional know-how as well as a lively imagination. Conjuring up a different mood, a fresh interpretation, and even variations in tones or colors is not as simple as it may seem. But this is precisely what each individual portrait requires.

Ideally, every portrait should be radically different. After all, every person is an individual – a unique personality with particular thoughts, ambitions and abilities of their own. In practice, it is possible to achieve something totally fresh with each sitting. But, while an unimaginative portraitist will tend to repeat a formula, the more creative photographer will manipulate his camera, lights and materials to bring an individual touch to all his work.

To create an individual portrait use your background knowledge of the sitter – age, profession, character and approach to life – to decide on the overall mood of the session. Is a dramatic, romantic, sentimental, energetic, serene, or businesslike treatment best? Plan out the techniques you will use to give this mood. Then decide whether you should carry out the sitting in a natural environment or in the studio. In the examples on these pages we produced all the variations in approach in a studio, using only light, arrangement, and expression to convey the differing personalities.

Deciding on a pose ▷
A small variation in pose can completely change the mood of a portrait. A small inclination of the head, for example, can make a radical difference — from a direct, confident attitude to a slightly coy one. Often it is impossible to ask for a specific pose — all you can do is shoot a number of variations and pick the one that most suits your subject's nature.
Pentax 6×7, 105 mm, 1/30 sec at f11, Ektachrome 160.

Creating mood ▷
This portrait of Glenda Jackson uses one lamp, see diagram right, and slight underexposure to give an air of mystery and drama. Only her head and hands emerge from the darkness, as if spotlit on a stage. Do not assume that you can photograph *all* actresses in this way — always take into account your subject's character.
Hasselblad 500C, 80 mm, 1/30 sec at f16, Tri-X.

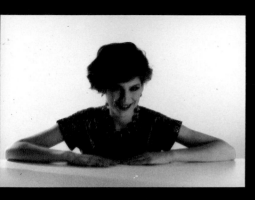
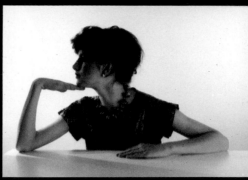

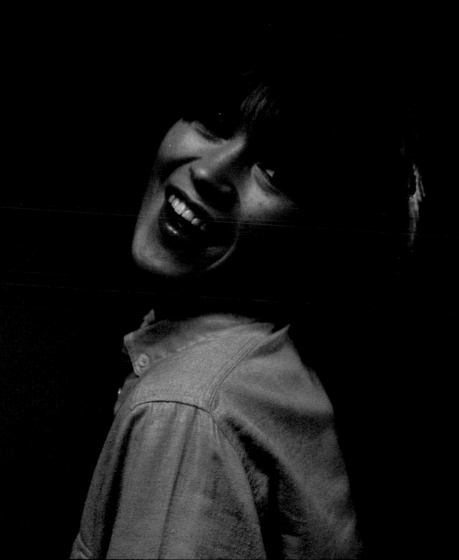

◁ **Capturing expression**
Controlling lighting and
exposure is much easier
than controlling your
sitter's expression. Smiles
are often fleeting and, in
general, they are impossible
to turn on when required.
Be prepared to catch the
look you want at any time,
and try to anticipate its
occurence. While it is
difficult to command a
specific expression, you
should be able to create an
atmosphere during the
session which will evoke
the desired response from
your sitter. Here, I joked
with my subject to bring
out her attractive smile.
*Pentax 6×7, 105 mm, 1/60
sec at f16, Ektachrome 200.*

Self-portraits

Every would-be portrait photographer should try a self-portrait. It is great fun to do, and it can teach you a great deal. Start with a reflective surface, preferably a mirror. Even if you do not intend to include the mirror in the actual shot, it is still best to be able to see yourself as you will appear in the photograph so that you can assess your pose and expression. This will be quite instructive – you will realise how difficult it is to assume a natural-looking pose for a portrait.

There are two basic methods of taking a self-portrait. The simpler method is to photograph your own reflection directly in a mirror. The difficulty with this is that if you can see the camera in the mirror, then you will be able to see it in the picture too. If you do not want to include the camera, you will have to use the second method. Place your camera on a tripod, focus on a friend who acts as a stand-in for you or set the lens to a pre-measured distance, and then use the camera's self-timer or a very long cable release to fire the shutter release once you are standing in position.

All the self-portraits on these pages were taken by some of our photography students in the course of a portrait project.

Shooting your reflection ▷
The image is reflected in an enlarger lens fixed to a 5×4 studio camera for support. As well as studio flash, Paul O'Kane used available light. He cut a window shape in black paper and placed this in front of the window, blocking out the rest of the light, see diagram right. He used a friend as a stand-in to help him compose and focus the shot. When he was ready he took his place, firing the camera and flash with a cable release.
De Vere 5×4, 150 mm, 1 sec at f16, Ektachrome 64.

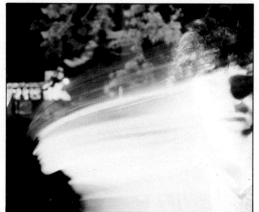

◁ **Nighttime self-portrait**
Carl Warner took this in a cemetery at night. He placed his camera on a tripod, focused on a pre-measured distance and then set the shutter for a 6 sec exposure. A tungsten street lamp lit his head. Once he had set the self-timer he ran to his chosen spot, stood still for the first 4 sec of the exposure, and then moved during the last 2 sec to produce the blurred effect.
Canon A1, 24 mm, 6 sec at f8, Ektachrome 160.

Triple self-portrait ▷
Tracy Nicholls' self-portrait is the reflection of herself with her camera. The other two "self-portraits" are, in fact, her twin sister, see diagram above. Working on your own, you could achieve a similar result using a double mask attachment (see p. 130). You could then shoot your reflection on one side of the frame, and use your self-timer to allow you to position yourself near to the mirror for a second image.
Pentax Spotmatic, 90 mm, 1/30 sec at f16, Ektachrome 160.

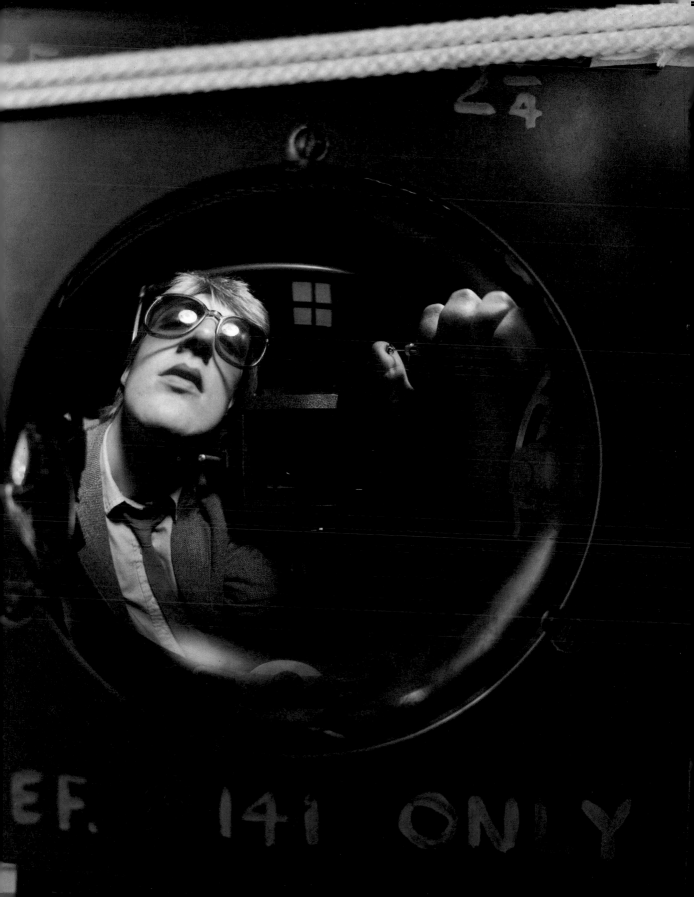

Children

Children are possibly the most rewarding portrait subjects of all. They possess a certain appealing innocence which often makes them quite unselfconscious. And the great majority of children enjoy being photographed. They like dressing-up, and will readily take up any position or pose you ask them to. Nevertheless, this willing cooperation is not entirely free – the photographer wins it by giving complete and undivided attention to the child. Children are keenly aware of the attitudes of adults, and they must feel that the photographer really likes them, and that he or she treats them as equal partners in the game of making pictures. Photographs of children should always be bright and cheerful, and therefore they must be well-lit. Use well-diffused lighting – either slightly overcast sun or artificial light of a similar quality, such as bounced flash or strong flood-lighting. Indoors, make sure that the whole room is adequately lit, both in front of and behind the subject. Poorly-lit interiors rarely suit child studies. In general, keep technique as simple as possible, but try to be inventive in settings and arrangements. A standard lens is the simplest, most effective lens to use. A wide-angle will give distortion problems, and the shallow depth of field of a long lens makes a sharp result difficult when photographing subjects who will not stay still.

Working in north light ▽
The available light for this picture was ideal. I took it in a north-facing painter's studio with a glass roof and walls. The whole room was filled with a soft, beautifully-textured light. *Nikkormat FT2, 50 mm, 1/30 sec at f11, FP4.*

◁ **Diffused daylight**
For delicate, soft skin texture, diffused daylight is unsurpassable. I took this shot early in the morning against a black backcloth, see diagram right, in a very well-lit room. White walls gave an overall light with hardly any shadows. *Nikkormat FT, 50 mm, 1/30 sec at f8, Kodachrome 25.*

Capturing expressions △
Some boys refuse to be
frivolous — they consider it
beneath their dignity. A
playful snapshot would
have been entirely out of
character for this child, so
I tried to capture his usual
solemn mood. Lighting was
overcast daylight.
*Pentax 6×7, 75 mm, 1/60
sec at f11, Agfachrome 50S.*

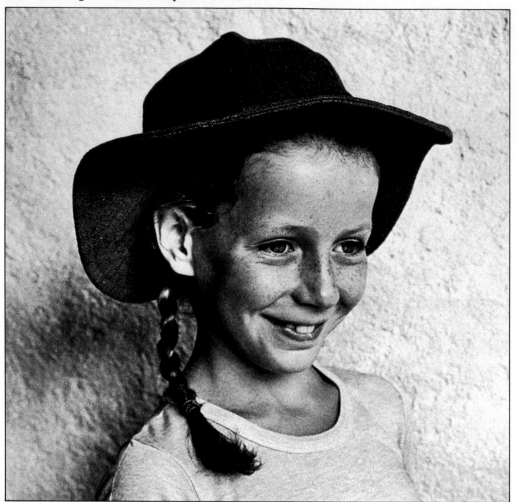

◁ **Using a white background**
Whitewashed walls always make an excellent background – they are brilliant white, yet textured. Diffused daylight from a large window lit the scene. Avoid direct sunlight – whenever possible choose overcast light instead. *Hasselblad 500C, 80 mm, 1/60 sec at f8, Agfachrome 50S.*

▽ **An unusual background**
This girl was photographed in front of a painting of a Greek church. The shape of the painting blends well with her head and shoulders, giving a pleasing alternative to a plain background. *Pentax 6×7, 75 mm, 1/30 sec at f11, Agfachrome 50L.*

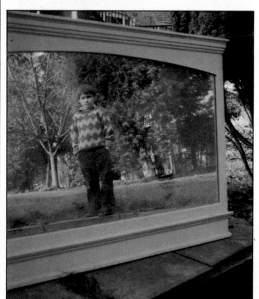

◁ **Using mirrors**
Mirrors are fun to use, and they can put a shy child at ease since you do not have to point the camera directly at him, see diagram below. The image in the mirror is at twice the distance of the mirror itself, so in order to get both mirror and subject sharp it is necessary to stop down. *Pentax 6×7, 75 mm, 1/30 sec at f16, Ektachrome 200.*

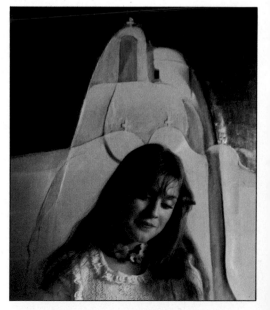

Effective "mother and child" studies depend on the projection of sincerity and complete naturalness. The best studies of this kind are usually shot by very close relations. It is important that there is no trace of artificiality, for the camera will reveal it. This picture was taken by the child's elder sister, who was able to capture a relaxed feeling.
Nikkormat FT, 50 mm, 1/125 sec at f8, FP4.

Babies and toddlers

Babies and toddlers can be easy subjects – they are totally unaware of the camera, and therefore refreshingly unselfconscious. For this same reason, however, young children are also difficult to work with, because the photographer cannot control them. They move constantly and tire easily, especially under strong, direct lights. Have soft, diffused lights that are strong enough to allow you to use fast shutter speeds (at least 1/125 sec), because babies never keep still. Harsh lighting, with its strong contrasts of light and dark, is totally unsuitable. Instead, you should use either diffused daylight, bounced flash (see p. 150), or flash fill-in diffused with a handkerchief.

The expressions of babies are often so fleeting that you may not notice momentarily closed eyes or a slight frown, so shoot liberally to make sure of a good result. Avoid deliberately posing a child – a natural situation gives a better photograph. Choose a plain, light-toned background, and place babies in their mother's arms, or have her close by to give reassurance. In general, it is best to shoot on the child's own level – photographing from above can create a feeling of formality and distance. And, as distortion of a child's face is unpleasant, avoid using a wide-angle lens.

◁ **Mother and children**
This seemingly informal portrait was taken for a magazine. Although it looks like a family snapshot, it was carefully arranged to get exactly the right expressions and grouping. I had to take a number of shots because the children were restless. The light was dull so I used flash to fill in, diffused with a handkerchief.
Pentax 6×7, 75 mm, 1/30 sec at f8, Agfachrome 100R.

Catching the moment △
When I saw the baby turn I shot quickly – with toddlers you should be ready for moments like this. A simple background is often best, but try to choose one that has some depth or texture. Here, the rough stone steps also act as a compositional counterweight to the position of the child's body. The print was sepia toned (see p. 162).
Nikkormat, 50 mm, 1/125 sec at f11; FP4.

◁ **Brother and sister**
With two small children as subjects, you will have to shoot several frames to get a result in which the expressions and positioning of both are acceptable. Here, the toy on the sofa acted as a magnet for the toddler, and his older sister was invited to join in the game. Use a low camera position, on a level with your subjects, and set a wide aperture to put the background out of focus and make it unobtrusive. *Pentax 6×7, 105 mm, 1/125 sec at f5.6, Agfachrome 50S.*

Older people

There are two methods of portraying older people – either by deliberately emphasizing the attributes of old age, or by a more sympathetic approach which minimizes the signs of age but preserves the subject's personality. The main use of the first approach is for editorial purposes (see pp. 112–15) or exhibition studies. Contrasty, angled lighting will emphasize the blemishes and ravages of old age by boosting the apparent texture. Or you can follow the example of Richard Avedon who deliberately accentuates age in his quest for ultimate realism by using diffused, moderately angled lighting and increasing texture and contrast by underexposing and then overdeveloping his negatives.

Most portrait photographers prefer the more sympathetic treatment. In the past, portraitists retouched their large format negatives to remove all wrinkles and blemishes. This drastic treatment often totally destroyed the likeness. However, it is quite acceptable to use other, more subtle methods to subdue the signs of age. After all, most of us have an inaccurate, usually flattering mental image of ourselves. Use soft, diffused lighting – overcast daylight is often best. To lighten the face try overexposing a little (from a half to one stop). Avoid shooting from a low angle, as this tends to focus the viewer's attention on the sitter's neck and chin. You can further diffuse the final image by printing it through a diffusing element such as 15 denier nylon. This will retain the essential sharpness of the image, while subduing the skin defects.

Capturing frailty ▷
To show this woman's age sympathetically I emphasized it through her pose rather than by taking a close-up of her face. I used only daylight from the open doorway, and slightly overexposed her face to make it appear lighter and less lined.
Pentax 6×7, 75 mm, 1/30 sec at f11, Ektachrome 200.

Dramatizing age ▽
It is sometimes preferable to use slightly more dramatic lighting for portraits of older people. Here, the lighting comes direct from a single, large tungsten-halogen floodlight.
Pentax 6×7, 105 mm, 1/30 sec at f11, Ektachrome 160.

◁ **Using diffused light**
Soft daylight from one window lights the sitter. To preserve the balance of light, I did not use a fill-in on the right-hand side. As a result, part of the face was distinctly underexposed and I had to hold it back in printing (see p. 160). I made this print through 15 denier nylon for extra softness, see diagram right.
Hasselblad 500C, 80 mm, 1/30 sec at f11, FP4.

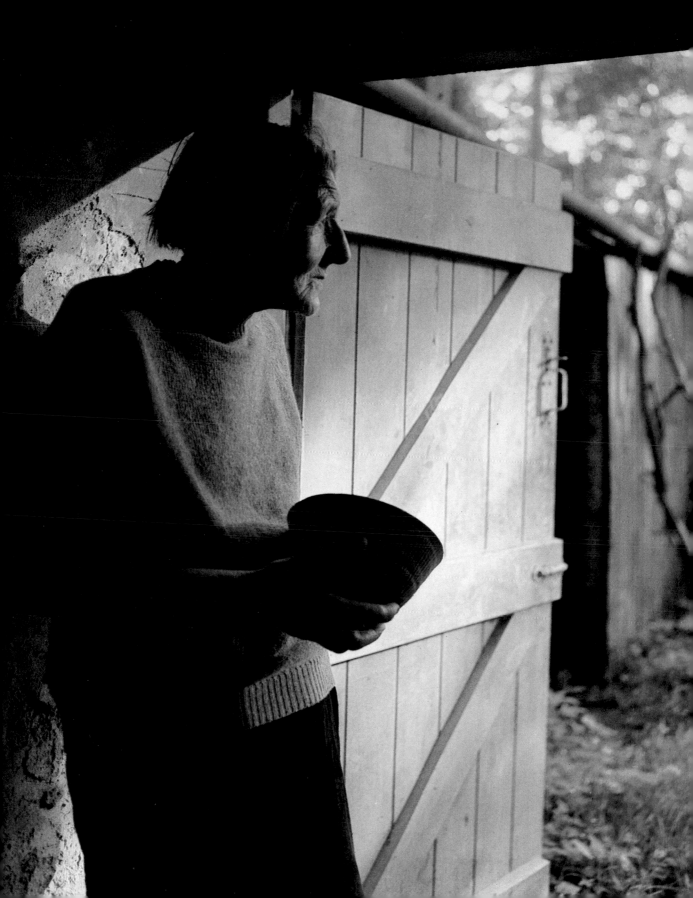

Groups of two

Taking a portrait of two people together can be twice as difficult as photographing only one. You should always try to establish or comment on the relationship between the two subjects. And the expressions of both sitters must be just right. If your pair are posing at some distance from each other, your eyes must constantly switch from one to the other. This means that you must keep up a high degree of concentration throughout the entire session. If you are taking the portrait indoors you will also have lighting problems – both sitters must be lit evenly and adequately. You can either arrange overall lighting, using a large flood or an umbrella flash to cover the whole area with diffused light, or you can light each sitter with a separate source, balancing both lamps (p. 32).

While it is difficult to watch both sitters and light them well, it is great fun to compose a picture with two people in the frame. There is greater scope for making an original arrangement and for creating dynamic balance (see pp. 22–4). It is best to keep the two heads at different levels – one higher than the other – because two heads in a row may look dull.

◁ **Composing a dual portrait**
When you photograph two subjects together, composition is very important. You are not only making a portrait of two people, you are attempting to create an interesting or beautiful image. Pose each of your subjects in a slightly different position – here, one sits and the other stands. Then try to "weld" them together visually – move around them with your camera, looking at them from different angles. If necessary, make some adjustments to their pose. Finally, you will arrive at the most interesting solution. Here, the two girls form a triangle.
Pentax 6×7, 75 mm, 1/60 sec at f11, Agfachrome 50S.

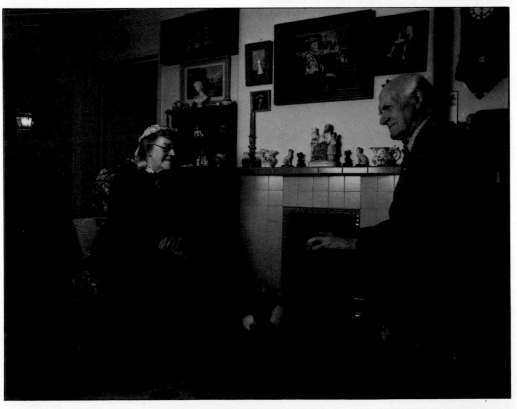

◁ **Photographing a couple**
I wanted to photograph the primitive painter Helen Bradley and her husband in their own environment. The cluttered setting made it difficult to select a viewpoint in which both heads were unhampered by background details. To create an interesting composition I chose an angle which makes one head higher and larger than the other. Although the man is larger in the frame, the viewpoint leads the eye toward Helen Bradley, the principal subject.
Pentax 6×7, 55 mm, 1/30 sec at f16, Ektachrome 160.

◁ **Shooting a double close-up**
This "postage-stamp" pose is a simple but effective way to photograph two people. The composition is based on the principle of continuity — the eye follows the line of the first profile, comes across the line of the shoulder to the second subject, then moves around the head back to the first face, see diagram below. The lighting is easy to arrange — you light the two subjects as if they are just one person. Place a diffused floodlight just in front of the face.
Pentax 6×7, 105 mm, 1/15 sec at f16, Ektachrome 160.

Larger groups

Good portraiture relies on a rapport between photographer and sitter, and also on the photographer's ability to control the subject without appearing to direct or bully him into pre-conceived poses. However, group portraiture is different. First, you cannot have a tête-à-tête with several people at once, and, second, it is impossible to control the movements and expressions of all the subjects, especially if some are children. Since it is highly unlikely that a large group of people will assume, miraculously, an orderly and pleasing arrangement, the only solution is to apply strict control from the start.

Select a location which is interesting visually but fairly uncluttered, so that attention is focused on the sitters, not their environment.

Place your camera on a tripod, and stop down well. Depth of field must cover the whole group, so in weaker light use a fairly slow shutter speed and ask your sitters to stay still for the exposure.

Avoid regular or symmetrical arrangements – these give dull, predictable results (look at most school or team pictures). Place people at different levels and at varying distances from the camera, so that their heads never form a straight line. And ask them to assume different postures and attitudes. Try to be as inventive in your groupings as possible – adding interest by isolating some figures, and forming others into a small unit. For inspiration, you might like to look at seventeenth century Dutch portraits, especially those by Hals and Rembrandt.

◁ **Coping with numbers**
Controlling a large number of sitters, especially if some are children, is practically impossible. Here, I asked some of the subjects to sit next to the television set, and told the rest to huddle close to their "spiritual mother" Erin Pizzey. The children kept moving all the time, and I had to remind them to keep still. I took several shots to get this picture. *Pentax 6×7, 55 mm, 1/30 sec at f11, Tri-X.*

Group in close-up ▷
This composition was carefully arranged in a symmetrical manner to unite the idiosyncratic appearances of the members of this musical group. I used one large flood at the left, another reflected from a screen to act as a fill-in, and a third lamp on the background. *Pentax 6×7, 75 mm, 1/30 sec at f16, Ektachrome 160.*

Formal arrangement △
For this formal shot of a Spanish family, I positioned each person separately, asking them to pose in a certain way. By the time the whole picture was set up and I was ready to shoot, all the subjects had relaxed slightly, giving the picture a natural look. The sitter's heads are arranged to form a distinct semi-circle, see diagram above, with the verticals of the windows and doors breaking the visual monotony.
Pentax 6×7, 55 mm, 1/60 sec at f16, Agfachrome 50S.

Weddings and ceremonies

Weddings and ceremonies are special occasions not only for the participants but also for the photographer. This is the one time that you should put aside your own style or creative attitudes and use all your skills to take the traditional set of photographs. These portraits will be treasured by the subjects, so they should be shot exactly as they wish. Some photographers try to enliven wedding photographs by shooting from different angles, or using grainy films or some other special technique, but their efforts are rarely appreciated. Weddings and ceremonies are steeped in tradition, and portraits that record them should reflect this.

The principal portrait at most ceremonies is the group shot. At a wedding, arrange the group with the bride and groom in the center. Outdoors, diffused, overcast light is best. If the sun happens to shine use a flash fill-in to soften contrast. Many photographers also use flash on a dull day to add a touch of sparkle. Indoors, use strong, simple tungsten lighting. After shooting the formal portrait, take a few snapshots with a 35 mm camera — for example, photograph the newly-married couple getting into the automobile or being showered with confetti. Not all churches allow photography during ceremonies, so you should always ask permission in advance. If possible, take up a high position in order to get a clear view. Whenever you shoot portraits on special occasions you should follow these rules for simple, traditional results.

Family group ▽
This Sabbath scene was a special occasion — a family gathering on the day before a barmitzvah. For occasions of this kind use a simple but strong illumination in order to record expressions. Here, I used a strong tungsten lamp placed slightly to the left of the camera. The wide-angle lens allowed me to include as much of the festive table as possible in a small dining room.
Nikkormat FT2, 24 mm, 1/30 sec at f11, Agfachrome 50L.

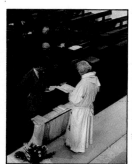

◁ **Formal individual portrait**
The formal shot of the bride should be as glamorous and romantic as you can make it. Use high key lighting, especially if the bride is dressed in white. Avoid direct lights and harsh shadows.
I used umbrella flash for this portrait.
Pentax 6×7, 55 mm, 1/30 sec at f11, Ektachrome 200.

Shooting in the church △
If you have permission to photograph in the church try to use a high position. Flash is inappropriate — use fast film and give a long exposure if necessary.
Nikon FE, 80–200 mm zoom, 1/30 sec at f4, Ektachrome 400.

Unexpected moments △
After the formal portraits are taken the participants will begin to relax, and it is always worth having your camera at the ready to catch moments like this.
Nikon FE, 50 mm, 1/125 sec at f11, Ektachrome 400.

Action shots

Action portraits are shots which capture your subject in motion. The focus of attention *must* be the expression on your subject's face. You are aiming for a portrait, not just a picture that conveys a sense of action. With fast film and a motor drive there should be no difficulty outdoors. But when taking portraits of someone performing or working indoors there are a number of problems. Combined with natural light, flash tends to falsify the mood of the situation, and with stage lighting you will have color balance problems. Also, at some events, flash is forbidden. As an alternative, use fast film, or a tripod and longer exposures.

You can make use of the blur that movement and long exposure create to give the impression of action to your portrait. However, if you want to stop movement it is important to wait for the peak of action. Even in a fast action there is usually a fraction of a second when the subject is still – a dancer, for example, will seem motionless at the highest point of a leap. If you press the shutter release at this moment you may be able to catch a sharp image with a shutter speed as slow as 1/8 sec. In situations where the lighting is very poor, try "pushing" film – underexposing it and then extending the development time.

◁ **Blur for effect**
In general, flash is not allowed at performances so you will have to push your film, set a slow shutter speed and wide aperture, and use a tripod to get a good exposure. Some areas will show blur, but this can often add to the impression of action.
Pentax Spotmatic, 50 mm, 1/15 sec at f3.5, Ektachrome 160 pushed 2 stops.

◁ **Using stage lighting**
This shot was taken in a theater where flash was forbidden. Therefore, I used a tripod and a slow shutter speed, catching the dancers at a moment when their movement had stopped.
Pentax Spotmatic, 50 mm, 1/15 sec at f4, Ektachrome 400.

Coping with lighting problems ▷
Because my subject was quite still during his work, I was able to use a slow shutter speed to emphasize the spray of the sparks. I used a single tungsten floodlight and tungsten film. Some daylight from outside has given a blue cast to part of the picture, but this adds to the mood.
Pentax 6×7, 75 mm, 1/30 sec at f5.6, Agfachrome 50L.

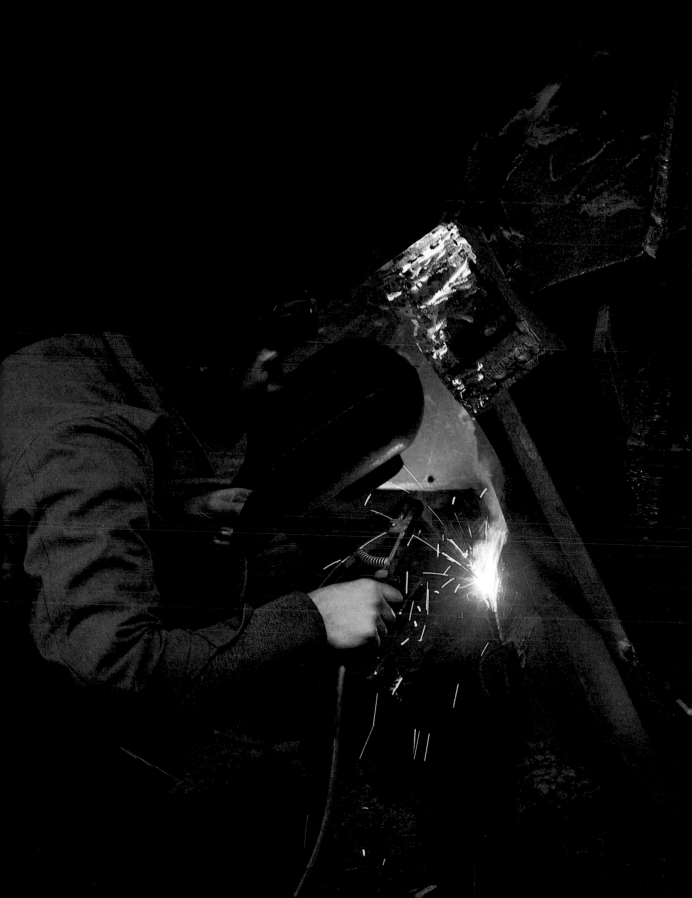

Stopping action ▷
I used fast film and a motor drive on my 35 mm camera to catch the peak of the action. On a championship tennis court it is often difficult to get a clear background behind the player as well as getting a good, strong expression and the right body position all at the same time. Try to sit near the front because it is best to shoot from a fairly low angle, using the scoreboard as a plain background.
Nikon FE, 80–200 mm zoom, 1/250 sec at f16, Plus-X.

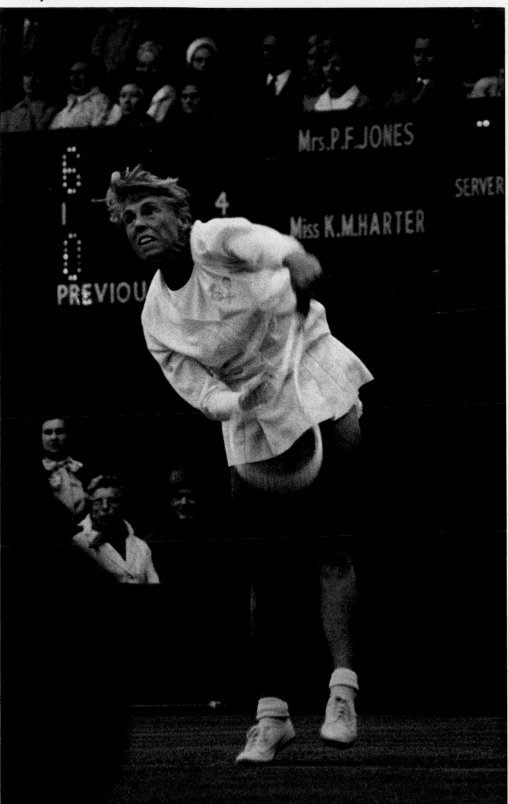

EXPERIMENTING WITH STYLES

In the past, many famous portraitists have deliberately established a personal, original style, and often their fame rests on a widespread public recognition of this individual style present in all their pictures. Yet style can be very restricting. Why limit yourself to one, often narrow, manner of representation when the subject matter is so rich and diverse, and when differences between individual sitters are often so fundamental? The answer is simple: first, it is undemanding to keep to a certain formula that has already proved successful; second, it makes economic sense, since people start demanding to be photographed in this well-known style. However, subjects vary so much that a formula approach, which treats each subject in the same way, may fail to show the individual personality of the sitter. On the other hand, each photographer is also an individual, and, even if you would like to be totally objective, in order to fulfil the role of a portraitist you must be an interpreter – a subjective image-maker. The answer lies in a compromise. To be a good portraitist you must always consider the sitter first, but an element of your personality – your style – must also be a part of your work. One of the best ways to learn about portraiture is to try your hand at a wide range of styles and master a number of them, so that you are able, in time, to develop your own way of seeing and interpreting. For this reason, this section considers the possibilities of style in sequence portraits, humorous and candid shots, and instant snapshots and then ends with portraits taken in the manner of famous photographers. The following selection of different images is intended to help you to understand the scope and variety of a number of styles of portraiture.

Trying different styles

The early photographers claimed that the camera could not lie, that it documented the reality in front of it, and recorded without bias. Fortunately this is not the whole story – the camera is also a great interpretive instrument which will record precisely what the photographer wants it to record.

The pictures here and on the following pages were all shot in two sessions and are all portraits of the same girl. However, each one has been photographed in a different style,

proving that a thoughtful photographer can achieve a subjective interpretation of most sitters at will. The variation is arrived at not just with the camera alone but by using different lights, color schemes, arrangements, environments, props, make-up and expressions. The combination of all or some of these elements creates a different mood each time.

Apart from make-up, which can alter the face considerably, light is the most important factor in changing appearance. A face lit by hard,

The femme fatale ▷
Some oriental carpets, a strange turban, a carved chair, and a little make-up transform my sitter into an oriental femme fatale from the silent movies. I used one tungsten-halogen lamp fitted with an amber filter in order to give a warm color cast.
Pentax 6×7, 75 mm, 1/15 sec at f16, Ektachrome 160.

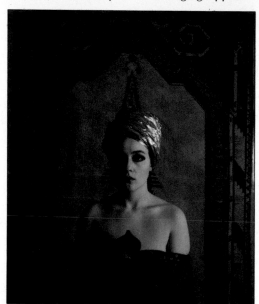

A ladylike portrait ▷
For this soft, romantic image my subject wore hardly any make-up. The main lighting was diffused daylight. Fill-in on the left side was provided by a tungsten floodlight fitted with a blue conversion filter, see diagram below, to maintain the color balance for daylight film.
Pentax 6×7, 75 mm, 1/8 sec at f16, Ektachrome 200.

◁ **The clown**
Simple props — a red eiderdown, and a piece of silk together with strong make-up on eyes and cheeks — turn the subject into a clown. I took this shot in the studio, using tungsten floodlighting. In order to keep the whole picture warm in color I used a red gelatin filter over the spot that lit the background.
Pentax 6×7, 105 mm, 1/15 sec at f16, Agfachrome 50L.

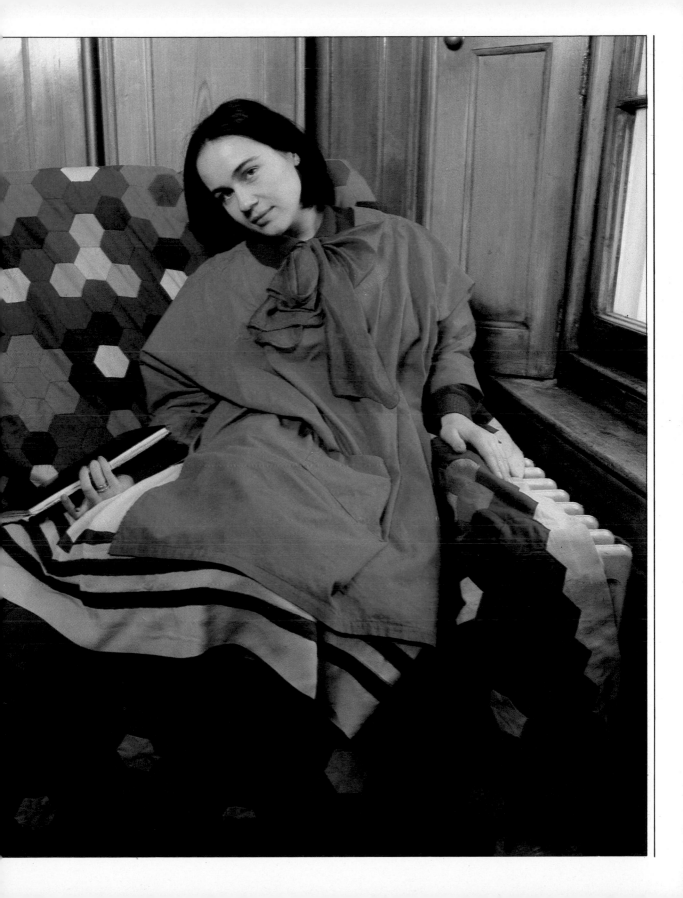

direct light looks very different to the same face illuminated by diffuse, delicate light – the mood switches instantly from severity to softness. For the same reason, it is very important to watch how the light illuminates the sitter's whole figure, and his or her surroundings. The overall effect of light has been used to give the picture on the facing page a period atmosphere, and to add a touch of romanticism to the shot on p. 97. Another important factor in creating mood is pose and expression. The hard, direct gaze in the shot below contrasts very strongly with the dreamy posture and expression in the photograph on the facing page. And the odd position of the girl's clown-like head adds to the strange quality of the picture on p. 96. Contrast this with her graceful pose in the portrait on p. 97. Finally, the props you choose and the environment in which you place your subject will also help you to control your result. For example, the house chosen as a setting for the picture on p. 99 creates a period atmosphere, whereas the props used for the shot on p. 96 give it an oriental mood.

Creating a period mood ▷
I took this photograph in a house in London which was once occupied by a Pre-Raphaelite artist. The long white dress helps the transformation. To enhance the atmosphere I wanted to retain the feeling of existing light on the room's wooden paneling. However, I had to bounce a flash off the ceiling to light my subject's face.
Pentax 6×7, 55 mm, 1/15 sec at f16, Tri-X.

◁ **A "modernist" portrait**
This composition uses stark black and white, with hardly any half tones, for a futuristic look. I used two background papers — black on one side, white on the other. Lighting was hard, with very little fill-in, see diagram below. And I overexposed the film slightly to give an overlit effect on the face. To help the stark mood the sitter made up her eyes with dark shadow and used a strong red lipstick.
Pentax 6×7, 75 mm, 1/60 sec at f16, FP4.

Sequence portraits

A sequence portrait is a portrait in depth. It is a succession of separate pictures designed to be seen together as one portrait. Every image in the sequence should show a different aspect of the personality of the sitter. Although a single portrait can reveal a great deal about its subject on many different levels, it is often impossible to present the viewer with sufficient information on the sitter's character, temperament, professional involvement, and home life in one picture. A sequence portrait can perform this function admirably.

Making a sequence usually involves photographing the subject on many occasions, preferably over a period of several days, portraying him in different aspects of his everyday life. You might choose to assemble a "day-in-the-life" sequence, or put together a series of pictures that show the sitter in different moods, activities and situations. The final presentation of the sequence can also vary – for example, you can mount a "mosaic" of small prints of different shapes and sizes on a single sheet of mounting board, or present the collection as a book with each page devoted to a different facet of your subject's life or character.

Choosing a theme △
The pictures on these pages form a sequence portrait of Daley Thompson, the Olympic decathlon gold medalist. I followed his activities for several weeks to take this series of pictures. Sequence portraits demand that you "stalk your prey" all the time – observing and shooting. After a while your subject will get so used to seeing you that he or she will no longer be aware of your camera.
Nikon FE, 50 mm, 1/125 sec at f11, FP4.

◁ **Looking for facial expressions**
In order to build a successful sequence you must try to capture expressions. For this shot I placed my camera on a tripod and focused, waiting for exactly the right expression of concentration on the subject's face before pressing the shutter release.
Nikkormat FT2, 80–200 mm zoom, 1/125 sec at f11, FP4.

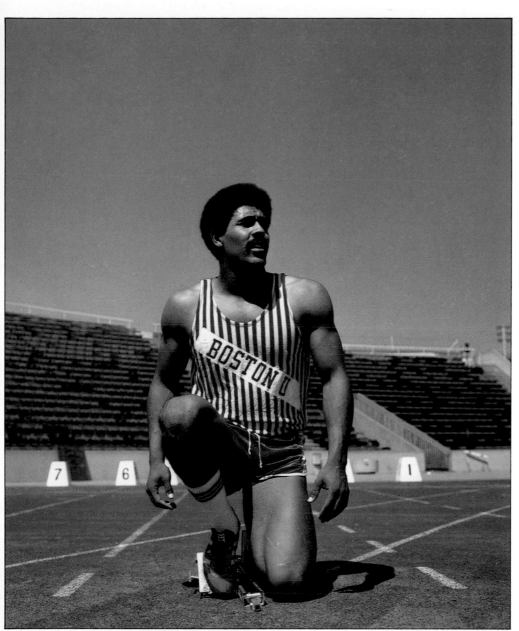

◁ **Low viewpoint**
I took this shot from a low position — in fact, I was lying on the ground — so that the empty stands and the sky provide an excellent background for the figure of the athlete. The low viewpoint also tends to exaggerate the subject's size and stature.
Pentax 6×7, 75 mm, 1/60 sec at f16, Ektachrome 200.

Using a motor drive ▽
I used a motordrive to get this picture. From the succession of frames I took while my subject was in the air I chose the shot that showed the most interesting position during the jump.
Nikon FE, 50 mm, 1/250 sec at f16, Ektachrome 200.

◁ **Showing the subject's possessions**
Here, Thompson displays all the equipment he needs for the decathlon. These were carefully arranged on the field to provide a triangular pattern with the athlete at the apex of the composition.
Pentax 6×7, 55 mm, 1/30 sec at f22, Ektachrome 200.

Humorous and candid portraits

Humor is an elusive commodity – what makes one person laugh may not even raise a smile with another. A photographer of humor is instinctively aware of all the small quirks and oddities of human behavior, and will react instantly when these moments occur. Often, humorous portraits are best if they are candid shots, taken when the subject is completely unaware that he is being photographed.

One of the foremost humorists of the camera is Robert Doisneau. He discovers many funny situations, and even creates them – as in his series showing various people's reactions to a painting of a nude in a shop window, captured with a hidden camera. Another well-known exponent is Elliott Erwitt. Neither of these great photographers is in any way cruel. It is important to be able to make gentle fun of your subjects, but not to ridicule people.

A photographer is usually within his rights to photograph people in public places without asking their permission. The only injunction is on publishing photographs of a defamatory nature. If you make someone look so ridiculous that it may be detrimental to his character or reputation, you risk a law suit.

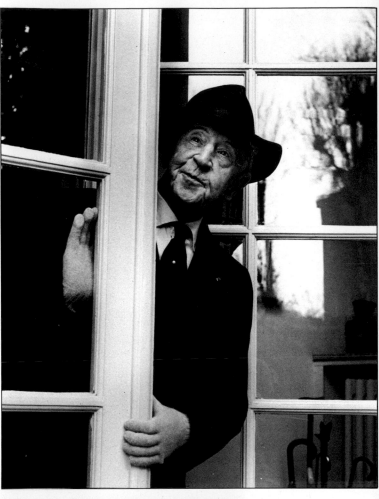

Taking a candid picture ▷
I noticed the saleswoman in a street market through a crowd of passers-by, and shot quickly so that she did not spot my camera. The best way to photograph without being noticed is with a twin-lens reflex camera — point it at the subject sideways and look the other way. The subject will not notice the lens peering at him, because the photographer will appear to be interested in something in the opposite direction. *Mamiyaflex, 80 mm, 1/125 sec at f11, Tri-X.*

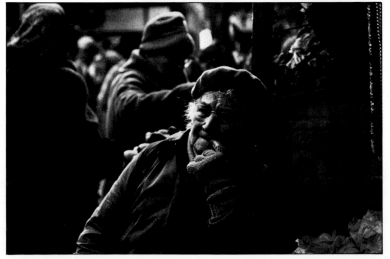

Gaining the subject's cooperation △
This gently funny moment was captured during a session at the subject's apartment. He had a sense of fun, and accepted the photographer's suggestion that he should peep round the door. *Hasselblad 500C, 80 mm, 1/125 sec at f8, HP5.*

Comic groupings ▷
An unusual combination of people often creates a funny picture. This family group is amusing because of the incongruity of the scene — one of the sons is sporting a full uniform, the other nothing but a towel. *Pentax 6×7, 55 mm, 1/60 sec at f16, Tri-X.*

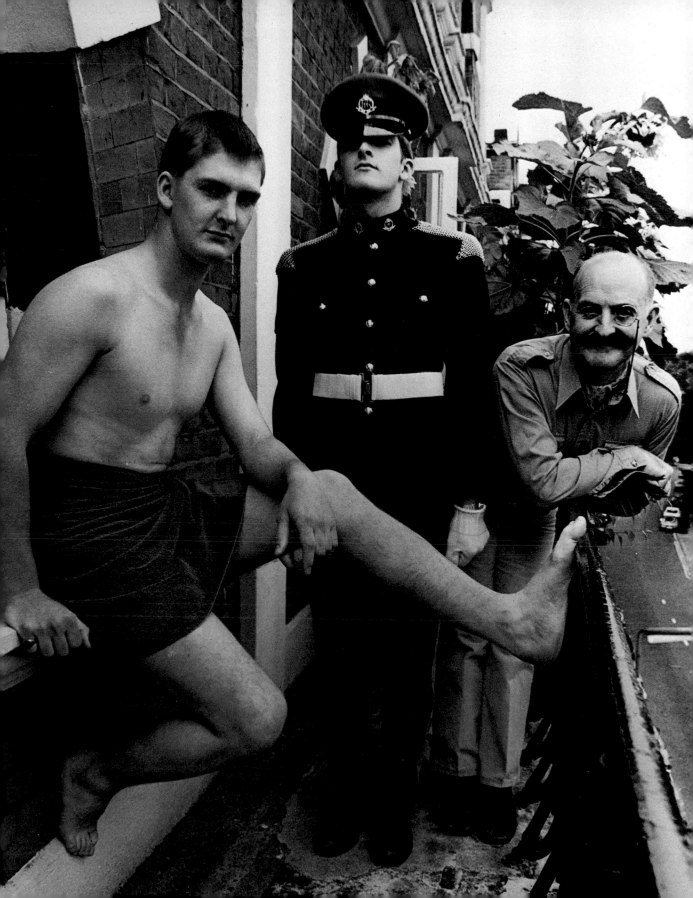

Snapshot and instant pictures

The snapshot is no longer totally despised by serious critics of photography. On the contrary, some consider it a valid form of portraiture, mainly because snapshots are most often taken by close members of the family, and are usually very natural and spontaneous.

There is no better snapshooting camera than an SX-70 instant picture camera. The kind of incredulous awe that greeted the first demonstration of the Daguerreotype in 1839 is still present when you watch the square print emerge from the bottom of the SX-70 camera. Suddenly the picture begins to form, and in about one minute a complete full color image appears right in front of your eyes. The controls on the special cameras are limited – no adjustment of f stop or shutter speed is possible, and the lens is fixed. Nevertheless, it is feasible to alter the overall exposure slightly using the camera's lighten/darken control.

In spite of the constraints of the system, which precludes any printing controls, some photographers do achieve highly artistic results from Polaroid instant materials. Many use peel-apart film because it fits special backs for 2¼ square or large format cameras, allowing greater control of the image quality. Marie Cosindas – a noted exponent of instant portraiture – gives Polacolor film a fairly long exposure, and then prolongs the development time. You can also create interesting effects not from the result but from the by-product that is usually thrown away. Transfer the peel-away part with the residual image onto an ordinary sheet of paper, and thoroughly blot it to obtain an unusual, impressionistic image.

◁ **Snapping the reaction**
Your subject can examine an instant portrait almost immediately, and this is a good opportunity to take another shot. With some earlier cameras it was not possible to shoot close-ups, but the new version is able to take pictures as close as 1 ft (7 cm). Take care that the flash does not blind your subject.
Polaroid SX-70 Alpha, SX-70 Time Zero Supercolor.

◁ **Getting the right exposure**
When a large area of the picture is in shadow, the result tends to be over-exposed. You can alter this by adjusting the lighten/darken control on the camera.
Polaroid SX-70 Alpha, SX-70 Time Zero Supercolor.

Polaroid SX-70 Alpha ▷
This model is a sophisticated example of the instant picture camera. It offers SLR viewing, automatic focusing on the sonar principle (with the option of manual focusing), and an exposure compensation device. A few seconds after you release the electronic shutter, the print emerges from a slot at the base of the camera and starts to develop. The sensitive film sandwich used with this camera produces a picture of full intensity 60 sec after ejection.

◁ **Instant portraiture**
If you give the same attention to your instant pictures as you give to your 35 mm portraiture, choosing the background and the sitter's pose carefully, you can create a very effective portrait.
Polaroid SX-70 Alpha, SX-70 Time Zero Supercolor.

Special effect portrait ▷
There is an element of chance in this method of transferring the "reject" part of an instant peel-apart image onto ordinary paper. You will never get the entire picture, only fragments of it, so choose simple, uncluttered images.
Polaroid 600, Polacolor II.

The professional's methods

Photography is an ideal medium for recording the elusive gesture or smile which reveals the essence of a personality. But this does not mean that anyone with a camera can take a good portrait. One way of understanding portraiture better is to study and practice the methods of the masters as a starting point for developing your own techniques.

The main aim at the start of a session is to get the sitter to relax and reveal his or her "real" face, not the "artificial" one put on for the outside world. The approach of the masters of the medium varies greatly. Bill Brandt, for example, believes in leaving his sitters alone, and not talking to them much, if at all. The idea

is that they eventually get bored, forget the photographer's presence and become themselves. Others like Yousuf Karsh take the opposite view. He conducts a lively conversation so that his sitters cannot become bored.

However, even when they relax, most people manage to hold back quite a lot. For this reason some portraitists devise special methods to force their sitters to drop the mask. Philippe Halsman made his sitters jump – his theory was that you cannot possibly control your features while airborne. Irving Penn, on the other hand, placed boxes in an empty studio, and asked his sitters to pose on them, so that they revealed themselves by the posture they chose.

▽ **Portrait in the style of Richard Avedon**
Avedon usually confronts his subjects with a large view camera – often 8×10 ins (20×25 cm). His personal technique involves using soft, diffused lighting and underexposing then overdeveloping Tri-X film to boost contrast. Here, I gave one stop underexposure and increased the development time by one third. The result is a very strong, textural image with every pore and wrinkle standing out.
De Vere 5×4, 150 mm, 1/30 sec at f32, Tri-X.

Portrait in the manner of Bill Brandt ▷
Every image Brandt produces is different, tailored to the requirements of the individual sitter. But many show a personal preference for a dramatic low key effect. Usually he takes his sitter to a carefully selected spot which he feels suits the subject's character. He mainly uses a 2¼ square camera and existing light. He often improves or alters his originals by skilful print manipulation.
Mamiyaflex C3, 65 mm, 1/30 sec at f16, Tri-X.

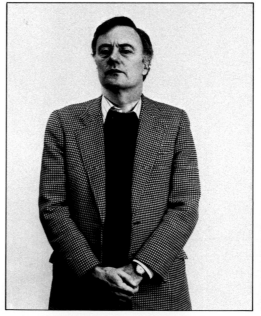

Imitating the style of Philippe Halsman △
Presidents, princes and famous actresses jumped for Halsman. Sometimes he shot his subjects in his studio against a white background, as here, but often he made them jump just anywhere. He used strong flash lighting and a Polaroid camera. Here, I used two flash heads, one on either side of the subject.
Pentax 6×7, 55 mm, 1/30 sec at f16, Tri-X.

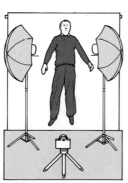

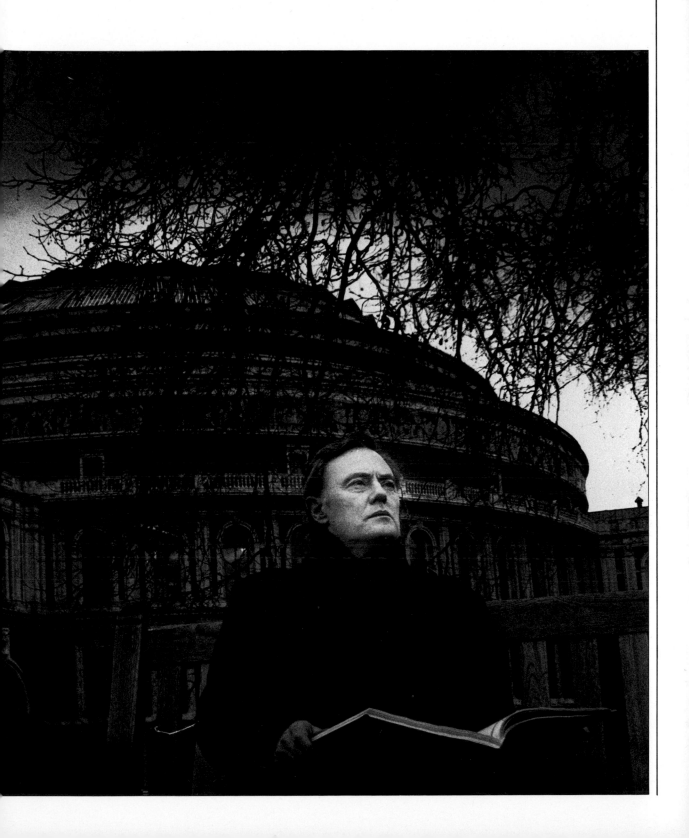

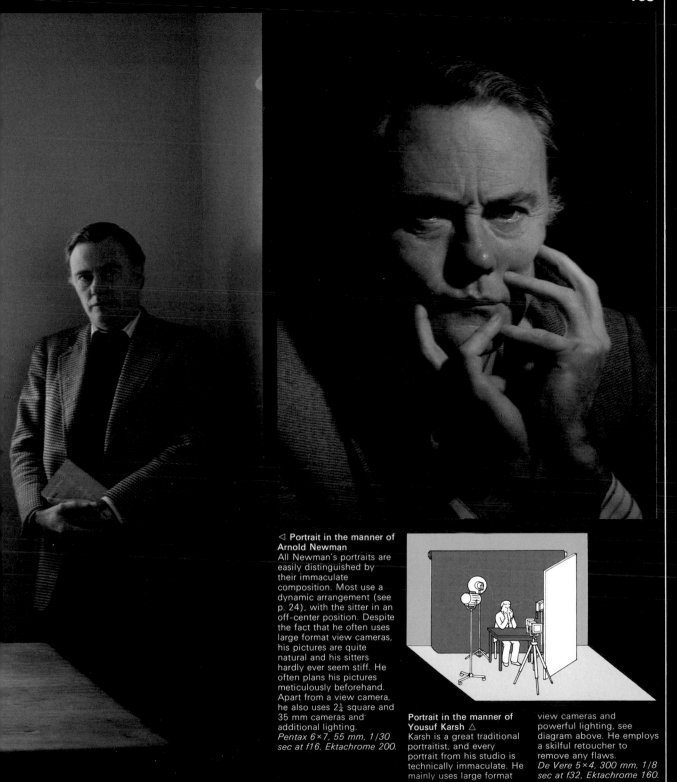

◁ **Portrait in the manner of Arnold Newman**
All Newman's portraits are easily distinguished by their immaculate composition. Most use a dynamic arrangement (see p. 24), with the sitter in an off-center position. Despite the fact that he often uses large format view cameras, his pictures are quite natural and his sitters hardly ever seem stiff. He often plans his pictures meticulously beforehand. Apart from a view camera, he also uses $2\frac{1}{4}$ square and 35 mm cameras and additional lighting.
Pentax 6×7, 55 mm, 1/30 sec at f16, Ektachrome 200.

Portrait in the manner of Yousuf Karsh △
Karsh is a great traditional portraitist, and every portrait from his studio is technically immaculate. He mainly uses large format view cameras and powerful lighting, see diagram above. He employs a skilful retoucher to remove any flaws.
De Vere 5×4, 300 mm, 1/8 sec at f32, Ektachrome 160.

**Portrait in the style of
Irving Penn** ▷
One of Penn's devices to
make his sitters reveal
themselves was a narrowly
angled corner — about 60° —
into which they had to
squeeze. Penn is also a
great believer in north light.
In fact, he even constructed
a travelling tent-studio
which used only this light.
Here, I used a soft top
skylight as a "poor
man's" north light.
*Pentax 6×7, 55 mm, 1/15
sec at f22, Tri-X.*

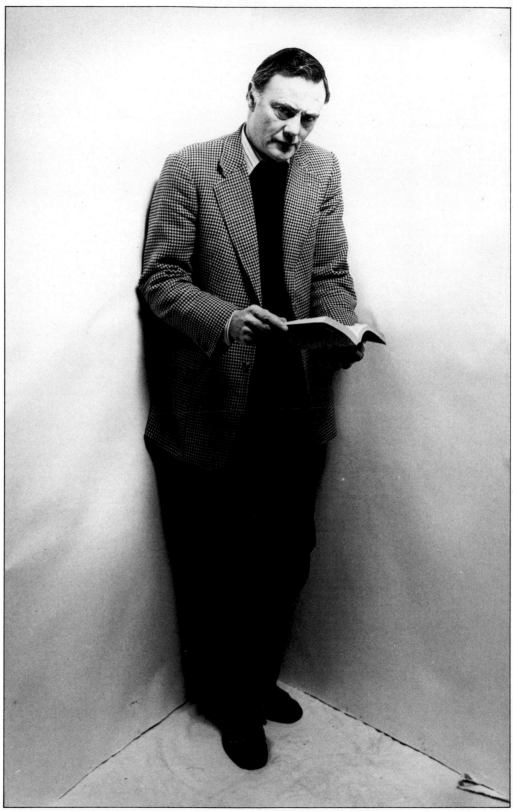

CONTEMPORARY PORTRAITURE

Tastes are subject to constant fluctuations with the passage of time. Photographic portraiture continually undergoes changes in line with the changes in social attitudes and beliefs. Traditional studio portraiture was based on the perfection of technique, and it established a formal, classical style posing which symbolized stability and serenity. But this is not very relevant to the world today, and therefore it is no longer a universally accepted style. The development of modern communication methods, with pictures electronically and instantaneously transmitted from one continent to another, has made us look at the nature of images in a different way.

In order to be relevant, contemporary portraiture must reflect all the new aspects of life. Portraiture cannot remain unchanged when its subject has changed so radically; it must represent modern men and women as they are and not as they used to be. People live a much more demanding existence than their grandparents did, and they are subject to greater tensions and stresses. Where appropriate you should try to reflect all this in your images. Interpretive portraiture which explores the personality of the sitter, glamor shots which embody contemporary attitudes to beauty, and the freer photojournalistic pictures are obviously more in tune with modern life than traditional styles. But this does not mean that only currently fashionable styles are valid. The portraitist may also be required to cater for the minority, for whom formal styles may be more apt.

Photojournalism

Portraiture for the media first developed into a distinct style in the German illustrated magazines of the 1930s, and blossomed in the 1940s and 1950s in *Picture Post* and *Life* magazines. This type of portrait aims to catch the eye of the viewer as he or she turns the pages. The photographer may have to cooperate with or be directed by a picture editor, who may give specific instructions on subject approach. Shooting usually takes place in the sitter's own environment.

When you start your session, begin by selecting the most attractive or unusual location. Since you have to offer the editor some choice, it is advisable to use more than one set-up. Photograph a writer, for example, in his or her study, or at the scene of one of the novels. Avoid static poses – pictures should be lively and informal. Do not include too much in a picture, and think twice about placing your subject centrally – an off-center composition is always visually stronger. Whenever possible, try to give the viewer something out of the ordinary, either by shooting from an unusual angle or by employing an original treatment. A touch of humor (see pp. 102–3) is always welcome, but you should beware of ridiculing your sitter – it may alienate future subjects. And always make sure that you choose a style and approach for your photojournalistic portrait that relates to your sitter's identity, character or occupation.

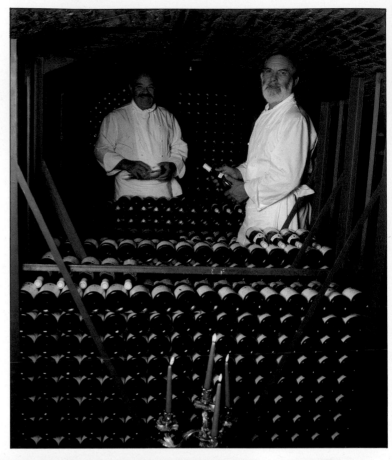

Making use of an unusual pose ▷
In editorial photography it is essential to catch the reader's eye and hold it. Here, I used an eye-catching pose and the visual similarity between the statue and the sitter as a compositional device to attract the eye.
Pentax 6×7, 55 mm, 1/30 sec at f16, Ektachrome 200.

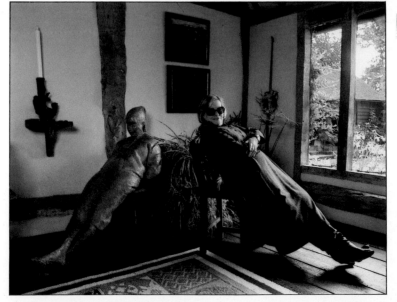

Lighting a dark setting △
Interesting locations are often difficult to light. I used a tungsten-halogen lamp, see diagram above, for this portrait of two restaurateurs in their cellar. Direct flash would have created excessive reflections in the bottles, and the black walls ruled out bounced flash.
Pentax 6×7, 55 mm, 1/15 sec at f11, Ektachrome 160.

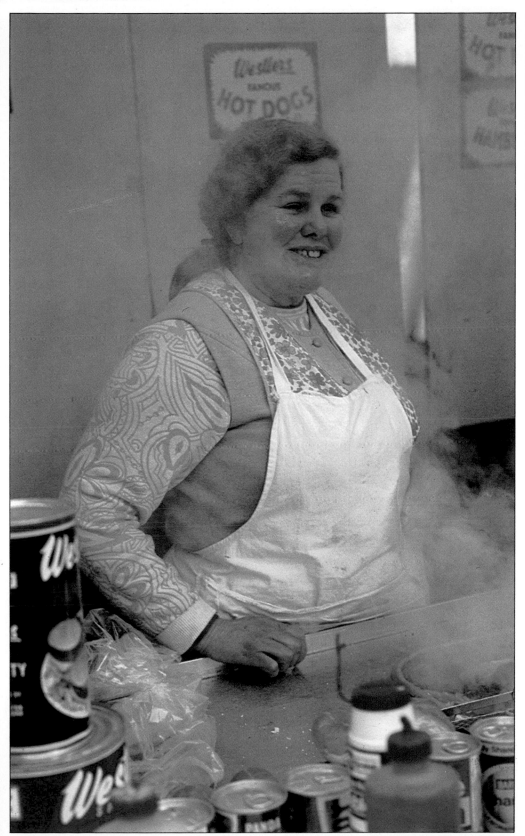

◁ **Capturing familiar sights**
This picture was shot for a photojournalistic story on London's Sunday markets. For this type of work try to find interesting people — in particular, individuals who seem to fit a stereotype. The viewer generally prefers a photograph which confirms his ideas to one which shatters his illusions. This subject fulfills the typical image of a cheerful street market vendor.
Pentax Spotmatic, 50 mm, 1/125 sec at f5.6, Agfa CT18.

The quality of reproduction is beyond your control – only high-quality magazines, using expensive paper, will successfully reproduce the subtle tones of black and white prints. On coarser materials, such as those used by newspapers and most large circulation magazines, most of the details will be lost. Consequently, photographs must be simple and strong in tone as well as very sharp. In practice, it is best to make a slightly harder than normal print, otherwise your picture may appear too soft and gray when reproduced. With color shots most printers prefer a fully saturated image, so you should have an accurate exposure. Unlike negative film, which has some latitude, overexposure will destroy highlight areas.

You should always give the editor a choice of formats – both horizontal and vertical, because he may require a specific picture shape to fill an available gap. More often than not, your picture will be trimmed, or "cropped" so leave some space on all sides.

Shooting a commission ▷
A magazine will often commission a photographer to illustrate an existing article, giving him a brief indicating what kind of picture would be most suitable. At the time I was asked to take this photograph, Diana Rigg was appearing in a popular television serial in an extrovert, bouncy role, and I was asked to reflect this. I set out to create a lively, informal picture. I used two photofloods to light my subject, see diagram below, and waited for a relaxed moment before I pressed the shutter.
Mamiyaflex C3, 65 mm, 1/125 sec at f5.6, Tri-X.

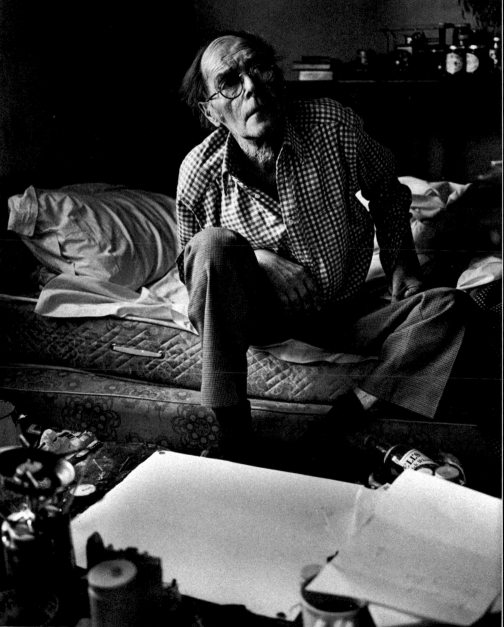

◁ Photographing a tragic situation
Photojournalists often have to capture the tragic aspects of life. Try to be sensitive and sympathetic to your subject without hiding the true nature of the situation. This picture typifies the unhappy final months of the painter Roger Hilton. When I took this photograph in his tiny cottage in Cornwall he was already very weak and mostly confined to bed. He could only paint small gouaches, and frequently the sheet of paper next to to his bed remained blank. I used only available light, see diagram below.
Pentax 6×7, 55 mm, 1/60 sec at f11, Tri-X.

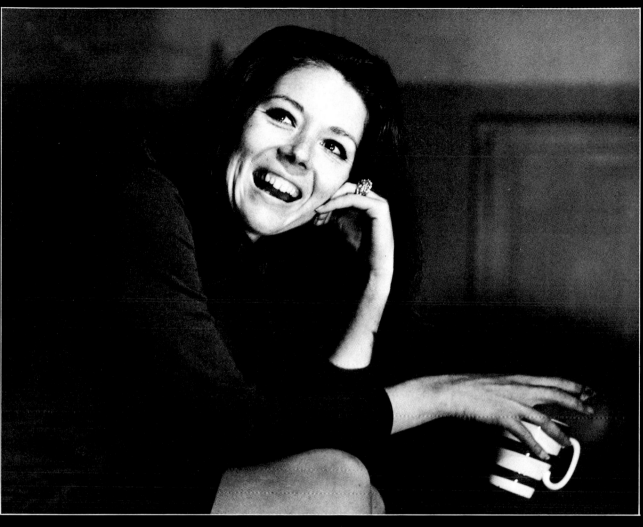

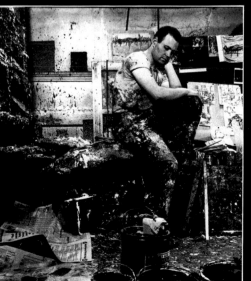

◁ **Including an interesting environment**
The painter Frank Auerbach lived and worked in one large room with most of the space totally devoted to painting. This picture captures the mood of his environment – the painter seems to become an integral part of his own painting.
Mamiyaflex C3, 65 mm, 1/30 sec at f11, Tri-X.

Photographing in the street ▷
Do not hesitate to photograph children in the street – they are usually fascinated by cameras. I took this shot in Portobello Road to illustrate an article on the London street markets.
Mamiyaflex C3, 80 mm, 1/125 sec at f8, Plus X.

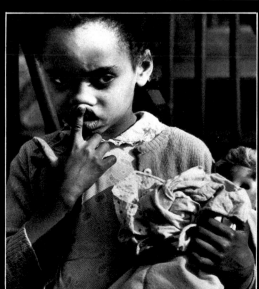

Interpretive portraiture

An interpretive portrait should be the most complete portrayal of the sitter that the photographer can achieve, not only capturing physical appearance, but, more importantly, revealing fundamental character traits. In an ideal interpretive portrait everything you include in the picture should have some relevance to the sitter. Not only the elements of the sitter's environment, but also the principal colors and tones of the portrait, the position of the sitter and his whereabouts within the frame, his pose, gestures, and facial expression, are all part of the interpretation. In practice, you will probably concentrate on only one or two important aspects – the sitter's attitude to life, his profession, temperament, or affectations. You must convey at least one important, basic idea about the sitter very strongly.

The first step is to undertake preliminary research and find out all you can about your subject. Once an overall image of his personality emerges, you will be able to decide on the location which best suits your subject. Look at his home or place of work, and then examine other locations. For example, you may be able to convey the personality of an architect through his buildings, and an explorer may come to life in an empty, open space. Avoid stylization of your own; instead you should vary your approach according to the character of your sitter.

There is little doubt that the most effective environment for an interpretive portrait is a natural setting. It is far more difficult to achieve a meaningful interpretation in the alien (for the sitter) situation of the studio. Once

Portraying an individual's "style" ▽
The deliberately eccentric and outrageous sculptor Andrew Logan bought a large model castle from a bankrupt store and installed it in his home. I used one flood to photograph him through the castle window, see diagram below, creating a bizarre, stylized image.
Pentax 6×7, 75 mm, 1/15 sec at f16, Agfachrome 50L.

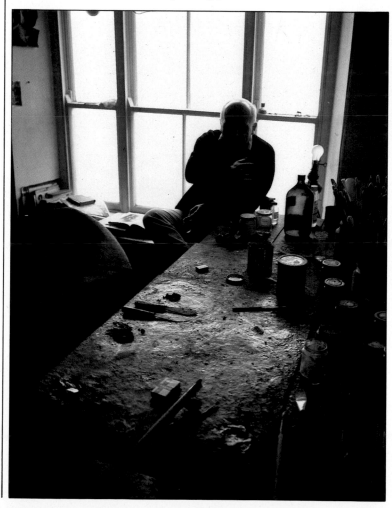

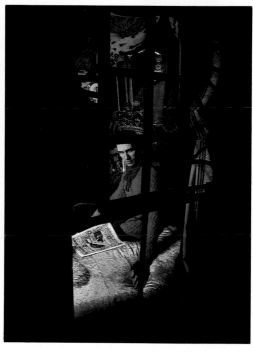

◁ **Lighting for effect**
I shot the painter Karl Weschke against the light to give the impression of an oil-painted canvas. The high viewpoint eliminates most of the strong, direct light from the window. The sitter's face is slightly underlit – flash fill-in would have lessened backlighting.
Pentax 6×7, 55 mm, 1/15 sec at f16, Agfachrome 50S.

Using the sitter's own environment ▷
One tungsten-halogen lamp almost directly in front of the subject increased the brilliance of the laboratory glass (the reflective surfaces ruled out flash). Because I wanted to use daylight film, I fitted a blue conversion filter over the lamp.
Pentax 6×7, 55 mm, 1/30 sec at f11, Ektachrome 200.

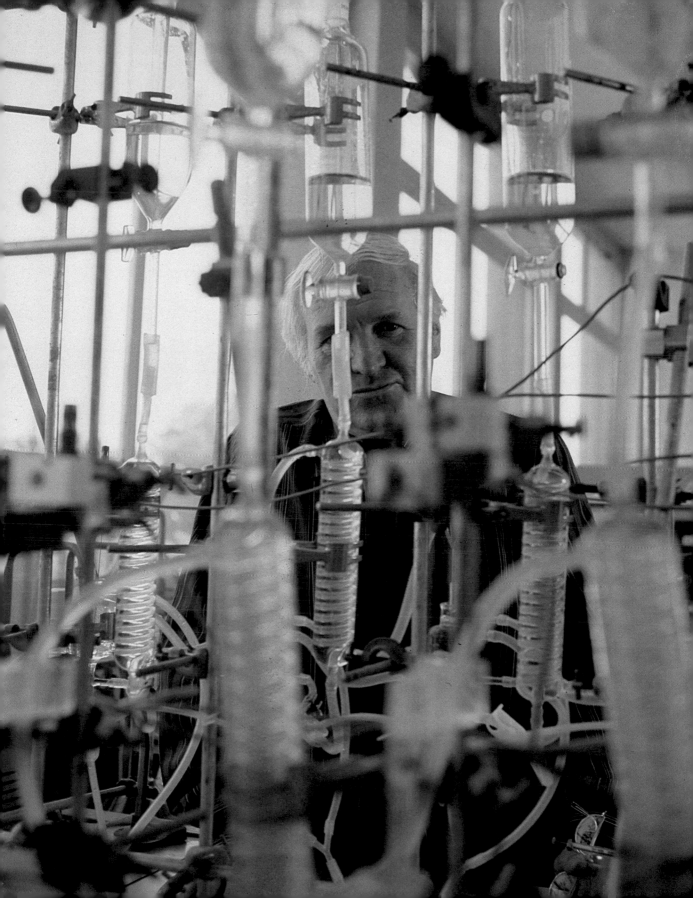

in the sitter's environment, you can select the most important details. Look for any interesting or unusual objects in your subject's house or workplace. For an interpretive photograph you should select only those that are the most appropriate and revealing. You can also make use of the ability of the lens to emphasize certain elements while subduing others or to make some aspects of the sitter's environment seem larger than life by distortion, framing or magnification.

Once you have established the leading feature of your interpretation, you can then add other clues and hints about the sitter as secondary elements so that they do not compete too strongly with the fundamental concept that you are presenting.

Interpretive portraiture is one of the best areas for experimenting with special techniques. I used double printing (see p. 138) for one picture on these pages, but you can also make effective use of filters (see p. 128) and other techniques like toning (see p. 140).

◁ **Using props**
An easel often appears in portraits of painters. Here, I have used it as a symbol of a cross, fusing Francis Bacon's figure with it to suggest the tormented nature of his work. *Nikkormat FT2, 65 mm, 1/60 sec at f11, Tri-X.*

Using a wide-angle ▷
Wide-angle lenses allow you to include the sitter's environment, and to move in close for an intimate mood. You can also use them to distort props, like the strange pair of boots in this picture. *Pentax 6×7, 55 mm, 1/60 sec at f16, Tri-X.*

Double-printed portrait ▽
Bacon often paints blurred faces, shown from several angles at once. To give an impression of his style I printed his face twice on one sheet of paper (p. 138). *Mamiyaflex C3, 105 mm, 1/60 sec at f16, Tri-X.*

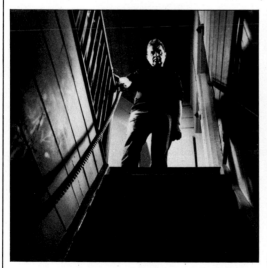

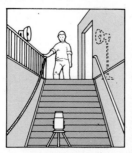

Capturing outlook △
I placed Francis Bacon at the top of a flight of stairs to convey a sense of isolation. His figure, foreshortened by the wide-angle lens, looms toward the viewer. I arranged the lights, see diagram right, to give him a sinister appearance, reflecting his preoccupation with man's potential for evil. *Mamiyaflex C3, 65 mm, 1/60 sec at f11, Tri-X.*

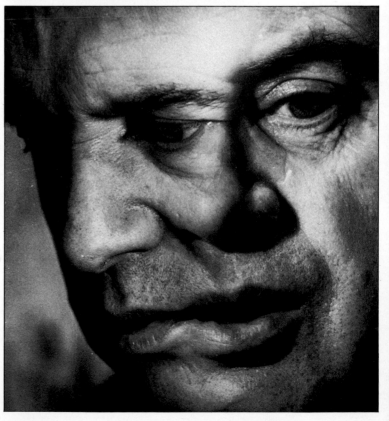

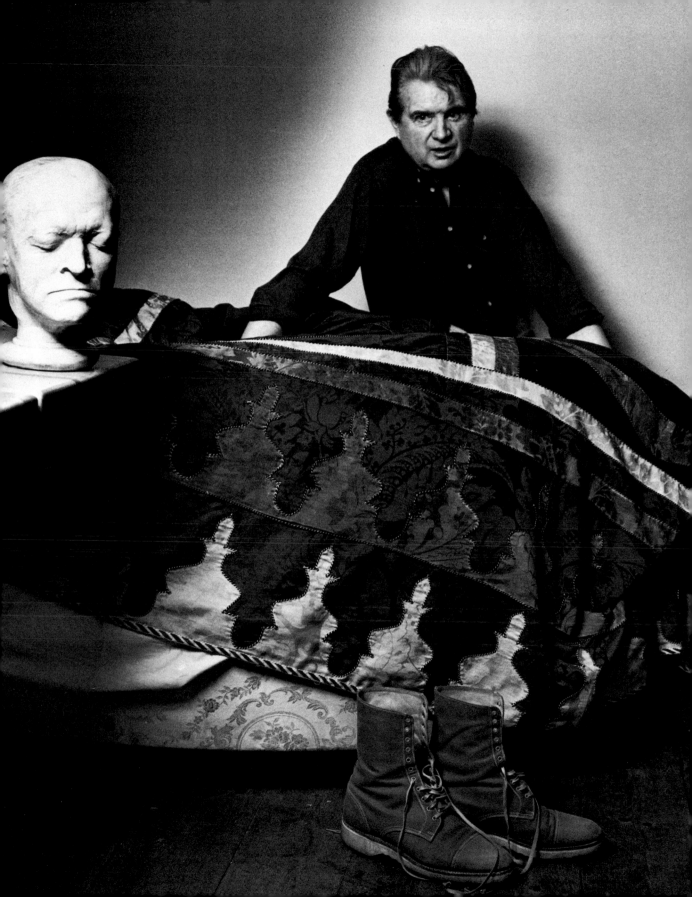

◁ **Using props as symbols**
I photographed the conductor Bernard Haitinck framed by a carefully arranged pattern of instruments. All the elements here were selected not only for their graphic effect, but also because they act as interpretive symbols.
Pentax 6×7, 55 mm, 1/15 sec at f16, Ektachrome 160.

Finding an interpretive setting ▷
I photographed the film director Lindsay Anderson in an empty classroom not long after the release of his film *If*, which was set in a school.
Mamiyaflex C3, 65 mm, 1/15 sec at f16, Tri-X.

Interpreting your subject through composition ▽
For this shot of Henry Moore in front of one of his sculptures I placed the subject at the edge of the frame in order to create a strong sense of the scale of his work.
Nikkormat FT2, 24 mm, 1/30 sec at f11, Agfachrome 50S.

Glamorous and romantic portraits

Glamor in photography is not a question of turning a pretty girl into a "pin-up". You will often see serious glamor photographs used as fashion magazine covers. And magazines such as *Vogue* often feature glamorous and romantic portraits by leading photographers like Clive Arrowsmith, David Montgomery, and David Bailey. A successful glamor picture requires an extra factor both from the sitter and from the photographer. A glamorous subject should possess more than just beauty – she should have a quality of "allure". The photographer must be able to recognize which particular feature of the model represents this "magic" factor, and then bring it out in the portrait. It possible to single out specific points which produce instantly glamorous results because these vary from person to person – it may be the way a girl looks or smiles, it may be her gestures or her hair, or it may be her pose or

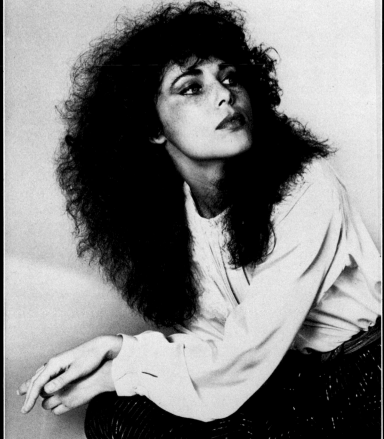

Posing for glamor
The most glamorous features of the girl in the shots above and left are her hair and eyes. Both poses are designed to bring the viewer's attention to the sitter's hair. And the direction of the eyes is important in both pictures. I used a diffused floodlight as a main light with a reflector to fill in. I lit the background with another flood and used a diffused spot for her hair. Lighting for glamor shots should be quite soft, but you can boost contrast in black and white by slightly underexposing the film, then giving it a longer development, as here. *Pentax 6×7, 105 mm, 1/60 sec at f16, Tri-X pushed one stop.*

Romantic glamor ▷
I decided to emphasize this subject's combination of delicacy and innocence by using a pose that suggests a sense of traditional romance. The classical design in the background and the subject's veiled hat accentuate the effect. *Pentax 6×7, 105 mm, 1/15 sec at f16, FP4.*

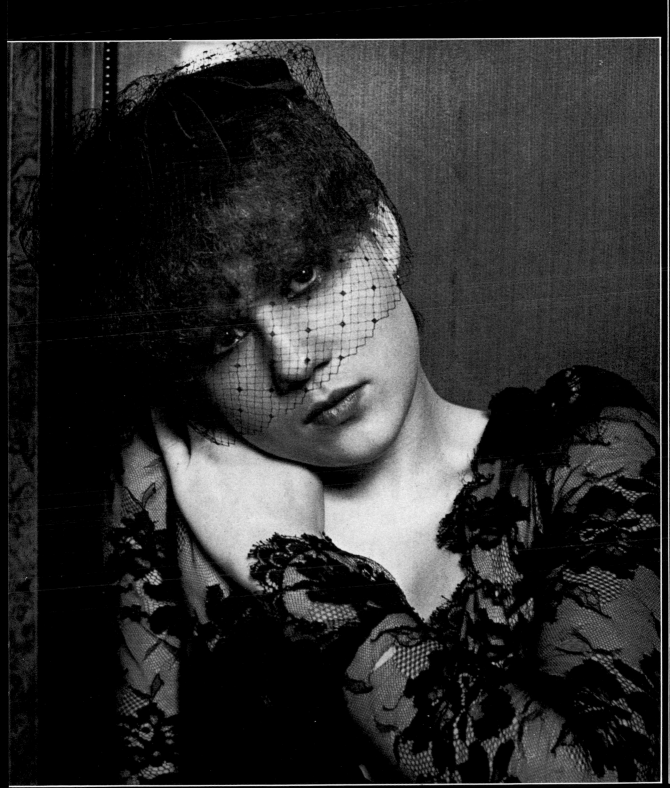

attitude. Romantic portraits and glamor portraits often overlap – it is sometimes difficult to draw a line between the two. But romantic portraits are usually very gentle, pretty images of young girls and women, often taken with a soft focus attachment (see p. 69).

The way that you light your subject for this type of portrait is of utmost importance. Only very rarely will strong, contrasty lighting be successful. In the majority of cases you should use the "Hollywood" lighting set-up (see p. 32). And the pose should be carefully worked out – the lines of your subject's body must be smooth and graceful, without any harsh angles or ugly shapes. The line of the neck, shoulders, chest and arms in particular play an important part. There is no special formula for a romantic or glamorous shot – every subject will require a different approach. The moment you forget about the individual personality of your sitter and start working toward a prototype of glamor your shot will end up as a mere "pin-up".

Unusual lighting ▽
This portrait was shot with strong light rather than the usual soft, diffused light. I used strong light because it suited my subject's bright red dress and blonde hair, and because the pattern of light and shade gives the lines of her body a feline air which is underlined by the black fur on which she is kneeling.
Pentax 6×7, 75 mm, 1/8 sec at f11, Ektachrome 160.

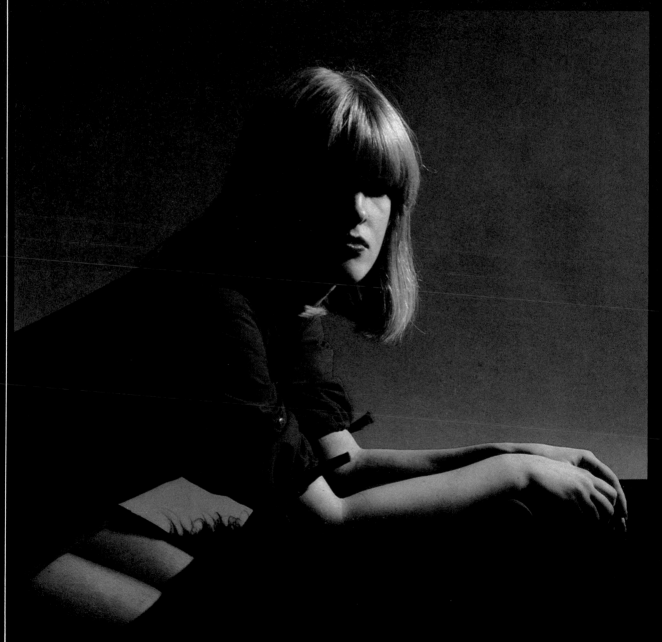

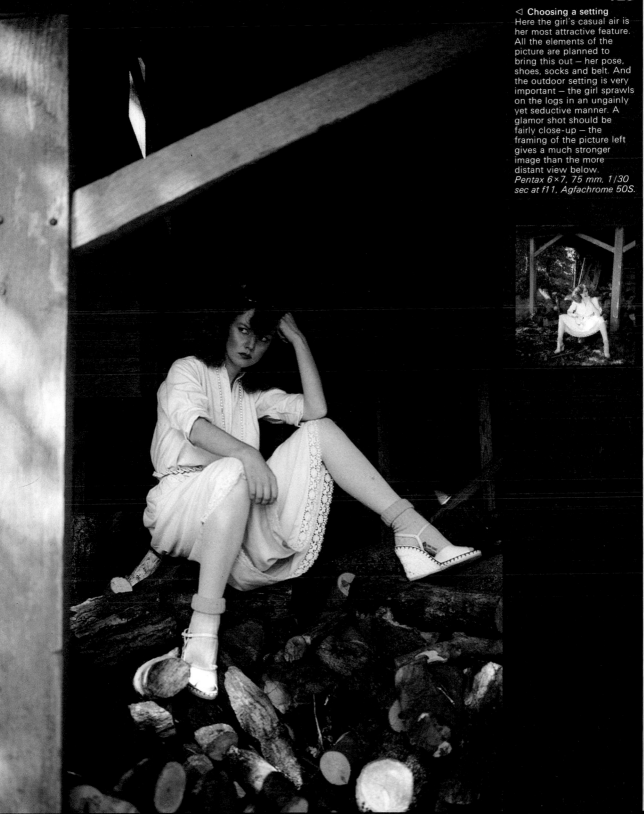

◁ **Choosing a setting**
Here the girl's casual air is
her most attractive feature.
All the elements of the
picture are planned to
bring this out — her pose,
shoes, socks and belt. And
the outdoor setting is very
important — the girl sprawls
on the logs in an ungainly
yet seductive manner. A
glamor shot should be
fairly close-up — the
framing of the picture left
gives a much stronger
image than the more
distant view below.
*Pentax 6×7, 75 mm, 1/30
sec at f11, Agfachrome 50S.*

Exotic glamor ▷
This type of glamor shot recreates the "femme fatale" of the silent movies through pose, look, dress and lighting. The expression and eyes were most important, and once this was established the rest of the arrangement fell into place. The formal pose of the hands follows the line of the collar which in turn frames the exotic necklace. *Pentax 6×7, 105 mm, 1/15 sec at f16, Plus-X.*

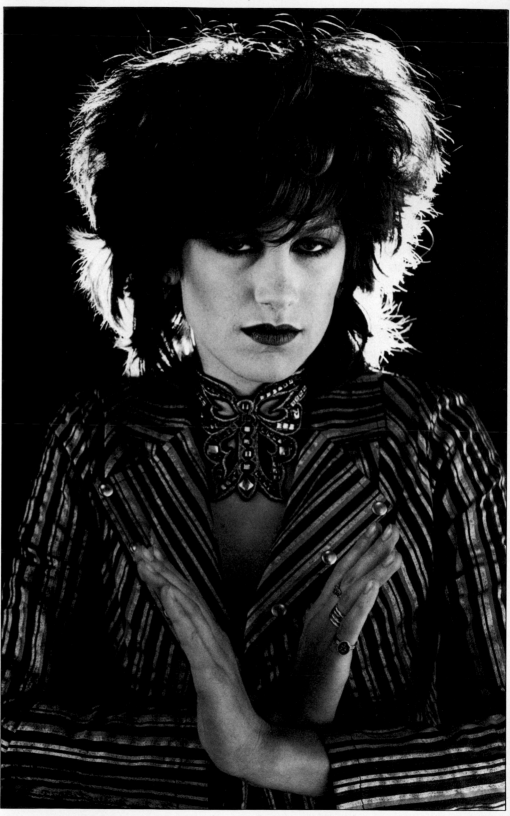

SPECIAL
TECHNIQUES

The meaning, impact and beauty of a good portrait all revolve around the human being at its center. When you make use of special techniques you must take this into consideration. Special effects are only valid if they help to further the projection of your sitter's personality. However, this does not mean that you should only use these techniques as interpretive tools. On the contrary portraiture can also be highly decorative, amusing and light-hearted. And it is frequently in this direction that you will be able to make the most of a number of special techniques.

When considering the use of a special technique, you should never forget or minimize the presence of the sitter in front of your camera. Always choose your technique in relation to your sitter. Will it improve his or her appearance? Will it simplify your interpretation or make it more apparent? Or will it confuse the viewer? The simplest and most important question that you must always ask yourself is whether the picture will be better with or without this special effect. A good portrait photographer will never fall under the spell of a new technique and then feverishly search for a victim to subject to special manipulations.

Filters and attachments

In contrast to correction filters which help to achieve normal, realistic color, special effects filters and attachments introduce an element of fantasy or surrealism to your portraits. They are all deliberately designed to create a pictorial effect not present in the original scene. As always in portraiture, you should consider the person you are photographing before you use an effect filter. Even if the viewer knows nothing about your subject, your own satisfaction will be much greater if, in your opinion, the special effect you use matches your sitter's personality.

Although the majority of special filters and attachments – whether starburst gratings, multi-image filters, dual color filters, double exposure masks, or prisms – are intended as amusing gadgets, you will occasionally find them useful for more serious interpretive portraiture.

Modern filter systems offer a huge range of possibilities, especially in the field of varying or modifying color to achieve a specific mood. If you approach these filters in the way that you regard a zoom lens for example (that is as a technical aid to help your interpretation rather than as an end in itself) you may well achieve some worthwhile results.

Some special filters can be used in unusual ways, and it is worth experimenting and trying to think up new ways of using these attachments which will create original and interesting portraits. For example I used a prism attachment unconventionally for the shot on p. 129.

Portrait in a prism ▷
Instead of inserting the prism in the lens hood as you normally do, I placed it on a small platform on a tripod. You may have to try your prism in several positions before you get the desired effect.
Pentax 6×7, 200 mm and No. 1 close-up ring, 1/8 sec at f22, Ektachrome 160.

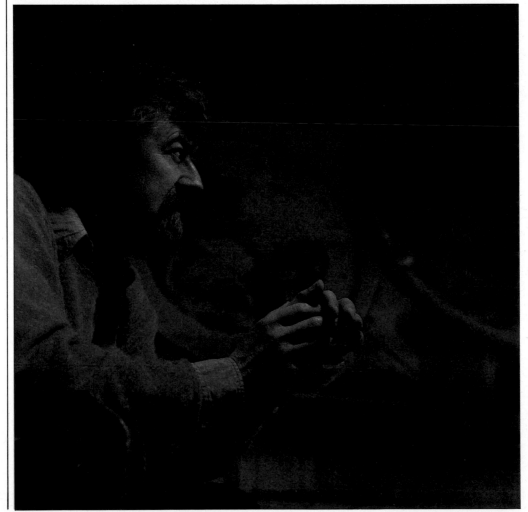

◁ **Using a color filter to convey mood**
The painter Jeffrey Camp is noted for his unusual images and dreamlike subject matter. To create this moody effect, I used artificial light film in daylight with a strong magenta filter on my lens.
Mamiyaflex C3, 65 mm, 1/15 sec at f8, Ektachrome 160.

◁ Shaped masks
These masks give an effect
reminiscent of the oddly-
masked Daguerreotypes.
You can buy a dozen or so
ready-made shapes, but it
is not difficult to make your
own from black cardboard.
For a reasonably sharp
outline you should either
stop down to a very small
aperture or hold the mask
at a distance from the lens.
*Pentax 6×7, 105 mm, 1/8
sec at f22, Ektachrome 160.*

Rather than place it directly in front of the lens, I set the attachment on a tripod and photographed my subject reflected in it. Another alternative is to attempt to shoot through the filter whilst holding it at an angle.

The way that you use a double exposure device is entirely dependent on your own imagination. There is no reason why it should always be used in a serious way. Double masks are, in fact, ideally suited to comic effects. Some filters, such as starburst gratings or color filters, make only a slight change to the picture, perhaps increasing its impact. Used in this way, the filters become a secondary feature of the image, and the danger of repeating the effect for its own sake is reduced.

When using special effects filters and attachments you must be aware of the fact that they tend to produce very similar results, and that, after a while, they may lose their novelty value and become merely repetitious. The more pronounced and unusual the effect, the quicker it tends to become a mere gimmick. For this reason, it is best to use the more "extreme" filters and attachments in moderation, applying them only where they will be most effective.

◁ **Using a starburst filter**
A good star effect is not easy to create because you need a concentrated light source in the image. I used a well-lit jewel to reflect rays of light, and rotated the filter until I achieved the optimum effect.
Pentax 6×7, 105 mm, 1/15 sec at f11, Tri-X.

Double mask effect ▽
A double mask allows you to take two exposures side-by-side on one frame of film. I made my own, with a jagged join so that the two halves of the image fitted together well.
Pentax 6×7, 90 mm, 1/15 sec at f16, Tri-X.

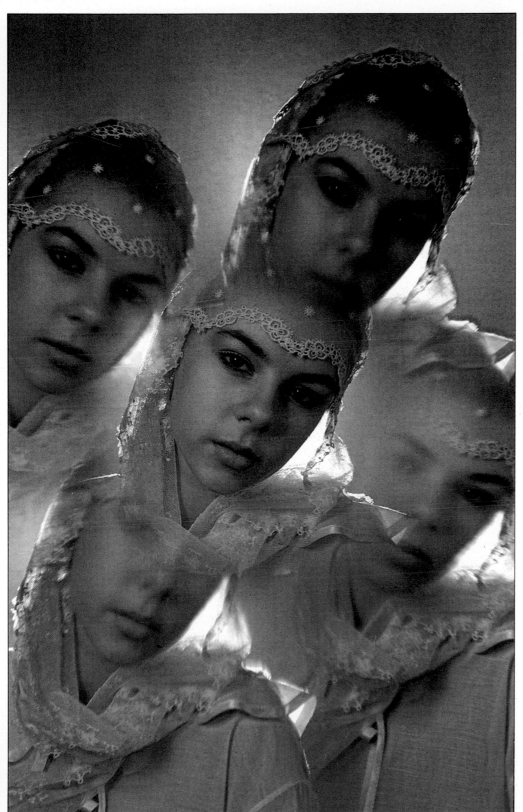

◁ **Using a multi-image filter**
There are several types of multi-image filter available. Some varieties have colored segments, others are plain, as here. And you can choose between a different number of facets, giving three, five or seven images, for example. If you rotate the filter in its mount you will see that each small movement alters the effect quite considerably. It is best to select a subject that will benefit from the filter's characteristic effect. *Pentax 6×7, 105 mm, 1/30 sec at f16, Tri-X.*

Solarization

Solarization – also called the "Sabattier effect" – is the partial reversal of the negative to positive caused by briefly exposing it to light during development. Of all the manipulative darkroom processes, solarization is possibly the most difficult to apply to portraiture. Fast, modern materials react very quickly to manipulations, and the facial features may distort so much that the portrait becomes totally unrecognizable. The great surrealist photographer and artist, Man Ray, who discovered solarization accidentally, worked in the 1920s and 1930s when negative materials were far slower and easier to control. He was able to create beautiful effects, outlining the contours of his sitter's face in black while keeping the rest of the face unchanged. Nowadays it is still exciting to try his process, but you will find it difficult to get direct solarization, especially on color negatives. Instead, you will have to make a copy negative with which to work.

Start by giving the negative a brief fogging exposure midway through development. A long exposure to light brings about a complete reversal to positive but a short exposure – usually just a few seconds – results in only partial reversal. Where light and dark areas of the image meet, a strong black and white line, known as the "Mackie line", appears. For best results, process your color negatives normally, copy them onto a contrasty negative material such as Kodalith, and then solarize the copy halfway through development (see p. 161). Print this solarized positive first, and then superimpose the color negative in exact register as a second exposure on the same piece of color paper. In this way your portrait will still be more or less recognizable. Since you are solarizing a copy and not an original, a number of variations are possible. For example, instead of solarizing the first copy, try developing it normally without a fogging exposure, make another copy from it – this time a negative – and then proceed to fog this second copy.

Some photographers prefer to use a modern solarizing developer such as "Solarol" to solarize prints rather than negatives because the process is more controllable. To get a color result you will have to rephotograph the black and white solarized print and make three intermediate negatives – one with a red filter, one with a blue, and one with a green. Combine these color separations in a sandwich for the final film transparency.

◁ **Solarization in black and white**
Here, I contact printed my black and white negative onto Kodalith sheet film, made another copy from it, and gave this copy a fogging exposure at the halfway stage of development. For the fogging exposure I used a 15 watt bulb about 3 ft (1 m) above the developing dish, switching it on for 3 sec only.
Mamiyaflex C3, 65 mm, 1/60 sec at f8, Tri-X.

Solarizing in color ▽
Tim Stephens made a contact positive on Plus-X film from his original color negative, fogging the copy during development for 1–2 sec to get the "Mackie line". Then he printed the solarized positive and the original color negative on a single piece of color printing paper. He controlled the colors through his enlarger's filtration system.
Pentax Spotmatic, 50 mm, 1/30 sec at f1.4, Vericolor Professional Type S.

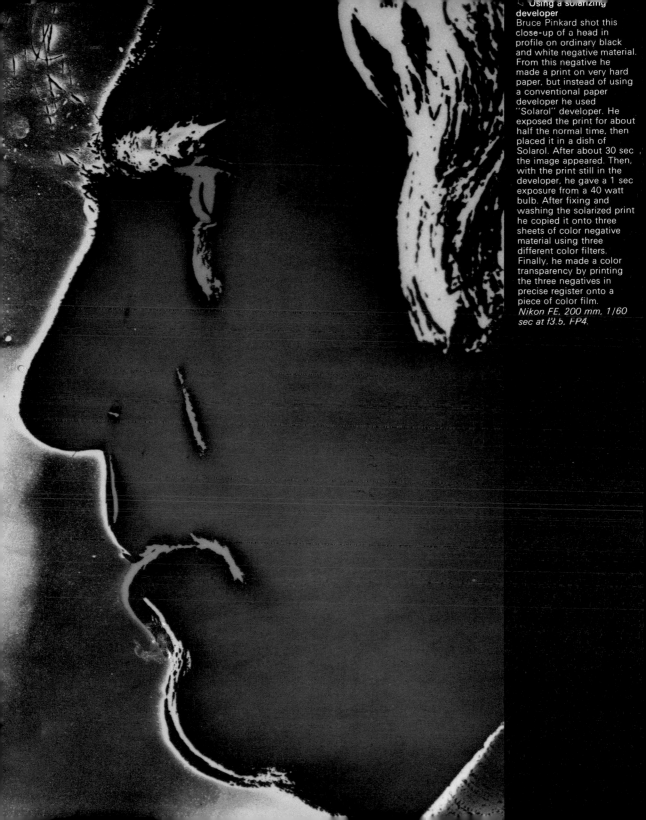

◁ **Using a solarizing developer**

Bruce Pinkard shot this close-up of a head in profile on ordinary black and white negative material. From this negative he made a print on very hard paper, but instead of using a conventional paper developer he used "Solarol" developer. He exposed the print for about half the normal time, then placed it in a dish of Solarol. After about 30 sec the image appeared. Then, with the print still in the developer, he gave a 1 sec exposure from a 40 watt bulb. After fixing and washing the solarized print he copied it onto three sheets of color negative material using three different color filters. Finally, he made a color transparency by printing the three negatives in precise register onto a piece of color film.
Nikon FE, 200 mm, 1/60 sec at f3.5, FP4.

Tone separation

Tone separation or posterization is a printing process which reduces the usual wide range of tones – known as "continuous tone" – in a normal image to just three flat tones – black, white and gray. It will create a bold, strong portrait image, but you will have to carry out a great deal of preparatory work before making the final print. First, make a good, full-tone copy of the original negative by contact printing it onto an ordinary negative material such as FP4 or Plus-X. This gives you a master positive from which you can then make the "separation negatives" you will need (see p. 161). Because you are trying to condense several mid-tones into one, you should make your separation negatives on a very hard negative material such as Kodalith. However, even copying your image onto very hard material is not enough to condense all the mid-tones in one operation, so you must repeat the copying process to get

a further three negatives. You print these three final negatives in turn in perfect register on a single piece of printing paper. In order to get accurate registration you must use a register punch. Start with the shadow negative, then print the mid-tone negative and finally the highlight negative. You must make a test strip in each case to ensure that you print a precise tone.

A simpler special printing technique, also involving the use of separations, is "bas-relief". This gives a black and white print a pseudo-three-dimensional effect, resembling a bas-relief sculpture. You start by making a very thin (underexposed) copy of your original black and white negative. The print is then produced by sandwiching the copy with the original slightly out of register so that some lines become thicker or even double. For best results start by using a thin original.

◁ **Bas-relief image**
This subject suits the treatment particularly well – his craggy face and wild hair gives good scope for the outline. I used Plus-X film to make an under-exposed copy of my original negative and then sandwiched the two together, slightly out of register, to make the print. *Mamiyaflex C3, 80 mm, 1/30 sec at f11, Plus-X.*

Using tone separation ▷
The picture above shows the image as it appeared before the tone separation, right. This technique seems to suit both the personality and the work of the abstract artist Victor Pasmore.
Mamiyaflex C3, 65 mm, 1/30 sec at f11, Plus-X.

Hand coloring

The process of hand coloring black and white prints is an interesting alternative to using color film. If carried out skilfully and tastefully it can produce a satisfying result. In fact before color films were perfected, the technique was widely used to get a colored portrait. Many nineteenth-century portrait studios took extensive notes on the subject's skin tone, hair and eye color, and clothing at the time of the sitting, and then employed a colorist to tint the black and white photograph. But why should you bother with this laborious procedure today, when we have excellent color printing processes? The reason is that tinting gives you total control over color choice and produces results which no ordinary color photographic method can provide. For example, you can choose a totally unrealistic set of colors to produce a highly surrealistic image. Alternatively, you can use colors symbolically or humorously, or to evoke a specific emotion.

There are two methods of hand coloring – using water-colors or oil-based paints. In each case it is best to sepia-tone your prints first, because the black of a normal black and white print will usually debase the applied colors. For both methods use bromide prints, not resin-coated ones. And you will find that mat or semi-mat surfaces are easier to handle. On the whole, hand coloring will darken your picture, so begin with a lighter than normal print.

Water-colors provide delicate, pastel effects. They should be applied when the print is damp (first soak it, then blot it almost dry). Oil paints, however, should be applied when the print is dry and after it has been mounted. Oils are easier to handle, because unlike water-colors they do not soak into the print immediately, so you have time to swab off any excess paint or even change the color if it does not look right. It is best to apply colors to the largest areas of the picture first, allow them to dry for 24 hours, and then fill in the details. It is not necessary to color all the areas of the print – often it may be better to leave some parts uncolored. As shown here, you can color the subject only, leaving the background intact.

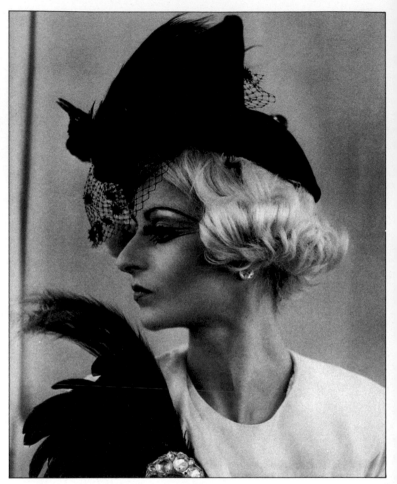

Oil-colored print ▷
Amanda Currey used oil paints to get this delicate result. She took the original image, above, and made a sepia print from it. Then she used oil paints to color the dry print for the effect on the right. This treatment is particularly suited to decorative and romantic portraits.
Hasselblad, 80 mm, Tri-X.

Hand coloring equipment △
You will need a sepia-toned print to work on. For oil paints you should use fine brushes (sizes 0, 1, 4 and 6) moistened in turpentine, a palette, and a cotton bud to remove any excess color. For water-colors, you will need water, fine sable brushes, containers for diluting colors, and some blotting paper to prepare the damp print.

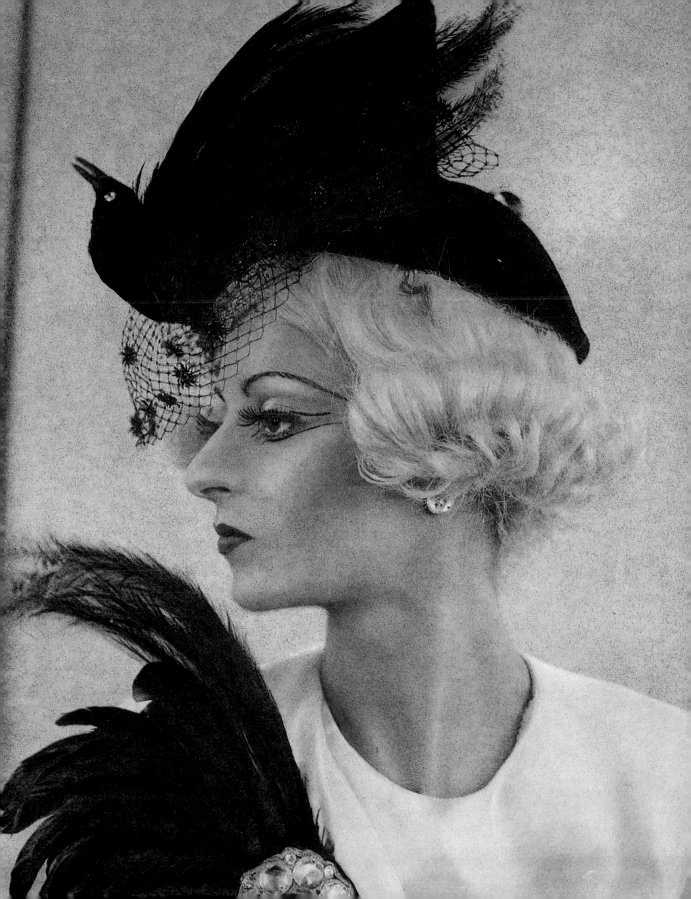

Multiple printing

Double or multiple printing is the combination of images from two or more negatives on one piece of printing paper. One of the best exponents of this method is Jerry Uelsmann, who uses two or even three enlargers at the same time to build his intricate images, fitting all the separate parts together like a jigsaw puzzle.

If you have more than one enlarger, you simply move your masking frame from one enlarger to the next for each successive exposure. However, you can make double or multiple prints quite successfully with only one enlarger. First, make a sketch of the complete image – project each negative on a piece of tracing paper exactly the same size as the final print, and draw in the main outlines of each element. Next, make test strips of each component negative, so that you can match all the exposures for density. Then print one component after the other, exposing only a selected part of the paper each time, and shading the remaining portion. To avoid harsh outlines between elements you must use dodgers (see p. 160). And to prevent accidental fogging of the paper, you should always use your red filter between exposures.

You can apply multiple printing techniques to portraiture very effectively. After all, the main aim of a portrait is to make an accurate representation in pictorial form of the sitter. Consequently, the more characterization as well as information about the sitter that the portrait provides, the more successful it is. The multiple print of the artist Francis Bacon on p. 118 illustrates one interpretive application of this method.

◁ **Making a join**
I photographed the artist Allen Jones against an entirely white background, so that joining his top half to a copy of a pair of legs from one of his works was quite easy. First I printed the top, screening the rest of the paper with cardboard held a few inches above the masking frame to soften the join. I removed the printing paper and placed a tracing of the top image over the masking frame, see diagram below. Next, I inserted the second negative in the holder, and adjusted the enlarger height until the width of the legs and waist matched. I replaced the partly-exposed paper in the masking frame, and made the second exposure.

Joining two images ▷
This kind of double print is quite simple because the join between the two negatives will not be very obvious. Choose two negatives with similar tones – either dark or light. *Hasselblad 500C, 80 mm, 1/60 sec at f11, FP4 (both pictures).*

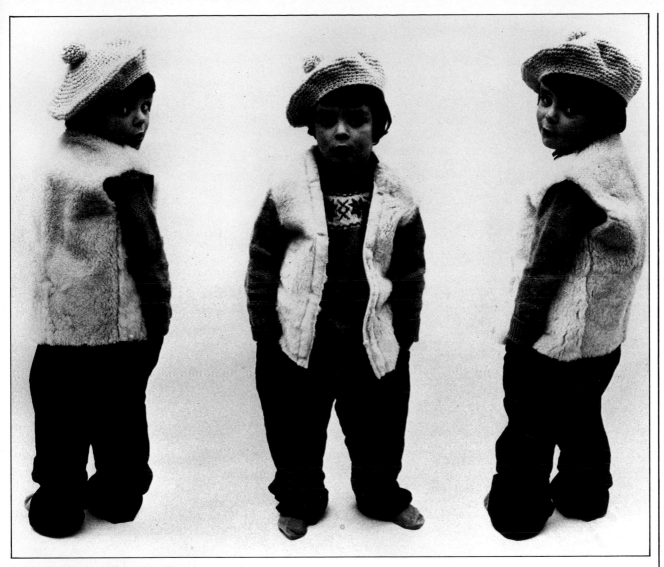

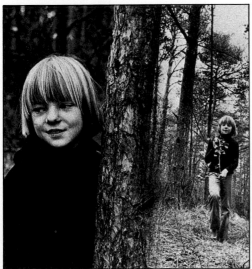

Simple double printing △
This boy was photographed several times in different positions, but always against the same white background and at the same distance from the camera. This makes double printing very easy — you simply trace the position of each figure and then expose one while screening the space left for the other two, see diagram left. The uniform white background ensures that no join shows between the figures. *Nikkormat FT, 50 mm, 1/125 sec at f8, FP4.*

Toning

Treating black and white prints with chemical toners changes the black silver image to a single color. Toning a portrait to create an overall color image is a technique that can produce striking results.

While black and white pictures are usually viewed in a cool, logical manner, we respond to color in an emotional way. Color always provokes a more spontaneous, sensuous response. And particular colors are often sub-consciously associated with different feelings or moods. For example, green may evoke thoughts of joy, youth and spring, red brings to mind fire and anger, and blue may be associated with ice, water, or calm. Bear these qualities in mind when you plan to tone a picture, and always try to choose a color that matches the mood of the image. Sepia toners, for example, are particularly suited to romantic studies or portraits of older people, and you can also use them effectively to give a period mood to a picture.

When choosing a toner, you must take into consideration the fact that while a portrait presented in a specific color may produce the desired emotional response, when people see the human face – usually associated with flesh tones – in a vivid, unnatural color they may find it disconcerting or even shocking. You should therefore use toning with caution, and only when it is really appropriate.

Sepia toner ▷
Toning this portrait of the writer J. B. Priestley sepia gives an impression of age and solemnity. Sepia is reminiscent of old photographs, giving a period air to the image. *Hasselblad 500C, 80 mm, 1/15 sec at f11, Tri-X.*

Blue toner ▽
I tinted this portrait of an artist in blue. I felt that this color created a mood which suited the graphic qualities of the subject's painting in the background. *Mamiyaflex C3, 80 mm, 1/60 sec at f8, Tri-X.*

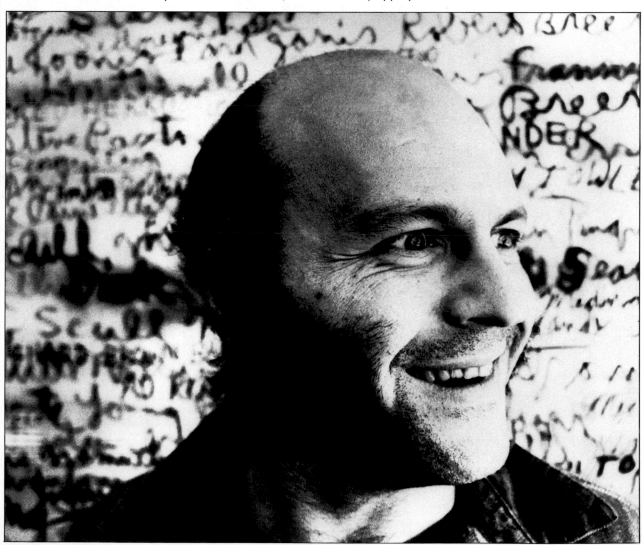

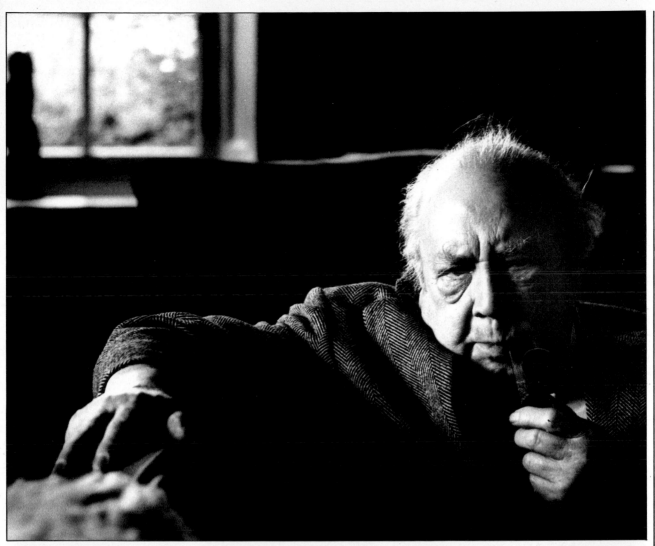

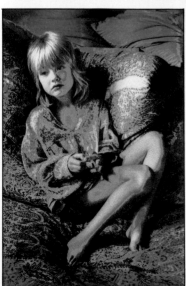

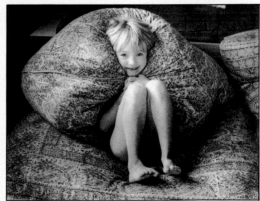

Using bright colors
Toner kits such as the one made by Colorvir are generally best suited to portraits of young people. Here, a set of pictures of one subject has been toned in different colors to form a series. Colorvir kits (see p. 162) also contain pseudo-solarization chemicals which you can use in daylight to create unusual effects, far left. *Nikkormat FT, 50 mm, 1/125 sec at f8, FP4.*

Using grain

Grain and film speed are interdependent – the faster the film (the more sensitive to light), the more pronounced the grain. Although most manufacturers of negative and positive materials constantly strive toward production of films with as little grain as possible, at times it can be interesting to use grain as part of interpretation. If you want a grainy print for a special you often have to work for it. One way is as fast a film as possible. Kodak 2475 Recording film is at present the fastest commercially-produced film. If you "push" it – underexpose it by one or two stops – and then overdevelop it for about double the required exposure time in a fairly contrasty developer it will produce attractive grain. If still more grain is your aim, try developing Recording film in a very high contrast developer.

You can also achieve grainy prints by underexposing and overdeveloping high speed film, then enlarging a very small portion of the negative. Or to obtain a very regular grain pattern effect you could try reticulation. Develop a black and white film in a very hot developer (104–113°F/40–45°C) then plunge it into an icy cold fixer to break up the emulsion. However, modern films are quite resistant to reticulation and it is not so easy to achieve a good result as it used to be. An alternative way to obtain a regular pattern is to use a ready-made grain screen over your printing paper.

Grainy results in color can also be very effective, as shown on p. 144. The well-known fashion photographer, Sarah Moon, became famous for her grainy shots on GAF 500 film (no longer available). She pushed this film considerably to get coarse grain and warm colors. You could try to achieve a similar effect with the new 640 ASA (tungsten) film. If you push it to 600 ASA and then extend development, you will get an attractive coarse grain.

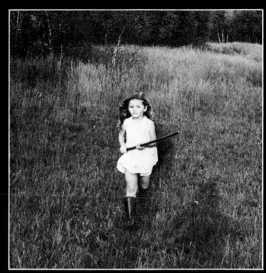

◁ **Using Kodak Recording film**
To create this image I used the film at about 2500 ASA and developed it in high contrast developer. However, the resulting negative was still soft in contrast, so I copied it twice on Kodalith Ortho Type 3 film to get good blacks and whites.
Pentax Spotmatic, 28 mm, 1/125 sec at f22, Kodak 2475 Recording film.

Enlarging for grain △
I used normal 400 ASA film and underexposed it by one stop (setting the meter to 800 ASA), then I gave a third more development than the recommended time. The top print was made from about half the negative, while the bottom one has been blown up still further, then printed on very high contrast (Grade 6) paper. High contrast printing paper usually produces a more grainy image than normal grade paper.
Nikkormat FT, 50 mm, 1/250 sec at f16, Tri-X

Grain in color ▷
Part of the attraction of
the photographic medium
is the texture of a
photographic print —
monochrome or color. But
modern fine grain films
reduce the grain — the
texture of the emulsion —
to a minimum. To achieve
a grainy effect in color I
tried using a very fast (640
ASA) film and gave it one
stop underexposure, then
extended the development.
This gives a romantic, very
slightly grainy image.
*Nikon FE, 50 mm, 1/125
sec at f16, 3M 640.*

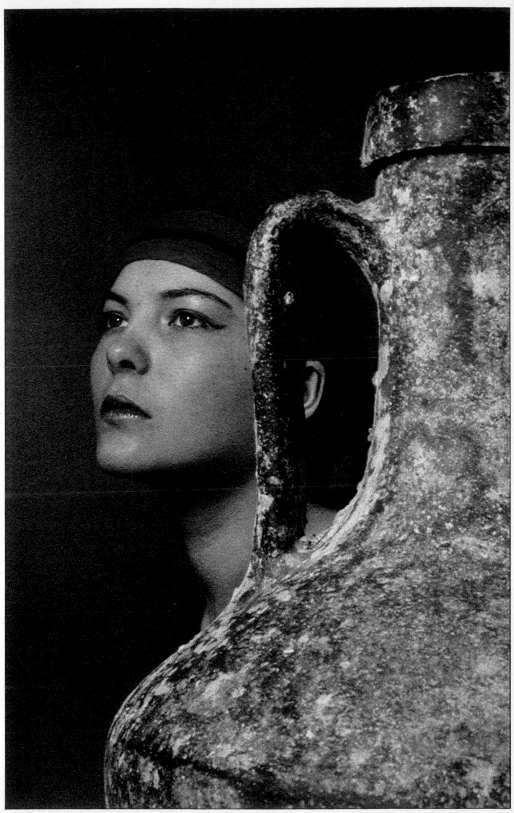

APPENDIX

Photography is essentially a simple process, and modern equipment and materials make it very flexible and adaptable. The most important asset a photographer can possess, apart from creative talent, is a commonsense approach to the medium. You can solve most of the problems you are ever likely to encounter with a little calm reasoning and rational thought. The best, most meaningful portraits were not created by the most expensive, sophisticated equipment but by a thoughtful individual using good, dependable instruments and materials with which he or she was thoroughly familiar. For example, Henri Cartier-Bresson used a Leica and one lens for the majority of his pictures, Bill Brandt worked with a simple Rolleiflex, and Snowdon uses only natural light for his portraits. These great photographers have, in general, pared down technique to allow them to concentrate on creating the most effective image.

We have tried to assemble this appendix to supplement the information in the main body of the book, suggesting simple, dependable equipment and straightforward, workable techniques. These are often the most fruitful, so we suggest that you start with the basics and only add to your stock of equipment and methods when you are sure that the new addition will positively benefit your work.

Basic equipment

Cameras

For portraiture you will need a camera which gives a reasonable image quality and has a fast enough shutter speed to arrest movement. Although some excellent portraits have been taken with simple automatic cameras, to ensure a consistently high standard it is important to use equipment which you can control. Look for a clear, accurate viewing system (so that you can see exactly how much of the area around the sitter is included in the frame) and a controllable shutter/aperture combination. Avoid automatic SLRs which do not allow you to adjust settings to cope with backlighting. Make sure that your chosen camera has a good focusing aid; this is very important because whenever you or your sitter change position you must be able to adjust the focus precisely and instantly. A camera with interchangeable lenses allows you to select the lens that best suits your shot.

The popular 35 mm single lens reflex cameras are very light and relatively inexpensive. They have interchangeable lenses and built-in meters, and their through-the-lens viewing and focusing give you accurate control of the image. However, the small size of the negative means that shooting has to be very precise, and for a high-quality result you will have to use slower, finer-quality films.

Single lens reflex cameras with a $2\frac{1}{4}$ square (6×6 cm) format produce a negative almost three times larger, giving excellent quality even on big enlargements. But the square format is often inconvenient for portraits, and the cameras tend to be expensive. $2\frac{1}{4}$ square twin lens reflexes are usually a little bulky, and they create problems of parallax (because you view through the top lens and shoot through the bottom one, you may chop off part of your sitter's head). Parallax is adjusted internally in some cameras, like the Rolleiflex, but this generally means that you cannot change the lens.

An alternative format, and our favorite one, is the 6×7 type. This has all the advantages of the 35 mm format, but with a larger negative size for improved quality. However, a 6×7 camera is heavier than a 35 mm SLR.

For general, informal portrait photography a 35 mm SLR is the cheapest, most portable and versatile system to choose. However, if you intend to carry out a good deal of studio work, try to obtain a 6×7 or $2\frac{1}{4}$ square camera as well.

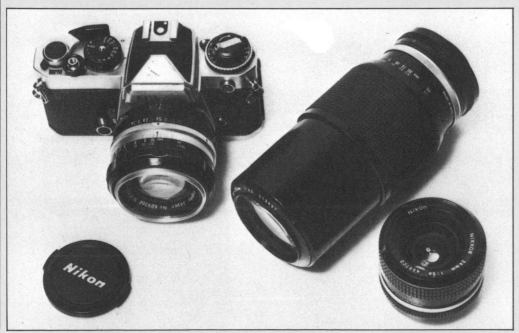

◁ **35 mm camera system** A 35 mm camera is especially useful for photojournalistic portraits, where flexibility, speed of operation, and lightness of equipment are important. Models like the Nikon FE shown here are good all-round amateur or professional cameras. The precision of modern camera design and the improvements in all photographic materials enable you to use a good 35 mm SLR such as a Canon, Minolta, Nikon, Pentax, or Olympus, for all types of portraiture, even in the studio. The 28 mm wide-angle, 50 mm standard, and 80–200 mm zoom lenses in this picture are a good choice for portraiture.

Lenses

A large selection of lenses is not essential for good portraiture. On the contrary, it is far better to use no more than perhaps three basic lenses, and to get well-acquainted with their performance, and the effects that they produce. In general, one good quality standard lens will suffice for most portraiture. Henri Cartier-Bresson worked most of the time with one 50 mm lens on his 35 mm Leica, not from necessity but purely from choice. One standard lens (50 mm for a 35 mm camera, 80 mm for a $2\frac{1}{4}$ square, and 105 mm for a 6×7) will fulfill almost all the requirements of a portraitist.

However, if you want a shot that includes some of the sitter's environment, moving further off may be impossible if space is restricted — when working in a small room, for example. In such situations you will need a wide-angle lens (28 or 35 mm for a 35 mm camera, 65 mm for a $2\frac{1}{4}$ square, and 55 mm for a 6×7 camera). But do not get too close to the sitter's face if you want to avoid distortion.

If, on the other hand, you want a close-up of the face, a standard lens may be a little too short, and you may have to use a long focus lens — for many decades the favorite of traditional portraitists. Because you must keep a long lens at a distance from the face, it will give natural proportions with no distortion. However, your long lens should not be too long (at the most 135 mm for a 35 mm camera, 150 mm for a $2\frac{1}{4}$ square, and 200 mm for a 6×7 model). The longer the lens, the more restricted the area of sharp focus (or depth of field) is at a given aperture; and as a result, you may have to use faster film, with a consequent loss of quality, in order to be able to work at a small stop and keep the whole of the head sharp.

Whatever your choice of lens, the performance and image quality that the lens produces is of the utmost importance. It is certainly better to use one excellent lens than four indifferent ones. For this reason zoom lenses are not always ideal for portraiture — only the most expensive zooms, like the Nikon shown on p. 146, will perform as well as a good single focus lens.

Larger-format cameras
The Pentax 6×7, above, is a larger version of a 35 mm camera. The Mamiyaflex, top right, was the first twin lens reflex with interchangeable lenses. It provides a high-quality $2\frac{1}{4}$ square image at a reasonable price, but it is bulky and can create parallax problems. Many portrait photographers consider that the Hasselblad $2\frac{1}{4}$ square single lens reflex, bottom, provides the highest image quality. However, it is very costly. Backs are interchangeable — one type takes Polaroid film, making the camera a favorite with professional studio photographers.

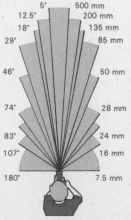

5°	500 mm
12.5°	200 mm
18°	135 mm
29°	85 mm
46°	50 mm
74°	28 mm
83°	24 mm
107°	16 mm
180°	7.5 mm

◁ **Angle of view**
The shorter the focal length of a lens, the wider the angle of view it covers, and the smaller in size the subject becomes. In contrast, long lenses reduce the angle of view quite dramatically — thus enlarging the subject. A standard lens (50 mm for a 35 mm camera) has an angle of view that is similar to the field of human vision — about 46°.

Equipment care
Keep equipment clean and well-protected. Fit a UV filter (see p. 42) to each lens, and cover with a lens cap when not in use. Use only lens tissue or cloth. Clean cameras with a soft camelhair brush. Check your batteries about once every six months. If you get caught in the rain, dry your camera and lens afterward. Note that seawater is very harmful to photographic equipment.

Accessories and film

Tripods

Many photographers are unenthusiastic about using a tripod — they find a hand-held camera more convenient. For portraiture make it a rule to use a tripod whenever possible, to steady your camera for a pin-sharp result, and leave you free to adjust lights or arrange your sitter. Your tripod should be light but steady, with easily adjustable controls. A ball-and-socket head allows you to move the camera quickly in any direction at the touch of a single control. Clip-fastening, telescopic extension legs are easier to operate than screw-fastening types. A reversible center column will allow a very low camera position. Carry a long cable release with you for exposures of $\frac{1}{4}$ sec or longer.

Filters

For black and white work indoors you will not need filters. Outdoors, you may need a yellow filter to strengthen clouds in the background. For color work you should have conversion filters for Type B tungsten film and for daylight film (see p. 42). Carry a pale pink filter to warm up your transparencies in a high altitude or near the sea, or on a dull, gray day. A pale blue filter will adjust the overwarm color of late afternoon sun. And have diffusion or soft focus filters to minimize skin defects like wrinkles and spots, and an ultraviolet (UV) filter to reduce excessive blueness.

◁ **Tripod types**
The medium-size tripod, top left, has additional support arms attached to the legs and center column to give greater steadiness. Some models have reversible center columns, allowing you to position the camera at a low level. The small tripod, below left, is for a 35 mm camera. It is lightweight, and easy to carry, but it is not sufficiently robust or steady for larger format cameras. A cable release, bottom, is useful for long exposures.

Ball-and-socket tripod head △
This type of head is excellent for portraiture because you can adjust the position of the camera on the tripod with just one control.

Filter fittings ▷
Filters are either circular glass types in metal mounts which screw into the lens mount, top right, or square high-quality plastic types which fit into a holder that you attach to the lens mount, bottom right. The circular types can only be used with one lens thread size, but the square types have different-sized adaptor rings which attach the holder to different lenses.

Lens hoods △
A lens hood prevents extraneous light from entering the lens and affecting image quality. Modern lenses are coated to combat flare, but it is still important to fit a lens hood when shooting into the light. Hoods are rubber, plastic or metal.

CdS exposure meter △
This Lunasix meter provides readings ranging from 1/4000 sec to eight hours. A special optical attachment will convert the meter into a spot meter.

Exposure meters

Only a very accurate exposure will ensure a top quality photograph. There are three alternatives: a meter built into the camera, a hand-held selenium cell meter, or the more modern CdS hand-held type. Built-in meters which provide a through-the-lens (TTL) light measurement are not ideal for portraiture. A TTL meter usually gives an average reading of the whole scene, while the portrait photographer is mostly concerned with the light reading for the sitter alone. It is best to take a reading for the sitter's head with a hand-held meter. Modern CdS meters are highly sensitive and accurate, and if you intend to take a lot of portraits in dimly-lit interiors a CdS meter is ideal. Selenium cell meters are less sensitive, but equally accurate, cheaper, and perfectly adequate for most situations.

There are two methods of reading exposure with a hand-held meter: first, by reflected light, reading directly off the sitter's face or off your own hand held in the same light; second, by incident light— you point the meter's translucent dome from the sitter in the direction of the camera and the light.

Film chart ▽
For straightforward portraiture fine-grain, slow speed films are best. For photojournalistic shots, where you may not be able to light the subject well, a faster speed (400 ASA) film is preferable, despite the increased grain. If you are shooting in color for editorial purposes, transparency film is essential for high-quality reproduction. With color material, make sure that you match film to lighting— use tungsten film for tungsten lighting, and daylight film for natural light.

Film types

Film	ASA speed	35 mm	Roll	Sheet	Result	Notes
Black and white						
Kodak Panatomic X	32	●	120		Neg	
Ilford Pan F	50	●	120/220		Neg	
Ilford FP4	125	●	120/220	●	Neg	
Kodak Tri-X	400	●	120/220	●	Neg	
Ilford HP5	400	●	120/220	●	Neg	
Kodak Royal X Pan	1250		120		Neg	
Ilford XP1	200–1600	●			Neg	
Agfa Vario XL	200–1600	●	120		Neg	C-41 process
Color						
Kodachrome 25	25	●			Slide	
Agfachrome 50S	50	●	120	●	Slide	50L-tungsten version
Agfacolor CT18	50	●	120/127		Slide	
Kodachrome 64	64	●			Slide	
Agfachrome CT21	100	●	120/127		Slide	
Kodacolor II	100	●	120/620/127		Neg	
Ektachrome EPT160	160	●	120		Slide	Tungsten film
Ektachrome ED200	200	●	120		Slide	
Ektachrome ED400	400	●	120		Slide	
Kodacolor 400	400	●	120		Neg	
3M Colorslide	640	●			Slide	Tungsten film
Polacolor II	80		●	●	Instant Print	Peel-apart film for backs
Polaroid SX 70	150				Instant Print	Integral film for instant cameras

Flash

You cannot see and evaluate flash-lit results in advance. But with experience you will be able to foresee effects reasonably well, though never as precisely as with tungsten light. Flash illumination can be useful for portraiture. Small flash units are light, portable, and battery-operated, and flash is more powerful in its intensity than average tungsten illumination, allowing you to use smaller stops for greater depth of field, and slower, finer-grain films. Furthermore, it has a very brief duration which freezes action, enabling the sitter to move and act naturally. Flash has a similar color temperature to midday sun — consequently, all daylight color films are balanced for it.

There are two types of flash lighting; battery or battery and house-current-operated flashguns; and the more powerful, heavier studio units solely for operation from the house current. Apart from very heavy strobe units, all flash outfits are portable, and you can use studio types on location providing you have access to electricity. Most professionals use at least one power-pack-operated flash unit, with an umbrella as a reflector.

Flash exposure

Most battery-operated portable flashguns have a "magic eye" — a computerized light-sensitive cell — which adjusts the duration of the flash required for a full exposure. You dial the ASA number of your film, judge the approximate subject/camera distance, and select the aperture indicated on the dial of the flashgun. Flashguns without a "magic eye" usually have a guide number as an indication of their power — you calculate the required stop by dividing the guide number by the distance from the subject. For example, when the subject is 10 feet (3 meters) from the camera, and the guide number is 40, you should set an aperture of f4. The shutter speed you set with flash remains constant — set focal plane shutters at 1/30 sec or slower, and leaf (lens) shutters at 1/125 sec. Because the camera is connected to the flash unit by a synchronizing lead or a "hot shoe" on the camera, you will trigger the flash automatically when you release the shutter.

Portable flashguns
The gun, above, is a small simple type. The unit, right, is larger and more powerful, with an adjustable head for bounced flash. You can also use it with accessories, see facing page. Both types have computerized light cells and are battery-operated, although you can also power the larger unit from the house current. Batteries usually provide 50–100 flashes. Some flashguns have a separate battery charger, others are rechargeable on house current.

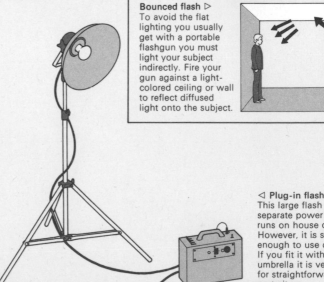

Bounced flash ▷
To avoid the flat lighting you usually get with a portable flashgun you must light your subject indirectly. Fire your gun against a light-colored ceiling or wall to reflect diffused light onto the subject.

◁ **Plug-in flash**
This large flash unit has a separate power pack that runs on house current. However, it is still light enough to use on location. If you fit it with a reflector umbrella it is very effective for straightforward portraiture.

Fill-in, off-camera and bounced flash

Small, single-head electronic flashguns can help solve some lighting problems. Use a small flashgun as a fill-in when shooting into the light — if the sitter is backlit and in shadow, flash will lighten details. The flash exposure should be no more than one quarter of the exposure for a frontally-lit subject in natural light. For example, if the normal exposure for a sun-lit face is 1/60 sec at f22, the fill-in flash exposure should be f11.

Direct on-camera flash is not recommended for portraiture. The light is too flat, and it leaves hard black shadows behind the sitter. It is far better to use a gun with a synch lead off-camera. This will give you a more flattering side-lighting.

A small flash can also be useful when shooting simple editorial portraits, or action shots of children. In such situations, it is best to use on-camera flash bounced off a light-colored ceiling or wall. To calculate exposure take into account the distance from the camera to this surface, and from there to the sitter.

Some flashguns have a special accessory consisting of a white cardboard reflector attached to the flash by a bracket. You fire the flash against the reflector to soften and diffuse the lighting.

Advanced flash units

A larger flash unit, with an umbrella to diffuse and soften the light is much more suitable for studio portrait work. You place it in a standard position (see p. 48), and use a reflector screen opposite as a fill-in. Or have a flash unit with two heads so that you can use the second head as a secondary source of illumination. You can activate two separate, unconnected units at the same time with a "slave" unit. The first flash unit is connected to the camera, and the second unit plugs into a hot shoe attachment on the slave. The slave unit has a photosensitive cell which fires the second flash in unison with the first.

Most larger studio flash units have a modeling light which gives you a rough indication of how the light will fall on the face and figure of the sitter. But the intensity of the flash — at least ten times stronger than the modeling light — will invariably create a different effect. Many professionals test their lighting with a shot on instant film (see p. 104).

Flash meters

With any studio flash unit, it is essential to use a flash meter for exposure calculation, since an ordinary exposure meter is not capable of recording a reading during the brief duration of a flash discharge. You must use a special flash meter — dial in the speed of the film you are using on the scale, plug the meter's lead into your flashgun, and point the flash meter with its light-sensitive cell at the camera from the position of the sitter. Set off the flashgun. The flash discharge will activate an arrow on the meter, indicating the appropriate stop.

Flash accessories ▽
1 Filters and filter holder — color light for special effects.
2 Reflector holder — holds the flash reflector which gives a softer, more diffused result.
3 Flash bracket — takes flashgun for off-camera flash effects.
4 Cable release.
5 Synchronization lead — triggers your flashgun off-camera for side rather than frontal lighting.
6 Sensor extension cord — directs the "magic eye" at the subject when bouncing flash against a side or back wall.
7 Power pack — provides power for larger flashguns.

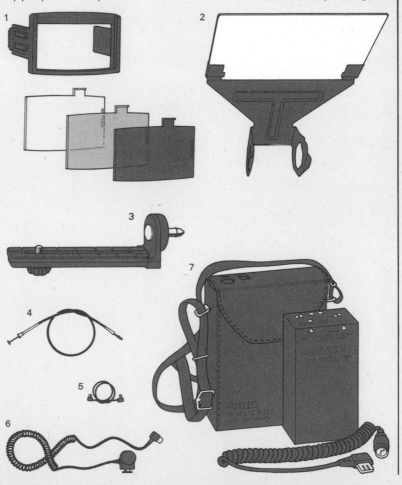

Setting up a studio

Portraiture does not necessarily require a specially equipped studio — you can take good portraits virtually anywhere. However, a well-planned studio will undoubtedly help you to achieve a consistently high standard. Professional studios are, of course, expensive and therefore outside the scope of most amateurs. But although you may find it worth renting one occasionally, you can build up a perfectly adequate small portrait studio at home by purchasing only a few basic necessities. Start by choosing a reasonably large room as a temporary "studio" — one where it is easy

A professional studio ▽
This shows the basic equipment required for a professional portrait studio. In order to get maximum use from all your equipment, the room must be a good size — at least 20×20 ft (6×6 m). In addition to the working area shown here, a professional studio would probably have a changing room, a darkroom, and administration and finishing areas.

Key
1 Spotlight
2 Multi-purpose light
3 Floodlight
4 Studio flash with umbrella reflector
5 Studio flash (with synch to 4)
6 Portable socket panel
7 Medium format camera
8 Studio tripod
9 Reflector board
10 Polystyrene board
11 Diffusion screen
12 Background papers and telescopic stand

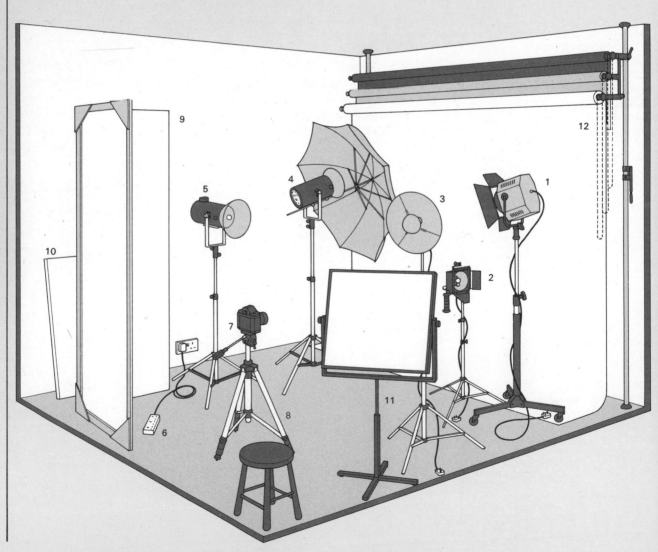

to clear an area in which to work. It should have at least one plain wall to use as a background or to bounce flash off. As a basic minimum, you will need to buy white background paper and a small stand, and two lamps. A diffused floodlight and a concentrated spotlight will give you a choice of lighting effects for different portraits. And one or two reflectors will increase the flexibility and versatility of your set-ups. Your room must have drapes or shutters so that you can shut out daylight during tungsten shots to prevent the problems associated with changing color temperature.

A professional portrait studio should be a minimum of 20 ft (6 m) long, so that you can take full-length portraits with a fairly long lens, and reasonably wide, to allow plenty of space for the lamps and screens. A studio 25×25 ft (8×8 m) is ideal. It should have at least two plain walls — white if possible — to use as backgrounds and for bouncing flash. The ceiling *must* be white so that you can bounce light off it, without it producing a cast on your color shots. It should also be at least twice the height of your model to allow you to use the lighting fully. Both walls and ceiling should be mat — glossy surfaces create unnecessary reflections or "hot spots".

A stand with two or three rolls of background paper ready for use — white, black and a few colors — should be positioned on one wall facing the longer side of the room. A large collection of colors is unnecessary since you can use a colored gelatin in front of a lamp or flash head to change white background paper to the color you need. Although you can usually use a plain white wall quite adequately as a background for portraiture, a roll of background paper suspended from a stand has the important advantage that you can roll it right down to cover the floor as well as the wall. Modern telescopic poles are probably the best choice for a stand — they are quite sturdy, you can dismantle them easily if necessary, and they fit any size of room. A professional studio should also contain at least one, but preferably two, folding reflector screens. One side should be

white and the other black — the black side is useful for blocking out unwanted reflections. A smaller white reflector on a lightweight stand can be very useful on occasions. Blocks of wood of various sizes will act both as supports and counterweights. Install plenty of sockets so that you can plug in several lamps in different parts of the room. A good extension lead and a multiple socket will also be useful. A professional studio should have a changing room with a table, mirror and lighting for the model or sitter to prepare for the session. And a small stock of make-up and accessories is also a good idea. The administrative area should have wall-mounted cupboards to store equipment and props, and an area for coping with paperwork. It is advisable to install some shelving space for your cameras and accessories, a compartmentalized tool chest for smaller items, and a small refrigerator for color films.

Basic studio set-up ▽
The minimum equipment that you will need for indoor studio-type portraiture consists of a tungsten spotlight and a tungsten floodlight, two rolls of background paper — one black and one white — plus a stand and a reflector screen.

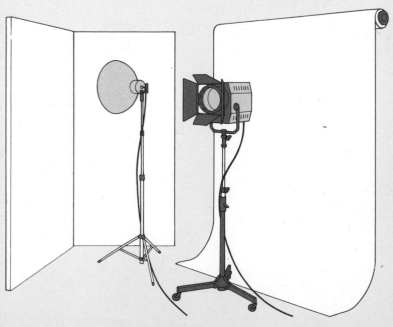

Studio lighting and accessories

Apart from studio flash units (see p.150), all artificial studio lighting has either tungsten filament or tungsten-halogen bulbs. Tungsten lamps provide a constant light independent of the camera, allowing you to select any shutter speed and enabling you to see at a glance the exact effect of your chosen lighting.

Choosing equipment

The kind of studio equipment you should choose will depend on your studio space. For a reasonable sized studio (not less than 20 ft/6 m), you will probably need two tungsten-halogen lamps — one with a diffused light, and the other with a more concentrated beam. You should have one or two reflector screens which will store easily when not in use. If you cannot afford a background stand, you can use one wall of your studio room instead — as long as it is painted white or a very pale color. A spotlight and a set of multi-colored gelatin sheets will turn this surface into any color you desire. This equipment will provide you with a very efficient basic studio. You can supplement this by renting extra equipment for special shots. Large professional photographic dealers often have a rental department where you can borrow almost any kind of lighting equipment, cameras and lenses. It is generally far more economical to rent items of a specialized nature if you only use them on rare occasions.

Bulbs

Tungsten filament bulbs are far brighter than normal domestic types, but they are less durable. The cheapest type, No. 1 photofloods, last only about two hours. Use these with caution because at the beginning and end of their working life their color temperature can be higher than 3,200K (to which Type B film is balanced), making your pictures too warm. No. 2 photofloods last longer — about 100 hours — and are constant in color temperature throughout their life. Tungsten-halogen lamps are more expensive, but they are more powerful and last longer. The introduction of tungsten-halogen lamps produced several new

types of studio and portable artificial lighting — because tungsten-halogen bulbs are considerably smaller in size than filament bulbs this has enabled the manufacturers to make the whole light source smaller.

Types of lamp

Spotlights use a fresnel lens to produce a strong, concentrated beam of light. You can narrow this beam still more by moving the bulb further away from the concave mirror at the back of the spot. Most modern spots use tungsten-halogen bulbs. You can also buy miniature spots which you use for lighting only small areas of the subject.

Floodlights have wide built-in reflectors, producing more diffused light. Some have additional mushroom reflectors in front of the bulb to increase diffusion still further.

Tungsten-halogen bulbs have led to the introduction of several portable floodlights. We use a portable Lowel light for a lot of our work. It is extremely

Lighting heads ▽
The spotlight, below left, provides a concentrated, narrow, partly-adjustable beam of light suitable for low key studio studies. The floodlight, bottom, has a large reflector, giving a wider beam and softer quality light. The Lowel light, below, has two tungsten-halogen bulbs behind a metal bar which point toward a wide, silvered reflector, making all its bright light indirect and softer in quality.

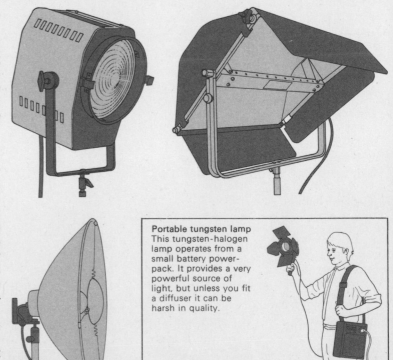

Portable tungsten lamp
This tungsten-halogen lamp operates from a small battery power-pack. It provides a very powerful source of light, but unless you fit a diffuser it can be harsh in quality.

bright but it has a large reflector, so it gives a very diffuse light which covers a large area. The whole lamp folds up into a fairly small suitcase for location work.

Accessories

There are several accessories which modify and control the size or quality of a studio lamp's beam. You can soften light with diffusing screens or umbrellas, and you can use barn doors and snoots to restrict it to a narrow area. With older-style lamps you can cut out shapes from black cartridge paper and attach them to the lamp with adhesive tape to restrict or alter the beam (although this is not possible with modern tungsten-halogen lamps because of the extreme heat that they emit).

Reflector screens are very important equipment in a portrait studio and can be placed at any distance from the sitter to provide very effective fill-in. You can make screens by covering large 3×7 ft (1×2 m) hinged wooden frames with white cardboard.

Inverse square law

This states that when a light source takes the form of a point, the illumination of a surface is inversely proportional to the square of the distance of that source. When you double this distance the illumination is quartered. To maintain constant exposure while allowing for this effect, increase the aperture by one stop for every doubling of the distance.

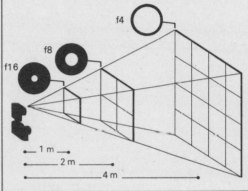

Diffusers ▷
You place diffuser screens, far right, between the light and the subject for a softer effect. Umbrellas, right, are made of a soft, silvered material. They spread and diffuse individual studio lights or flash units, giving a shadowless effect.

Background paper ▽
"Colorama" papers are the most popular method of achieving an even-colored, plain background. You hang the roll or rolls of paper on a telescopic stand, and pull out the amount you need.

Lighting accessories △
A snoot (1) narrows the beam of light — to light only the hands, for example. You can adjust barn doors (2) to any position to control the beam of light. Scrims (3) and half-scrims (4) reduce the amount of light.

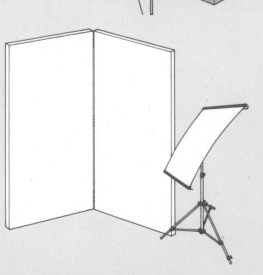

◁ Reflectors
An efficient, well-placed reflector screen can do the work of an additional light source. You can use home-made or purpose-built screens, see left. Or a projection screen will make a very good reflector, especially if you can adjust its height. Ideally, have one or two purpose-built screens.

Sitters and models

Sitters

Finding and selecting suitable subjects is very important. First, decide what kind of portrait you are aiming at, and what kind of subject you require. A model agency should be your last resort. It is very easy to get interesting subjects for portraiture just by asking — most people love to be photographed, but they often like to have some excuse for it. A good idea is to decide on a series of portraits — portraits of all the people living in one street, for example, or of all the children in one block. This gives you a long-term project, and serves as an excuse when approaching your next potential sitter.

Even well-known, busy personalities, given a plausible reason such as an exhibition or a projected book, may agree to sit for you. I started out as an amateur by contacting famous painters and sculptors. In those early days I never asked for a sitting immediately. Instead, I said I would like to come and show them some of my portraits of other people, and added that if they liked my work they might perhaps allow me to photograph them. This type of modest request, interspersed with some praise of their work, was rarely refused.

Sometimes an excuse will not be necessary. A direct approach on the

Carina

Height 5 ft 6½ ins/1.69 m
Bust 34 ins/86 cm
Waist 24 ins/61 cm
Hips 35 ins/89 cm
Dress 10/38
Shoes 5/38
Gloves 7/7
Hair Light Brown
Eyes Brown

MARCS MODELS

Make-up kit ▷
Often, your sitter or model may need a little make-up. It is a good idea to have a selection of make-up items available. A basic make-up kit consists of foundation, coloring pencils, lipstick, blusher and highlighter, translucent powder, and cotton balls and brushes to apply make-up.

Model card △
Most professional models have a "composite" or model card. This consists of one or two photographs — usually a close-up and a full-length study — and some relevant information. If the model card is not sufficient you can also ask to see the model's portfolio — a collection of pictures of him or her taken by other photographers he or she has worked for.

street will often be successful. You must convince the person you approach that you are a bona-fide photographer making a genuine request. A visiting card with your name, address, and the title "portrait photographer" will help a lot. Ask the person you approach to call you if they want to sit for you, and mention that you will give them some free prints. Make sure that they understand that you are offering them a portrait free of charge — most people love to get something for nothing. Above all you must act the part — self-assured, relaxed and convincing. And it may help to be an extrovert like the great Victorian portraitist Julia Margaret Cameron, who often dragged people in from the street if they seemed suitable for one of her numerous projects.

Models

For some subjects, like glamorous or decorative portraiture, you may have to turn to a model agency. The agency will show you several model's cards — often called "composites" — with their descriptions, but it is best to try and select models personally. Before going to an agency make a few notes on the kind of picture you intend to take. Most agencies are very helpful — if you tell them your exact requirements they will try to find you the right model. They will also ask you what kind of clothing and accessories you require. If these are not available, or if you are using a non-professional sitter, you will have to get them from a theatrical rental agency. Always draw up a model release form and ask the model to sign it. Good, experienced models are often quite expensive, but they are generally worth their fees. A good model will help you to get the best possible picture — she will relax from the first moment, and will almost invariably assume natural poses. A professional model should also know how to apply make-up successfully for a photograph. I am often amazed at the difference between the person who arrives for the session and the one who emerges half an hour later for the actual sitting.

Model release form

PHOTOGRAPHER **DATE**

DESCRIPTION OF PHOTOGRAPH(S)

For consideration received, I give . the whole copyright (including all rights of reproduction), and I agree that ., and all licensees and assignees, are entitled to use the photograph(s) described above in any manner or form whatsoever, either wholly or in part, in any medium, and in conjunction with any wording or other photographs or drawings, for any purpose worldwide. I understand that I do not own the copyright of the photograph(s).
* I am over the age of majority
* I am the parent/guardian of . and I consent to these conditions

NAME **DATE**

SIGNATURE

ADDRESS

WITNESS

*** DELETE WHICHEVER DOES NOT APPLY**

Model release form △
It is always best to acquire full legal rights to your photographs by asking your sitters to sign a model release form. If you are commissioned to take a portrait for a fee, the copyright belongs to the person who gave you the commission, unless you reach a specific agreement. Ask the person who commissioned you to pay you only a nominal fee as long as you can retain the copyright in exchange.

Organizing a session

For the portrait photographer every session is different. Each sitter is an individual and so every shooting session will require a specially adapted approach. Although some advance planning is a good idea, it is often impossible to predict the best way to portray the subject and detailed planning can turn out to have been a waste of time. During a recent session for *Fortune Magazine* it was intended to include one shot of the subject jogging, one featuring his car, and another showing him exercising a dog. All these were flatly refused, and it was essential to think up new ideas on the spot.

Broadly speaking, there are two types of portrait session. The first is intended to show a personality — someone photographed to convey his or her character. The second is a session with a model — arranged specifically for his or her external appearance. Both types may take place either on location or in a studio.

Photographing a personality

If you are commissioned to take a portrait it is best to try to arrange a brief meeting with the subject a day or two before the session. Such a meeting will enable you to find out about the sitter's personality. You can also inspect the environment, establishing the quality of the light, and finding out how many electrical connections are available.

You will now be able to plan your session in more specific terms. You can imagine your basic approach and decide what equipment you will require, and what lighting and film will be most suitable. In addition, this preliminary meeting will allow you to find out your subject's personal interests, so that you will be able to make conversation during shooting, putting the sitter at ease. You can also decide how you want the subject to dress, and make it clear if you want to use props suggesting the subject's background or work.

Photographing a model

With a model the procedure is different — although it is still a good idea to meet the sitter beforehand. When booking a model through an agency, you may want to meet him or her before making a commitment. You can then take the opportunity to discuss clothes, props, and the time required for the session. You can also give the model an idea of the type of pictures you intend to take.

Always start with simple poses, giving positive encouragement as often as possible. Harsh criticism will not make a poor model any better. While shooting you should always make conscious, regular checks on exposure readings and camera settings. It is also essential to make regular adjustments to lighting, especially if the model is changing poses continuously, and to watch the frame for stray shadows and unwanted highlights.

A typical studio shot ▽
The model sat at one end of a table, with the candles placed at the other end. I used a long focus lens to get the right proportions and perspective. Another advantage of this lens was that its narrow depth of field made it possible to separate the model and candles by means of selective focus. For details on how I planned this shot, see facing page.

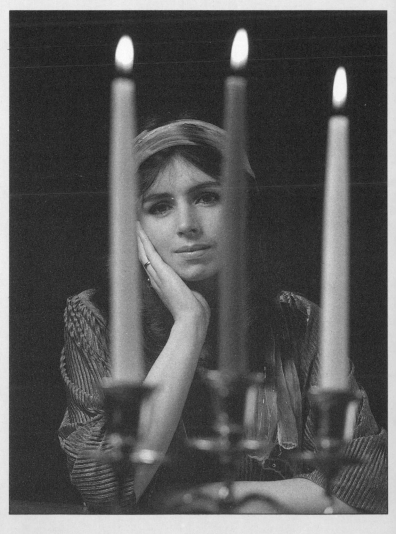

The shooting schedule
Shooting a studio portrait involves collecting together a variety of items such as props, clothes, and equipment. To ensure that you have everything you require before the session begins, you should make a list. It is also worth itemizing the times and other arrangements necessary for the session.

Model	Sarah Smith Agent: Julia Hunt
Clothes and accessories arranged	Model's own dress and rings
Other preparations	Make rough sketches of sets and poses
Time booked	10 am to 1 pm
Time for make-up	30 min
Shots to be taken	Series of portraits showing model's hands, with different poses, expressions

Props and clothes
Gray dress
Scarf
Rings
Colored candles
Candelabrum
Long table
Alternatives for additional shots
Dark coat
Boots
Umbrella

Camera equipment and films
Pentax 6×7
Standard and long focus lenses
Tripod
Cable release
Exposure meter
120 Ektachrome
160 ASA
120 Plus-X
125 ASA

Lighting and studio equipment
2 Lowel floodlights
1 studio spot
1 Lowel spot
2 studio reflectors
1 reflector screen
Background paper stand
Background paper roll

The session in progress ▷
We used tungsten lighting for the picture of the model on the facing page. A Lowel soft-light and a studio floodlight provided the main illumination, and a snooted spotlight on the model's right gave additional directional illumination. (The studio flash units on the left-hand side of the picture were not in use.) We positioned large reflector screens on either side of the model, who sits in front of a large roll of background paper. Taking advantage of the studio's length, it was possible to use the Pentax 6×7 with a long focus lens. By working together, it was possible for one person to make adjustments to the lighting, while the other could observe the effect from the camera position.

Darkroom work

The importance of having your own darkroom cannot be overstated. Commercial processing and printing laboratories will, in most cases, produce a good, "standard" result from a "properly" exposed negative, which has been taken in "average" lighting.

Many photographers, however, believe that this type of negative taken in "ideal" conditions does not exist, and that every print can be improved by adjusting exposure for different parts of the image.

Good printing technique starts with the ability to judge the negative. First, you must decide which paper grade best suits the contrast range of the negative. Weak, pale-toned negatives, for example, may require a hard, more contrasty paper — grades 3, 4, or 5. A dense, more contrasty negative, though, will probably require a softer paper — grade 0 or 1. Negatives with an extensive range of half tones often print well on normal, grade 2 paper. Next, look for parts of the negative which, if given a "straight" exposure, will print too dark or too light. To counteract this, you will either have to reduce or increase the exposure in these areas when printing by shading (also known as dodging) or burning-in. In a portrait taken in concentrated light, for example, the forehead may be so well lit that, if printed normally, it would lack detail.

Start printing by making a test strip. Using the "step-wedge method", divide the paper into sections and print a strip at a time, doubling the exposure at each step. Develop, fix, and wash your test strip and then examine it under white light. This is important because most prints appear too dark under safelighting.

After comparing your negative with the test strip you will know the best overall exposure. For darker parts, though, where the exposure should be shorter, you must hold back the light from the enlarger using either your hand or fingers, or a dodger. For parts of the negative that would print too light, you must shield the rest of the paper before giving them extra exposure. Use your hand for this, or cut a small hole in a large piece of cardboard and direct the light to the desired area of the print.

Dodger types ▷
Print dodgers are available ready-made in a wide range of shapes and sizes. You can also make your own using opaque cardboard taped to thin, stiff wire. If light reflects from the wire, cover it with black tape. The closer you hold the dodger to the paper, the smaller and sharper the shaded area is.

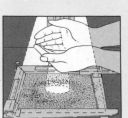

Shading and burning-in
Use your test strip to estimate the degree of shading or burning-in required. For some shapes, the most versatile tool you can use is your own hands. When using all dodgers, keep them continually on the move to prevent a hard edge of different density appearing on the print. If you have a contrasty area that you cannot tone down using ordinary burning-in techniques, try using a masked-down flashlight (torch) to fog the area to gray or black.

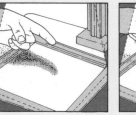
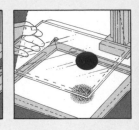

Cupped hands If you only have a small area that requires additional exposure, you can cup your hands together and expose through a small gap left between them.

Flashlight First make a cone of opaque cardboard and tape it over a flashlight. When using it during printing make sure the light is confined only to the area you want to tone down.

Fingers You can only use your fingers as a dodging device if the area to be shaded is near one edge. Otherwise, your hand will create unwanted shadows.

Dodgers Use a cardboard dodger for a more central area of the paper. Keep the dodger moving continuously.

Opaque shape on glass Using opaque dye or paint, you can make any shape you require on a sheet of clean, scratch-free glass.

Making black borders ▷
Often, you can intensify the visual impact of your photographs by printing-in a black border. This technique is particularly effective with a light-toned image that would otherwise seem to disappear into the normal white border left by most masking frames. You can vary the thickness of the black border to suit your image, but be careful not to allow it to become too dominant.

1 Cut out an area of black cardboard the size of your print. Trim the cardboard by an amount equal to the width of the border. Place this frame over your paper and expose the image.

2 Turn the enlarger off and add the central cut-out. Make sure that it leaves an equal gap all round the print. Remove the negative and give enough exposure to fog the edges.

Sandwiching

Normally, multi-image pictures involve successive printings. By contrast, sandwiching is done by printing two or more film images simultaneously. As with regular multiple printing, you must plan the image beforehand.

Usually, you will have to shoot the elements specially as it is important that the areas in the first negative that are to contain parts of the image from the second negative are empty or at least underexposed. If you do not pre-arrange this, the image detail to be superimposed will fail to project onto the first negative. You should also make sure that the images match each other in density.

The technique does not restrict you to black and white work. Experiment with color negatives or use color slides and print on positive/positive paper. You can also combine color and black and white. A further advantage is that you can get acceptable results with underexposed negatives and overexposed slides.

Posterization

Posterization transforms an image with a normal range of tones into one with distinct areas of tone or color. The first step with a black and white original is to make density separations. You enlarge the negative on three sheets of high-contrast lith or line film, giving underexposure with one sheet, normal exposure with the second, and overexposure with the third. The film has to be punched with registration holes beforehand.

Processing will produce one sheet in which the deepest shadow areas only will all be recorded as black, a second showing the mid-tones and shadows as black, and a third with all the tones, except for the brightest highlights, also as black. Next, using equal exposure, you contact print the film positives on three sheets of high-contrast register-punched film. You then contact print the resulting separation negatives individually using normal-grade bromide paper, and exposing so that you get a mid-gray result.

Making a vignette ▷
Vignetting is a method of changing the outline of your picture so that it shades off to black or white. It softens the overall effect, emphasizes the center, and eliminates distracting elements in the corners. Vignettes, which were popular in 19th-century portraiture, are traditionally oval. Start by making a mask. Focus the image on your masking frame, then rough out a shape on cardboard held just above the frame.

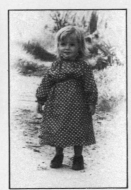

White vignette
Insert paper in masking frame. Using the red filter, put the cut-out surround in place. Remove filter and expose for result, right.

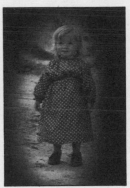

Black vignette
Vignette as before. Use red filter and remove negative. Hold dodger over image, remove filter and fog edges, as shown right.

Solarization ▷
When a negative is exposed briefly to light during development, it begins to become a positive. This effect is known as solarization. Results with today's sensitive film, especially of the color negative type, are unpredictable, and so it is best to work from copy negatives made on a contrasty material such as Kodalith.

1 Having selected the negative you want to solarize, contact print it onto a sheet of contrasty film such as Kodalith or similar.

2 Give the second sheet of film development half as long as that received by the original film. Use absorbent paper on the enlarger baseboard.

3 Place the developer tray under the enlarger. With the emulsion side up, fog the film for the same period as in step 1.

4 Complete the development and carry out the processing. When the film image is dry, cut it out. Enlarge it on bromide printing paper.

Print finishing

Toning

Toning tints your black and white print, while retaining the tonal values of the original (see pp. 140–1). The three most popular toners are selenium toner, sepia toner, and gold toner. Most toners change the normally black silver on monochrome emulsion chemically. You should therefore start with a fully processed print which has a rich range of tones — weak, soft contrast prints will not give good results.

Selenium toner adds a high-quality touch to a finished print, and is favored by perfectionist print makers like Ansel Adams. You purchase selenium toner as a ready-made, concentrated solution which you mix with 10 to 20 parts of water. Start by thoroughly fixing your print, next wash it for at least one hour in running water, then immerse it in selenium toner for 3–6 minutes. At first it will acquire a very rich black tone with a tinge of purple (some photographers do not proceed any further). A full selenium toning gives deep purple tones in the blacks and grays, while leaving the highlights almost clear. After toning, wash and dry the print.

Photography has become increasingly accepted as an art medium, and a number of galleries sell photographs for permanent display. You can make your exhibition prints more permanent with selenium toner. First, fix the print in three successive fixing baths. Next, wash it for two hours in running water, then immerse it in a hypo-eliminating bath. Finally, selenium tone the print to add to its permanence. You must mount archival prints on specially-prepared mounting boards.

A two-stage sulfide toner gives rich, sepia tones. Take a thoroughly fixed and washed print and bleach it until the black image disappears almost completely and only faint yellowish outlines are still visible. Wash the bleached print briefly, then immerse it in a sodium sulfide bath for 1–2 minutes. Thoroughly wash and dry the toned print.

In spite of its name, gold toner gives a cold, bluish hue to bromide prints. It suits cool, moody portraits. As usual, fix and wash the print first. You make up gold toner from two stock solutions which you keep separately and mix shortly before use. Immerse the pre-soaked print for about one minute only and wash it carefully after toning — prolonged washing may weaken bluish tones.

There are also several toning kits on the market. Although these have limited application for the serious portrait photographer, they are great fun to experiment with. The "Colorvir" kit not only provides a rainbow range of toners, but also has pseudo-solarization chemicals which you can use in broad daylight. All kits have detailed instructions on use.

Solutions

Sepia toner

Bleach the pre-soaked print until all dark tones disappear and only a few details are visible. Rinse briefly, then immerse in the toner bath. To achieve deeper tones dip the print in toner for a few secs before bleaching it. After toning, wash and dry the print.

Bleacher	
Potassium ferricyanide	25 g
Potassium bromide	25 g
Water to make	250 ml
Dilute 1:9 for use	
Toner	
Sodium sulfide	12.5 g
Water to make	250 ml

Gold toner

Just before use, mix the two solutions in equal proportions (1 to 1) and immerse pre-soaked prints in the resulting solution for about 1 min. (Never add water to acid, always add the acid to water.) Wash and dry the toned print.

Solution A	
Potassium ferricyanide	1 g
Concentrated sulfuric acid	2 ml
Water to make	500 ml
Solution B	
Ferric ammonium citrate	1 g
Concentrated sulfuric acid	2 ml
Water to make	500 ml

◁ "Colorvir" dye/toner kit
Kits contain dyes, toners and pseudo-solarization chemicals, as well as detailed instructions for each possible variation. Colorvir is most successful on resin-coated papers. For the best results select prints which have a full tonal range; contrasty prints are not suitable. You can work in bright daylight, but wear gloves because some dyes tend to stain.

Improving prints

To remove white marks spot them out using watercolor or dye. Dye is preferable because it is more permanent. You can buy a set of spotting dyes in a range of hues — black, gray, brown and intermediate tones — to match the color of your print. With a very fine sable brush pick up a small amount of dye, then partially dry the brush on absorbent paper so that it will apply dye evenly.

Black spots on the print are a result of dust on the negative prior to processing. Remove them by very gentle, gradual scratching with a scalpel. Larger marks are not easy to scrape off, but you can remove them chemically with Farmer's Reducer. This consists of two stock solutions: Solution A — 20g of potassium ferricyanide with 1 liter of water — and Solution B — pure hypo crystals dissolved in the same proportion. Mix one part of Solution A, four parts of solution B, and eight parts of water. Apply the solution with a brush, and swab the print immediately with a wet cotton ball to stop the action. Repeat until the spot disappears. Wash and dry the print.

You can also use very weak Farmer's Reducer, diluted with 50 parts of water, to clear highlights and make the print brighter. Immerse a wet print in the solution for 10 seconds, rocking the dish all the time, then rinse. Examine the result and repeat if necessary.

Mounting

The best method of displaying your prints is to dry mount them on thick cardboard. Attach a layer of dry mounting tissue (shellac) to the back of your print, and place the print, tissue and board in a dry mounting press. The press melts the shellac, forming a permanent bond between print and board. Most presses are not suitable for resin-coated papers — they produce too much heat and can melt the plastic surface. There are special dry mounting presses on the market for resin-coated papers.

Retouching

To remove white marks you need a small dish for mixing watercolors or dyes, and two sable brushes (sizes 00 and 1). A scalpel blade will remove black spots.

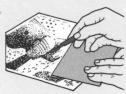

Scratching
To remove black specks, gently scratch emulsion with a sharp scalpel. Cover remainder of print with paper to protect it from greasy marks.

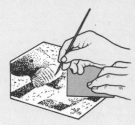

Spotting
To hide a white mark apply dye of the correct color with a very fine sable brush. Use only a very small amount of dye at one time.

Dry mounting
Dry mounting produces a permanent, professional result. The press melts the shellac adhesive contained in the special tissue which you place between the mount and the print.

1 Clean the mounting board and print.

2 Use a tacking iron to attach tissue to print back.

3 Trim tissue with a scalpel to fit print.

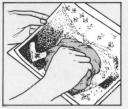

4 Tack corners of tissue to the mounting board.

5 Place print, board and tissue in hot press.

Cutting an overlay △
A cut-out mount with beveled edges is an attractive finishing touch to a mounted photograph. Normally, it is quite difficult to cut a perfect beveled edge, but you can buy a special knife which, with a little practice, makes this task quite simple.

Spray mounting △
As an alternative to dry mounting, you can use aerosol adhesive. It is cheap, convenient and quite permanent. Simply spray an even coat on the back of the print, wait a moment until the adhesive becomes tacky, then place the print on the mounting board and exert a gentle, even pressure.

Display and storage

A good storage system will ensure that your work is safe and easy to locate, and suitable frames or mounts will display your favorite pictures to their best advantage. There is no point in working hard to produce excellent portraits if they are then left carelessly in a drawer in the processor's envelopes.

Each time you process black and white or color film you should make a contact sheet from the negatives the moment that they are dry. Cut your negatives into strips — 35 mm into sixes, 120 mm into threes and 220 mm into twos. Then, under darkroom lighting, place an 8×10 ins (20×25 cm) piece of printing paper emulsion side up on your masking frame. Place the negatives emulsion side down on top of the paper, cover them with a clean piece of glass and give a 5–10 sec exposure at f16. Fix, wash and dry the resulting print. This will give you a miniature record of all your shots. Put the whole set of negatives in a separate envelope or file and enter each number and a brief description in your record book. Write a code number on the envelope or filing sheet of negatives and on the back of the contact sheet. Store the negatives in number order and file the contact sheets under special headings — for example, "children", "silhouettes", "weddings" — or under names in alphabetical order. You can display your best color and black and white prints in photograph frames or mount them in albums.

With color slides the procedure is different. You should only keep the best results, making a selection as soon as your films return from processing. If you have 35 mm transparencies you can keep them in small labeled boxes or slide magazines, or put them in a series of sleeves in ring binder files or in a filing cabinet. Mount large-format slides in black cardboard with a cut-out for each slide. Individual boards hold three or four exposures. You can buy these mounts ready-made or make them yourself. Insert the whole mount into a transparent plastic sleeve for protection. If you shoot a lot of color slides you should have a projector and screen so that you can give slide shows of your work.

◁ **Slide projectors**
Rotary magazines hold around 80 slides, allowing you to give a long showing. Smaller straight magazines may be more suitable for portraiture. You can use them to show a single series of pictures of one person as a kind of composite portrait. You can also use small magazines to store slides. Some projectors have variable-focus zoom lenses which allow you to control the image size. This is useful when projecting in a restricted space.

Choosing a frame ▷
Finding a suitable frame for a specific portrait is very important. A picture will always look better if it is displayed well. Decide on the shade of the mount — white, black, cream, or a color. Then choose a frame that matches the print and its mount. You should take into consideration the style of the portrait — a modern-looking image will best suit a clip-style frame, while a traditional, romantic photograph may look better in a painted, wooden or silver type.

◁ **Slide storage systems**
It is important to have a system of classification for your slides — either by name, occupation, or subject. The choice of filing method will depend on the extent of your collection. If it is very large, a filing cabinet with slides in labeled transparent sheets suspended on metal bars may be best. With a smaller collection ring folders with each sheet of slides restricted to a single subject are usually better.

Index

Acknowledgements

A portrait is never the result of the sole endeavors of a single person, but a joint venture between two people — the photographer and the sitter. Our book would never have materialized without the kind and enthusiastic cooperation of our sitters. We would like to thank them all most sincerely. In particular we would like to single out a few people who were directly concerned with this book: Julia Hunt and her charming models, Judith Deer who has modeled for us many times, several London College of Printing students who sat for us and also contributed their self-portraits, Sue Graham-Dixon who most generously illustrated diffusion in portraiture, our friend and literary agent Andrew Best who jumped, brooded and scowled for our camera, the versatile Sophie Parkin shown here in many moods, Mr Borg (the wizard with marble), Tenebris among his lamps, and Graham Kirkland in his stained glass workshop.

Our thanks also go to Tim Stephens, Bruce Pinkard and Fred Dustin for their pictures, and to Judith More and Mark Richards for their months of hard work.

And finally we are very grateful for the generous assistance and cooperation of: John Raddon of Pentax Ltd, Jeff Bullock of 3M, Alison McKay of Polaroid Corporation, and to Kodak Ltd.

Dorling Kindersley would like to thank the following people and organizations:
Joss Pearson
Richard Dawes
Phil Wilkinson
Jonathan Hilton
Chambers Wallace Ltd
F. E. Burman Ltd
Kizzy Harrison
Rosamund Gendle

All photographs by Jorge Lewinski or Mayotte Magnus except for:
6: Norman Parkinson/ Camera Press(top), Pete Turner/Image Bank (bottom)
7: Eve Arnold/Magnum
8: Julia Margaret Cameron/ National Portrait Gallery
9: D. O. Hill and R. Adamson/NPG
10: A. L. Coburn/Mark Twain Memorial, Hartford, Conn.
11: J. Lartigue/L'Association des Amis de Jacques-Henri Lartigue(top), Sir Cecil Beaton/Camera Press(bottom)
12: Yousuf Karsh/Camera Press(top), Bill Brandt (bottom right)
13: Dorothea Lange/Library of Congress, Washington
15: Ami Phul(top), David Hamilton/Image Bank (bottom)
76: Carl Warner(top), Tracy Nicholls(bottom)
77: Paul O'Kane
105: Fred Dustin
132: Tim Stephens(bottom)
133: Bruce Pinkard
137: Amanda Currey

Illustrations by:
Jackson Day Design
Gary Marsh